The Story of De Stijl
Mondrian to Van Doesburg

H.P. Berlage
Bart van der Leck
Piet Mondrian
Theo van Doesburg
Vilmos Huszár
Antony Kok
Georges Vantongerloo
Robert van 't Hoff
Piet Zwart
Jan Wils
J.J.P. Oud
I.K. Bonset
Lena Milius
Aldo Camini
Gerrit Rietveld
Cornelis van Eesteren
Truus Schröder
César Domela
Nelly van Doesburg
Mart Stam

The Story of De Stijl

Mondrian to Van Doesburg

Hans Janssen
Michael White

Abrams, New York

COULEURS FINE

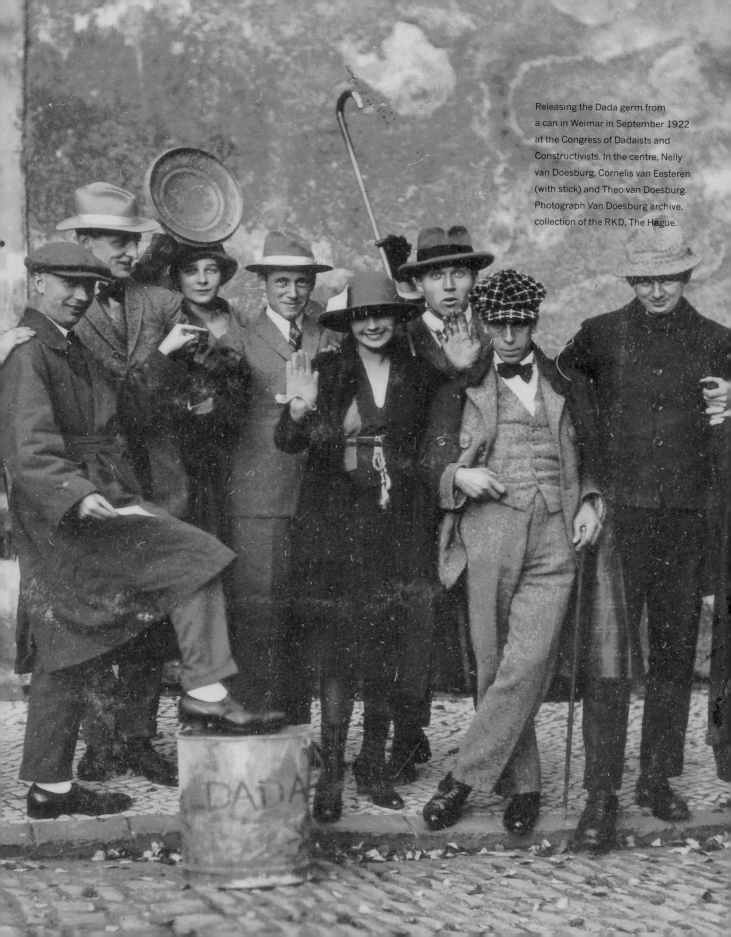

Releasing the Dada germ from a can in Weimar in September 1922 at the Congress of Dadaists and Constructivists. In the centre, Nelly van Doesburg, Cornelis van Eesteren (with stick) and Theo van Doesburg. Photograph Van Doesburg archive, collection of the RKD, The Hague.

Contents

Foreword

The Netherlands has an illustrious artistic tradition. For centuries this country has produced great artists, including many who are still world-famous today. Their work fills many galleries in Dutch museums. Yet some other aspects of the country's artistic heritage are not as well represented. This includes the Dutch twentieth-century art movement that made the greatest contribution to modern art. De Stijl, the circle of artists around Mondrian and Van Doesburg, blazed major new artistic trails. The work of these artists remains influential; their collective significance can hardly be overstated. In particular, the groundbreaking multidisciplinary character of this movement continues to inspire many contemporary artists, architects, designers and couturiers. De Stijl built bridges between art, design, architecture and society. Nevertheless, there have been few recent publications about these artists, and little of their work is on display in Dutch museums. The Gemeentemuseum Den Haag has decided to change that situation.

During the First World War, the Netherlands was a neutral power. Europe was burning, and there seemed to be little reason for optimism. Nevertheless, one of the most influential European art movements emerged in the neutral Netherlands during those years of war. The movement's innovative capacity is evident from its beginnings as a magazine, entitled *De Stijl*, first published in Leiden in November 1917. The group's members collaborated by modern means such as the post and telephone and through black-and-white photography. Months sometimes passed without a face-to-face meeting, but with energetic exchanges of letters. It is like today, with e-mail, Facebook and Twitter.

The essential aim of De Stijl was to find a new form of art that could be of the greatest possible benefit to society. Despite the universal appearance of their paintings and buildings, these artists had a typically Dutch outlook. By collaborating, they hoped to combine their disparate art forms into a total work of art. This was not an entirely new idea; what set their project apart from earlier ideas about the unification of different art forms is that they recognised no hierarchy between forms. Instead the arts were, in a manner of speaking, expected to fuse.

De Stijl went in search of a new kind of art for the society of the future and found it in an abstract visual idiom called Neoplasticism, consisting of lines, planes, the primary colours red, blue and yellow, and the non-colours white and black. Mondrian and other members of De Stijl concentrated on relationships: between colours and forms, lines and

planes, the wall and the painting, etc. By relieving paintings of their conventional function – namely, representing reality – they made room for a new plasticity in which paintings enter into a relationship with the world beyond their frames. In philosophical terms, they were investigating the whole in relationship to its parts, unity in diversity.

The reception of De Stijl among art historians has shifted, especially in the course of the twentieth century. While the movement has come to be described as rationalistic, structured and almost emotionless, the original intent of these artists was to create art that was dynamic, as well as unfailingly lively, unrestrained and cheerful, like the future itself. This lay behind their interest in dancing halls, advertising and fashion. In his article 'De jazz en de neo-plastiek' (Jazz and Neoplasticism), Mondrian describes jazz as a childlike experience. We do not look at De Stijl through this lens often enough.

The narrative of this book is based on a number of different confrontations. The innovative capacity of De Stijl arose partly from internal dissension. In Theo van Doesburg's case, confrontation even seemed to be a way of life. We chose this structure for the book because we believe that in today's society chronological storylines are hackneyed and outdated. Telling a chronological story might contribute to a linear understanding of De Stijl, which is not emphasised here, but could not do justice to the movement's many facets, forms of collaboration, combinations of artistic disciplines or social influence. With this in mind, we have opted for a fragmentary narrative style, moving from the smallest to the largest scales and from the intimacy of the living room out into the streets of the city. The story of De Stijl is a story of innovation, of faith in a new kind of art, confidence in the future and the conviction that change is necessary.

We are grateful to the many helpful individuals who played a role in this project – both the book and the accompanying exhibition. Our sincere appreciation goes out to: Ole Bouman, Behrang Mouzavi and Hetty Berens at the NAi, Tessa Wijtman and Max Risselada at Delft University of Technology, and Edwin Jacobs and Ida van Zijl at the Centraal Museum in Utrecht. We are much obliged to our lenders: Liz Kreijn at the Kröller-Müller Museum, Geurt Imanse at the Stedelijk Museum in Amsterdam, Christiane Berndes at the Van Abbemuseum, Frans Postma, Guido Widmer, Peter van Beveren, Bob Albricht, Matteo de Leeuw-de Monti, and Rainer Hüben at the Fondazione Arp, Jakob and Chantal Bill, Wies van Moorsel, Matthijs Schippers at Concepteer, Ton Okkerse at EMS Films, Charlotte Ebers at AVRO and Klokhuis. We are indebted to them for the inspiration they brought us and their enthusiastic support for our initiative.

Benno Tempel Director Gemeentemuseum Den Haag

Introduction

What is De Stijl? Of all the twentieth-century European avant-gardes, De Stijl would appear to be the most coherent in its core values and visual identity. It is associated with such instantly recognisable objects as the radical geometric abstract paintings of Piet Mondrian, with their perpendicular relationships and primary colours, the dynamic architectural drawings of Theo van Doesburg and Cor van Eesteren, which explode the conventional box-like structure of a building and show it as interpenetrating spaces unfolding in time, and the experimental furniture of Gerrit Rietveld, who took the most familiar of objects, the armchair, and reconfigured it as a series of self-supporting planks and struts. In each case, the artists, architects and designers in question would seem to have had a common goal in the discovery of the basic principles of their respective practices and a common aspiration that they might combine together to forge a new cultural consensus and 'style' appropriate for the modern age. From the 1930s onwards, De Stijl was recognised internationally as the most important contribution to modern culture made by the Netherlands.

As has been well established now, that gloss of unanimity and success conceals a huge amount of conflict and failure. Over the last thirty years, the myth of De Stijl has been gradually picked apart to leave the idea of a concerted 'movement' looking rather flimsy. Art historians have been quick to point out the lack of close contact between many of those named as its 'members', the limited number of De Stijl projects which were realised and the mismatch between the theory of De Stijl and its actual practice.

This book is intended neither to bolster the earlier version of De Stijl as unified movement nor to indulge in its critique. Anyone today who wishes to present De Stijl as the most consistent and dominant force in Dutch culture after the First World War would have to ignore a huge amount of readily available source material proving the opposite. However, the proposition that a De Stijl movement was simply a retrospective construction is also highly debatable. That leaves us with the awkward question then, 'What is De Stijl?' Our only consolation is that it was a question that was asked right from the very start by those whom we now file under this particular heading.

So, what answers did they come up with? They fell into three main categories: De Stijl was a magazine; De Stijl was an art movement; De Stijl was an idea, a world-view and an approach to life. Confusions

between these positions abounded, as contribution to the magazine could be taken as tacit approval of a broader outlook its editor, Theo van Doesburg, firmly believed it to represent. For example, following an argument with Van Doesburg, in 1921, the architect J.J.P. Oud decided not to publish in the magazine *De Stijl* any longer. The following year, an article in a different journal, *De Bouwwereld*, associated Oud with De Stijl.[1] Van Doesburg wrote an open letter to *De Bouwwereld* to protest that 'since his appointment as city architect in Rotterdam, the architect J.J.P. Oud no longer plays any active part in "De Stijl",' although he was 'theoretically at least, for some time a faithful adherent and disciple of De Stijl ideas.'[2] Given that Oud had taken up his post in Rotterdam in January 1918 and made his most recent contribution to *De Stijl* in the September issue of 1920, Van Doesburg was suggesting that, for a time at least, Oud was a contributor to the journal but not part of a "De Stijl" movement.

Oud responded to Van Doesburg's criticism to set the record straight and to stress the significance of his contribution to the journal and, by association, to a De Stijl world-view: 'I do not and have not adhered to "Stijl ideas," but published thoughts on architecture together with designs in De Stijl, which, together with what other contributors advanced, became, if you like, "Stijl ideas".'[3] Where Van Doesburg suggested that De Stijl pre-existed the journal as a set of principles which were reflected in it and bound together a group, Oud took the different view that it was the content of the magazine which had subsequently and, perhaps even fortuitously, forged a De Stijl movement.

Who was right? That does not concern us. Suffice it to say that a history of De Stijl that charted how it began as a journal, developed an identity as an art movement and finally became an idea that could be transported to different geographical locations and outlive its original participants would be as suspect as Van Doesburg's consistent presentation of the same but in reverse: De Stijl began as an idea, out of the idea a movement formed; the movement expressed itself in the form of a journal.[4] The former would have to ignore the fact that De Stijl was recognised as a group or movement as soon as the journal was published, the latter that De Stijl as both magazine and group was a very fluid and changing phenomenon, the 'ideas' of which changed enormously from the war years to the late 1920s.[5]

Taking up the debate on the identity of De Stijl with Oud yet again in 1924, Van Doesburg wrote in an extraordinary letter, What is the Stijl group? All of creative Europe and soon America! They all, without exception, experience not only the influence but the vital propelling force that radiates from the De Stijl idea. [...] What is the Stijl group presently? (Literally) not on your life a clique with a limited number of mates but a living immeasurable reality which forges its way ahead

1 Jan Gratama, 'Een oordeel over de hedendaagsche bouwkunst in Nederland', *De Bouwwereld*, vol. 21, no. 29 (19 July 1922), p. 219.

2 Theo van Doesburg, 'De architect J.J.P. Oud "voorganger" der "kubisten" in de bouwkunst', *De Bouwwereld,* vol. 21, no. 30 (26 July 1922), p. 229.

3 J.J.P. Oud, 'Bouwkunst en kubisme', *De Bouwwereld*, vol. 21, no. 32 (9 August, 1922), p. 245.

4 See Theo van Doesburg, '10 Jaren Stijl', *De Stijl* vol. 7, nos. 79-84 (1927), p. 5.

5 Press cuttings in the Van Doesburg Archive (RKD, The Hague) include many reviews of the first issue of *De Stijl*. It was linked by several commentators to the republication of Van Doesburg's 1916 series of articles 'De nieuwe beweging in de schilderkunst' (The New Movement in Painting) in book form in 1917. A review in *De Opmerker* (vol. 52, no. 50, 15 December 1917, pp. 393-394) of Piet Mondrian's first article in *De Stijl* identifies the contributors to the journal as 'a small group of modern artists'.

everywhere and torches whatever is impure and false.[6] The architect Robert van 't Hoff, one of the signatories of the first 'Manifesto of De Stijl', described that force as a 'spirit searching for new relationships in life' and associated it directly with the persona of Van Doesburg himself: 'Van Doesburg and "De Stijl", inseparable from each other, will retain their significance through the spirit which emerged from him and his work.'[7]

A journal, a group, a movement, an idea and now an individual? Little wonder that Van Doesburg felt there was such affinity between De Stijl and Dada, which had also begun as the name for a journal, was used instantly to describe a movement but was consistently described by its proponents as totally insubstantial, a state of mind or even as nothing. Unlike 'dada' though, the word 'stijl' was profoundly meaningful rather than virtually meaningless.

What's in a name? There is no record of how the decision was taken to call the magazine, which began publication in October 1917, 'De Stijl'. Many years later, Van Doesburg recounted that his initial wish had been for the title 'The Straight Line'.[8] It is unlikely that, if this choice had prevailed, you would be reading a book called 'The Story of the Straight Line', let alone that there would have been the equivalent number of exhibitions and publications dedicated to it such as have been to De Stijl.

Like the name of its contemporary, the German art school known as the Bauhaus, De Stijl is rich in associations and meanings that conjure up something much more than a magazine. From Heinrich Hübsch's 1828 brochure 'In What Style Shall We Build?' (In welchem Style sollen wir bauen?), to the monumental treatises of Gottfried Semper and Alois Riegl, to modernism, architectural and art critical discourse in Europe from the nineteenth to early twentieth century was dominated by the problem of style, in particular what kind of style was appropriate to the modern age. The present was often held up in unsympathetic contrast to the past as lacking a visual, stylistic identity of its own. The pursuit of a single, new, common style was seen as preferable and morally superior to the imitation or pastiche of existing styles.

In the Netherlands this view was promulgated most clearly in the writings of the architect H.P. Berlage who adopted the idealist viewpoint that the creation of a modern style was intimately connected to social and political reform. Architects and designers were charged with nothing short of the creation of a whole new set of social relationships. As he put it, a material and a spiritual process were converging: 'at the same moment economic (political) evolution reaches fruition, that will also be the case with the spiritual (artistic) one. And from that moment on we can properly work on the development of a style, as

6 Theo van Doesburg's letter to J.J.P. Oud, 11 November 1924, quoted in Evert van Straaten, *Theo van Doesburg, 1883-1931*, The Hague (Staatsuitgeverij) 1983, p. 128.
7 Robert van 't Hoff, '7 maart 1931', *De Stijl*, dernier numero, 1932, p. 45.
8 Theo van Doesburg, '10 Jaren Stijl', p. 5.

from that moment on the development of a new society can also begin. Because only then can we talk of a world idea, that is to say a collective ideal, for then the great principle of equality for all people will prevail, not only in religion but in politics and economics.'[9]

Choosing the word 'style' and moreover referring to it with the definite article, The Style, was an unambiguous claim to the inheritance of this idealist tradition. Moreover, three years of world war and massive upheaval across the entire continent of Europe gave credence to the feeling that a new world might be on the cusp of formation. The notion that it would fall to artists and architects to create it might seem odd to us now but was a common belief at the time. Seen through the old lens of the modern movement, we end up with a story of utopian aspiration ending in disappointment and heroic failure. Despite the ripeness of the historical moment, the world of pure and equal relationships dreamed by Mondrian or Van Doesburg did not come to pass. However, that is not to say the world did not change and that these individuals did not play a part in that change. We should not throw out the baby with the bathwater.

There is a humbler definition of the word 'stijl' in Dutch, meaning an upright post, such as a door jamb. As a vertical building component it is often opposed to and joined to a horizontal 'regel' which has the double meaning of 'rule' and 'bar'. The visual, graphic design identity with which De Stijl was launched evoked such constructional references rich in metaphorical implications. Each segment remained clearly visible while in a necessary relationship to another. The expression of cooperative interdependency was at the heart of Rietveld's innovative carpentry where structural elements were not joined so as to overlap or dovetail into each other but to retain a sense of individual integrity while clearly playing a supportive role. Just as Rietveld's furniture design has been described as the result of a kind of 'manual intuition' as much as the product of an idea or ideology, we can explore how what we now know as De Stijl resulted from the interaction between ideas and real situations.[10] It was the product of everyday experience as well as the desire to change that experience.

What's the story? The meaning and significance of De Stijl was in dispute from the very start, from both inside and outside. Rather than finding that to be a bad thing we might reflect on why people became so agitated about it. Although we may be sceptical about the claims of the modern movement to progressiveness and avant-gardism, the manner in which artists formed connections with each other, founded exhibiting societies and journals tells us a lot about the struggles for power and influence at work within society at a certain point in time. By becoming editor of a journal, Theo van Doesburg gave himself a platform and a voice which extended far beyond other artists. While

9 H.P. Berlage, *Studies over bouwkunst, stijl en samenleving*, Rotterdam (Brusse), 1922, p. 85.
10 Peter Smithson quoted in Paul Overy, 'Carpentering the Classic: A Very Peculiar Practice. The Furniture of Gerrit Rietveld', *Journal of Design History*, vol. 4, no. 3 (1991), p. 139.

only a few hundred people ever subscribed to the journal, it was set up as a challenge to the authority of newspaper criticism, academic art history and theory, professional associations and the art trade. That six years after first publication, a De Stijl exhibition in Paris could win the praise of the Dutch ambassador to France tells us how successful the strategy was.

This is not a story about heroic failure or one about avant-garde premonition but about the production of an artistic and cultural phenomenon out of basic human interactions. Very often disagreement rather than happy collaboration seems to be the dominant theme. This is partly because arguments tend to be better documented, as each party made sure to canvass support and put over the 'correct' side of the story. Van Doesburg very often seems to be at the centre of disputes but that is mainly because of his role as facilitator, agitator and publisher. His death in 1931 is frequently used to mark the end of De Stijl and provides the tragic element to a story of misunderstood genius. We have notably avoided this narrative device. There is no such obvious climax and subsequent moment of redemptive recuperation. Van Doesburg claimed that De Stijl was over as early as 1918. Later historians have noticed distinct moments of discontinuity in 1922, 1925 and 1928. To believe this is to believe in the De Stijl idea. Better, we think, to explore how that idea was always part of a lively debate and never owned by one individual. There is no such thing as De Stijl, only its artists, architects and designers.

A word of thanks

A story such as this could not be told without the previous work of many. In the last thirty years groundbreaking archival research has been carried out by K. Schippers, Evert van Straaten, Carel Blotkamp and his students, and Alied Ottevanger, and the results of their labour have made it possible to rethink the way in which De Stijl can be written about. Without Rudi Oxenaar, Nancy Troy, Sjarel Ex, Allan Doig, Yve-Alain Bois, Jane Beckett, Paul Overy and Yvonne Brentjens, the contours of the story would be shrouded in fog to this very day. Their pioneering analyses of the phenomenon are the foundations of our structure. But it is Carel Blotkamp, Els Hoek and, not to forget, Joop Joosten who, by means of their piercing insights, have prompted us to write this book. We stand on the shoulders of giants. The interval pieces are written by Madelief Hohé, fashion curator at the Gemeentemuseum.

H.P. Berlage

(1856 Amsterdam – The Hague 1934)

Every piece of furniture is a little architectural structure, H.P. Berlage
believes. To him, therefore, the difference between applied art, architec-
ture and urban planning is becoming blurred. From an early stage,
he is convinced that social and spiritual progress will engender an art
that suits modern life perfectly. That art will have 'Style' ('Stijl'): every
chair, every cabinet, every building, every neighbourhood and every
city will strive to attain the epitome of artistic achievement: simplicity,
clarity of structure and purity of form and ornamentation. But he
believes those architects who, around 1918, take things to the extreme,
demanding a modern architecture devoid of ornamentation, are going
too far. Nor does he much like the idea of painters concerning them-
selves with architecture and applied arts. He refuses to fall in with the
non-representational art of the young generation. And so, as he is over-
taken by events, he fails to realise that virtually every fibre of his ideas
is being woven into the fabric of De Stijl.

H.P. Berlage
(1856-1934)

001 'Society is changing, and so she pleads for a new robe, for her old one is worn through; patching it up will no longer do, for presently what appeared new will quickly have to be packed away. That new robe is the new style that must be created, that we shall have to seek with great urgency and, upon the "Eureka", shall have to welcome with hitherto unknown jubilation. [...] Away with all those time-consuming details, that cannot be realised as one desires. Away with everything that adds nothing to the overall impression of the whole; search only for a few characteristic large planes, delimiting lines!'

001 H.P. Berlage, *Plan chest*, 1895, oak, metal, 175 x 95.5 x 210 cm. Gemeentemuseum Den Haag, long-term loan from Nederlandse Postbank 1952.

Source
H.P. Berlage, 'Bouwkunst en Impressionisme', *Architectura*, vol. 2, no. 23 (9 June 1894), p. 99 and p. 102

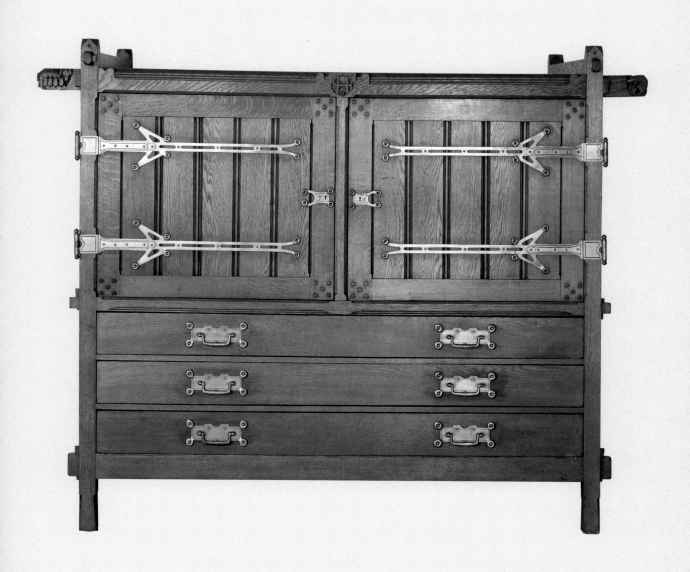

19

Bart van der Leck

(1876 Utrecht – Blaricum 1958)

Engaged for many years in an isolated search for a way of bringing together painting and interior design. Wants to bring beauty into everyday life. Seeks pure relationships and holds dear to his heart a socialist community in which, needless to say, art is a vital component. He approaches his work in a completely intuitive way ('insight driven by truth', as he refers to it). His view that the image must be open and spatial makes him an attractive partner for Mondrian from 1916 and for Van Doesburg not long afterwards. Van der Leck is hailed as a leading member of De Stijl. He helps write the first edition of the journal, but soon distances himself from the movement because he believes that, while De Stijl preaches openness, it does not appreciate what it is really all about. He goes his own way, disgruntled, particularly after 1951 when De Stijl becomes accepted as an art movement in which he had played a key role. He then paints completely abstract works again for a while.

How most of the original protagonists meet and form De Stijl

In 1916, collector Helene Kröller-Müller (1869-1939) of The Hague is becoming increasingly disenchanted with the paintings of Bart van der Leck (1876-1958). She has supported him by buying his work for four years, following the advice of art critic H.P. Bremmer (1871-1956). But Van der Leck's paintings are gradually becoming less real and increasingly 'linear art', with no atmosphere or illusion. He wants to 'relinquish what binds [him] to the old world' and is in search of a beauty 'that is without object, in pure relation', as he calls it, as in a poster. She calls it 'fact as abstraction' and has difficulty coming to terms with it.

Her relationship with Van der Leck becomes strained for other reasons, too. He advises Kröller-Müller on colour, and wants to make paintings in interiors into 'representatives of visual life', and for this reason too he tends towards abstraction. Kröller-Müller is more practical. She is mainly concerned with what door frame is to be painted what colour. In the spring of 1916 he declines any further commissions: 'If there was opportunity for contemporary monumentality, or even simply a room where something needs to be done, I would be honoured, but to be a kind of decorator's supervisor, I simply have no appetite for that.'

Ten months later, Kröller-Müller tries again. She has an 'art room' at the Groot Haesebroeck estate in Wassenaar, where art critic Bremmer gives courses on modern art. The furniture – tall display cases, an oval table and chairs – have been designed by the famous architect Berlage. Berlage's goal is to meld all art forms together in well-designed interiors, in service of the higher ideal of community. It is known as *gemeenschapskunst* (community art). The old-fashioned 'cabinet maker' must make way for the 'designer'. Hygiene, functionalism, honesty and efficient production methods are 'modern', have 'style'.

Van der Leck wants this too, but as a modern painter he also wants more. He produces a design: a white floor and white walls with a high black skirting and a band of red rectangles around the top with a separate blue line beneath. The bright blue upholstered chairs would be placed on a rug with geometric motifs, so that entering the room would be like stepping into a painting. The architect wants to examine the design with him at Mutter, the Hague firm that will carry out the work. Though Van der Leck attends the meeting, he leaves early. 'You left without deciding on the fabric and colour' writes Helene Kröller-Müller in dismay. Van der Leck replies that he does not wish to work with a 'high priest' who clings to the contrast between architecture and painting. 'The more tense and smooth', Van der Leck writes to his patron, 'without colour and line and form, without ledges, without extending beyond the essence of his field, the purer the architect will be; [...] the renewal of painting starts with the treatment of the surface that the architect creates.' If this is not so, he cannot complete the

002 Bart van der Leck, *The Sick Man*, 1912, tempera on canvas in a white-painted wooden frame in direct contact with the painting, 106.3 x 137.2 cm. Collection of the Gemeentemuseum Den Haag, on long-term loan from the Wibbina Stichting 1954. Van der Leck's style changes around 1912, as he strives to suppress outward differences between individuals and goes in search of a new way of portraying humanity.
003 Bart van der Leck, *Batavier Line poster*, 1915-16, lithograph, executed by Geuze, Dordrecht, 57 x 110.4 cm. Collection of the Gemeentemuseum Den Haag, gift, 1922. The large, simple shapes are immediately recognisable, as they must be in the fast-moving new age.
004 Bart van der Leck, *Poster design for the Volksuniversiteit in The Hague*, 1916, pencil and indian ink on paper, 119 x 86.5 cm. Collection of the Kröller-Müller Museum, Otterlo.

002

003
004

005

006

007

008

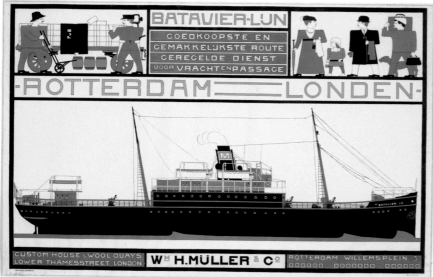

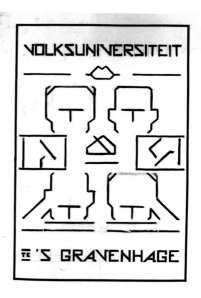

commission. The collaboration between architect and painter fails. And there are major implications. A year later, in the first edition of *De Stijl*, Van der Leck writes a manifesto on the role of modern painting in architecture: the painting creates a new sense of relationship and space which contradicts the closed relationships in architecture. Van der Leck calls it 'beelding van realiteit' (plastic expression of reality), taking an old word, one at the root of the terms for image (afbeelding) and depiction (uitbeelding), to mean something quite different – not representing the world as it is or making an image of it but creating a new reality from art. Painting has already determined its clear position, while architecture lags behind.

005 H.P. Berlage, *Six-piece suite of furniture for the Van Hengel family*, 1905-11, mahogany, fabric and metal, executed by 't Binnenhuis. Gift, 1981, collection of the Gemeentemuseum Den Haag; and *Hanging lamp*, c. 1895, red copper, glass and fabric. Berlage does not challenge the model of the traditional, well-run Dutch household revolving around a central hanging lamp, and he maintains a select, wealthy clientele.

006 H.P. Berlage, *Oak bench by the Chamber of Commerce meeting hall at the Beurs van Berlage*, 1903-04. Collection of the Beurs van Berlage, Amsterdam. The Beurs van Berlage is a building for the community. The architect intends for every detail to express social and artistic 'unity of will'.

007 H.P. Berlage, *Two streamlined, abstract glass sculptures*, 1926, pressed and cut glass, executed by Glasfabriek Leerdam, 14 x 6 cm. Collection of the Gemeentemuseum Den Haag. Berlage is fascinated with natural crystalline forms, which he sees as exemplary of the clear, simple and systematic way that architecture should work.

008 Bart van der Leck, *Colour design for the interior of the 'art room' in Groot Haesebroeck*, 1916-17, pencil and gouache on paper, 70 x 77 cm. Collection of the Kröller-Müller Museum, Otterlo. Van der Leck does not want merely to give colour recommendations; instead, he tries to make art an integral part of life.

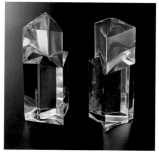

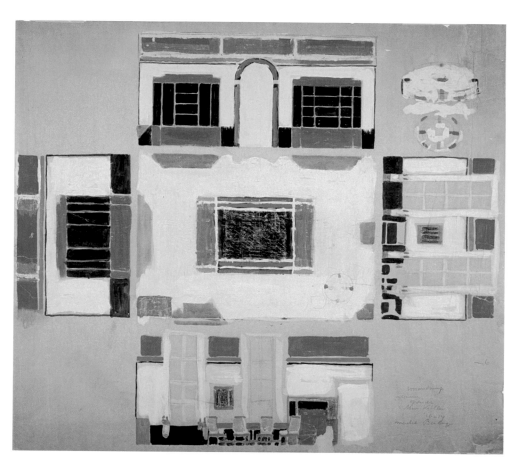

27

1916 **Theo van Doesburg**
(1883-1931)

009 'The latest news is that I have sent 3 of my works [to the De Branding society exhibition in The Hague in 1918]. They caused a real stir at the recent opening. My card players was hung among brown impressionistic pieces by Van den Uytanck, Le Fauconnier, Sluyters etc. It destroyed everything. The other pieces blackened. I suffered greatly at De Branding. Almost got into a fight. In the end, they rehung my work (my friends, Wichman etc.), moving my card players to a little back room. Everywhere elitism and obscurantism reign supreme!'

009 Theo van Doesburg, *The Card Players*, 1916/1917-19, oil and tempera on canvas, 120 x 149.5 cm. Gemeentemuseum Den Haag, long-term loan from Cultural Heritage Agency, The Hague.

Source
Letter from Van Doesburg to Antony Kok, 23 September 1918

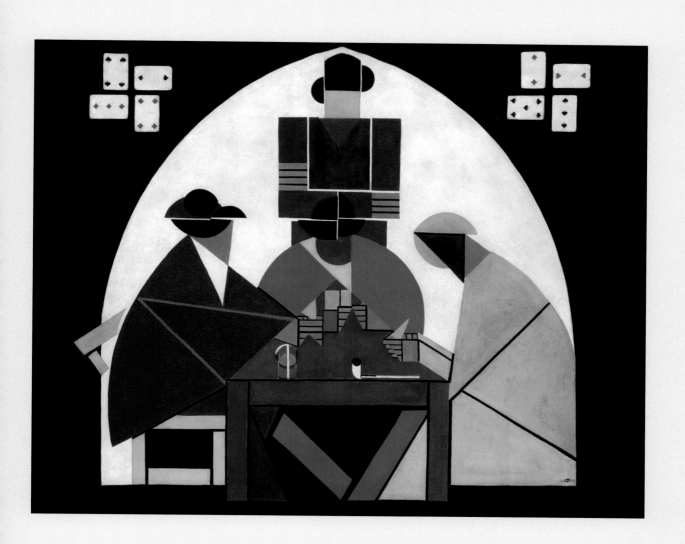

Piet Mondrian

(1872 Amersfoort – New York 1944)

From 1908 embarks on a quest for a truly abstract form of painting
that can stand entirely on its own. This would not merely combine lines
and colours in a decorative manner, it would have to make tangible
the 'spirit of the coming age'. Mondrian slowly but surely, through
experimentation, comes to the conclusion that pure, intense, inner
colours (the primary colours) and a strong, simple manifestation of
the line (the horizontal and the vertical) could help realise such an
abstract form of art. The visual manifestation – he calls it 'beelding'
(plasticism) – is not an aim in itself; it is based on philosophical and
moral considerations. Thus, beauty becomes truly visible in life. When,
around 1917, a younger generation excitedly begins to strive for an
art that is suited to modern life, Mondrian appears to have an answer
to the most frequently asked questions. He easily fills the first two
volumes of *De Stijl* with fairly inaccessible articles that give him the
reputation of being the founder of the new abstract art. He argues
with Van Doesburg but ultimately his faith in their common cause
– the new – remains unshaken.

It's a beautiful moonlit evening and the artist Piet Mondrian (1872-1944) is taking a stroll with a young woman, Maaike Middelkoop, through the heather fields close to the boarding-house 'De Linden' in the village of Laren where they are both temporarily lodging. She wants to talk about the moon's transforming effect on the landscape of Het Gooi (as the raised heathlands around Hilversum are known). For decades now, artists have been coming to paint here, finding ready subjects in its sheep farmers, who are often still to be seen about their business in traditional costume. Piet is not convinced that even moonlight can do enough to make this a scene of beauty for him. To Maaike's raptures he answers gruffly, 'Yes, but nature is really bloody awful. I can hardly bear it.' Many think the opposite and are worried that the area is in danger of being overdeveloped. Both Piet and Maaike are taking advantage of Laren's good transport connections. She goes to her office job in Amersfoort each day, while he goes to Amsterdam to make copies of Old Master paintings at the Rijksmuseum for clients; the local steam tram provides quick and cheap access. Nicknamed 'The Murderer of the Gooi' because of the accidents it causes, the steam tram has opened up Laren and its neighbouring villages to modern-day commuting.

The attractions of the village for Mondrian are not so much to be found in its farmhouses and woods but in its cultural scene, one of the most vibrant to be found anywhere in the country. He had not planned to be back in the Netherlands and was just on a summer visit when the First World War began. Now it is almost impossible for him to get back to Paris. Middelkoop is in Laren to be close to her fiancé, the composer Jacob van Domselaer. Mondrian, Middelkoop and Van Domselaer dine each evening with such writers as Jan Greshoff, Martinus Nijhoff and Adriaan Roland Holst, and the philosopher Mathieu Schoenmaekers. Afterwards they frequently go to the Hotel Hamdorff where, according to Greshoff, 'Roland Holst devotes himself to normal and Mondrian to geometric couple dancing.' Mondrian's rigid stance, with head tilted upwards and stylised steps, has earned him the name of the 'dancing Madonna' among the locals. That troubles him little; Hamdorff, for him, is a 'little Paris', a place in the Netherlands where he can still feel in touch with the big city. The domesticity of village life contrasts sharply with life in the metropolis, yet in Laren they seem to converge.

When the ambitious painter, critic and poet, Theo van Doesburg (1883-1931), visits Laren in February 1916 he thinks that Van Domselaer and Mondrian are under the spell of Schoenmaekers' ideas and his book on 'Plastic Mathematics' (Beeldende Wiskunde). 'The basis on which Sch[oenmaekers]. stands is mathematical. He considers mathematics to be the only purity; the only pure measurement of our emotions. That is why, according to him, a work of art must have a mathematical foundation', he writes. Van Doesburg is impressed by it too and the

010 The Heather Fields at Laren, c. 1920. Photograph, Historische Kring Laren. In this period it is still possible to sit out on the heath gazing up at the stars, without light from lampposts in surrounding neighbourhoods spoiling the view.
011 The steam tram from Hilversum to Baarn, c. 1920. Collection of Arjan Hart. It is the manager of Hotel Hamdorff, Jan Hamdorff, who secures this tram connection between Laren and Amsterdam in 1883, so that artists and 'country folk' can reach the village more easily.
012 Jacob van Domselaer and Maaike Middelkoop in Laren, 1916. Collection of Victor Nieuwenhuijs. Mondrian's housemates and dining companions in the modern living experiment that is the artists' colony in the Gooi.
013 Mathieu Schoenmaekers, c. 1915. National Library of the Netherlands, The Hague. In the period 1910-15 Schoenmaekers, a deeply religious man, develops the concept of 'visual thinking' [*beeldend denken*], derived from mathematics. He believes this will be conducive to spiritual life, and it has a profound influence on many artists.
014 Farmhouse on the Pijlsteeg (now Ruiterweg 5) in Laren. Collection of the Netherlands Institute for Art History (RKD), The Hague. From 1916 to 1919, Mondrian rents rooms from Marie Calisch, a teacher at the Humanitarian School established there by Jacob van Rees. Mondrian previously used the studio hut Van Rees built for his son, Otto, in the grounds of the collective farming colony he founded in Laren in 1900.

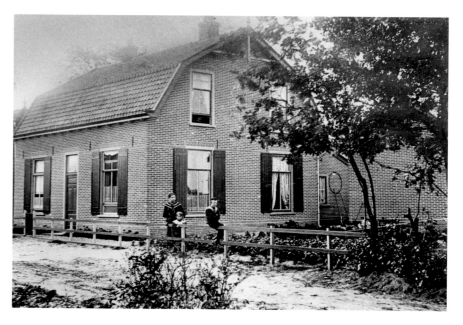

014

015

village strikes him as a wonderful place to live. 'There are so many folks living there engaged in the abstract life.' Two months later their number is augmented by Bart van der Leck who, having resigned his position at Müller & Co. in The Hague, moves into a house that Mondrian passes close by on his daily walk to his studio in the neighbouring village of Blaricum. The two men soon become billiard partners. Van der Leck has lived in the area before though. He came here first in 1907 in the hope of joining Antoon Derkinderen's stained glass studio, set up on the model of the medieval workshop. It is in response to Derkinderen's wall paintings in the town hall of Den Bosch that the term *gemeenschapskunst* is first used in the 1890s. For Derkinderen *gemeenschapskunst* means both making art for the community but also for artists to form communities in order to abolish the boundaries between the arts, and to create an art that penetrates the entire fabric of modern life. Unfortunately for Van der Leck, Derkinderen is appointed director of the Rijksacademie and closes the studio just as he arrives. By 1916 things have changed dramatically. One of Derkinderen's former assistants, P.H. van Moerkerken, has recently published a novel, *The Downfall of the Village* (De ondergang van het dorp), charting the gradual eradication of simple farming life in Laren as the village is gradually swamped by artists and those in pursuit of a 'new age' lifestyle in the many communes that are springing up around it. Cottages are being demolished to make room for comfortable villas, studios and holiday homes for wealthy Amsterdammers.

016

017

018

One such incomer, an estate agent called Salomon Slijper, sees Mondrian's paintings on the wall of 'De Linden' and starts helping the artist out with things like his rent – '14 quid and 50 cent for the light' – and a smart new suit for the Hamdorff dances, for which Mondrian gives him a self-portrait. Mondrian suggests that they pay a visit together to Van der Leck and draws him a little map in which he transforms Laren's winding lanes into a miniature grid. Some years later, as he prepares to return to Paris, Mondrian recalls the moonlit walk he took with Middelkoop and turns it into a scene in a theoretical text written in the form of a discussion, which he publishes in *De Stijl* in 1919. He doesn't disparage the natural world in the manner of his earlier brusque comment but now describes how he depicts nature 'merely in a different way'.

015 Antoon Derkinderen, *The Stages of Life*, 1900, chalk on paper, 188,5 x 128,5, 190 x 80, 189 x 89,5, 188,5 x 59 en 150 x 125 cm. Derkinderen sketched the five designs for mural paintings to be executed in the building of the Algemeene Levensverzekerings Maatschappij (a Life Insurance Company) in Amsterdam, designed and built by Berlage in 1900. Collection Gemeentemuseum The Hague, acquired 1926.

016 Willy Sluiter, *Exhibition poster, Hotel Hamdorff*, Laren, 1916, lithograph, executed by Drukkerij Senefelder, Amsterdam, 109 x 78 cm. Collection of the Gemeentemuseum Den Haag, acquired in 1936. Each summer from 1913 onwards, the Hotel Hamdorff throws notorious dance parties in its summer garden.

017 Piet Mondrian, *Self-Portrait*, 1918, oil on canvas, framed in a small, rough pine frame, 88 x 71 cm. Collection of the Gemeentemuseum Den Haag, Slijper bequest, 1971 (© Mondrian/ Holtzman Trust c/o HCR International, Virginia, USA). Mondrian paints this portrait for Salomon Slijper, who wants to acquire more of the artist's work as the basis for a museum collection. The role of this portrait in the collection is to make visible the relationship between art and life, between the person and his work.

018 Postcard from Mondrian to Salomon Slijper, 21 January 1917. Collection of the Netherlands Institute for Art History (RKD), Slijper archive, The Hague. The artist simplifies the winding streets of the village and transforms them into a grid to show his new patron where Bart van der Leck is living.

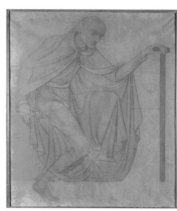

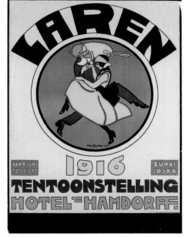

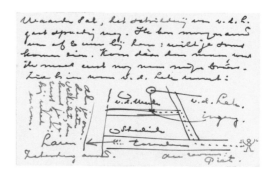

Theo van Doesburg

(1883 Utrecht – Davos 1931)

Born Emile Küpper, he adopts his stepfather's name, becoming
Theo van Doesburg. In 1908 it becomes his *nom de guerre* when
he exhibits drawings that enable him to 'move aside the curtain
that obscures his spiritual life'. In doing so, he reflects a commonly
held opinion in the Netherlands regarding the function of art. He is
enchanted by Kandinsky's abstract art when he encounters it in
1913. The door to a similar 'modern energy' opens when he meets
Mondrian in 1916 and they eagerly begin to exchange ideas. A radical
new modern abstract art will change all aspects of life. Establishes
De Stijl as an instrument of propaganda and takes on anyone who
appears to contradict him. Strives to ensure that, by around 1924,
De Stijl dominates art everywhere. Steals a march on Mondrian with
elementarism, a fierce rebuttal of Mondrian's ideas. This lays the
foundations for the concrete abstract art that achieves such influence
in the 1930s, after Van Doesburg's death.

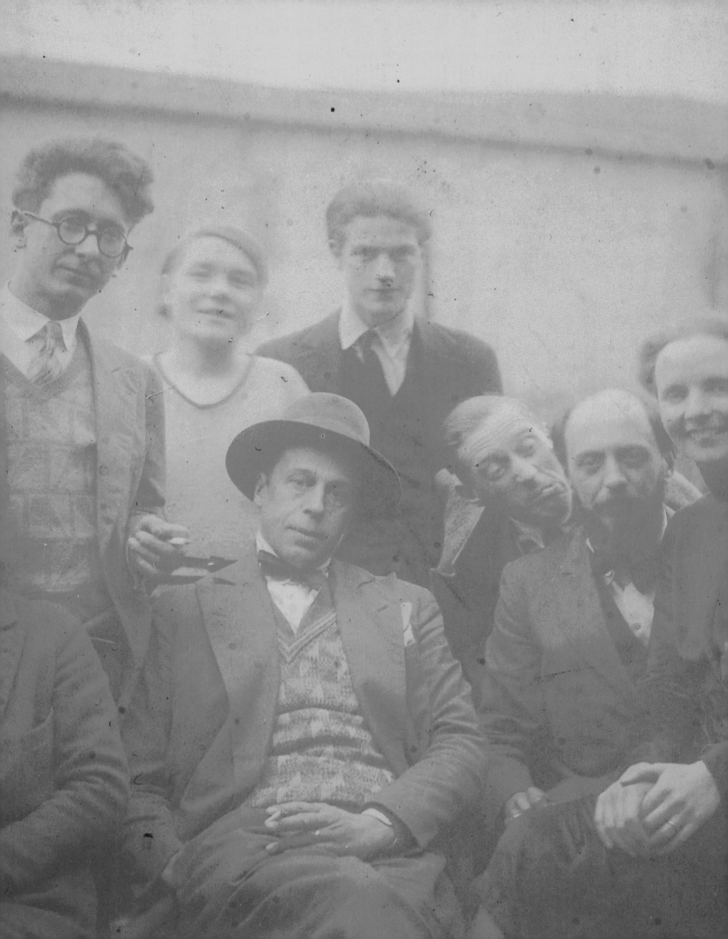

1916 03 **A new monumentality**
 Van Doesburg and Huszár at the Kröller-Müller collection
 in The Hague

Home City **Exhibition** Street

The approach of a new year brings with it desire for new beginnings
and a new art journal. A brief spell of unseasonably mild weather after
Christmas 1916 encourages Theo van Doesburg to interrupt a busy
schedule of public lectures and readings to travel from Leiden to meet
his new acquaintance, the artist and designer Vilmos Huszár (1884-
1960). At the time both are vigorously forging networks and exploiting
every means to create new opportunities to get their radical abstract
painting exhibited. In fact, they have met through a newly formed
modern art association, De Anderen (The Others), which Van Doesburg
had co-founded earlier that year. In May 1916 the organisation has its
inaugural exhibition at the Kunstzalen d'Audretsch on Hooge Wal in
The Hague. One of Huszár's important contacts, the influential critic
H.P. Bremmer (1871-1956), buys Van Doesburg's *Still-life Composition*
from this exhibition on behalf of Helene Kröller-Müller.

Using the wealth that came from her family's shipping and mining
company, Kröller-Müller has assembled one of the most significant
collections of modern art in Europe and uses part of Müller & Co.'s
headquarters at 1-3 Lange Voorhout in The Hague as a museum. As
her husband, the company director, often jokes as he walks from his
office to his wife's exhibition rooms, 'Now we go from the credit to
the debit side'.

What draws Van Doesburg to The Hague that day is not just the chance
to see his own painting hanging alongside the Van Goghs and Seurats
in Kröller-Müller's gallery but his desire to see the latest paintings of
Bart van der Leck. Kröller-Müller has acquired all of his most significant
work of the time and his stained-glass window representing the com-
pany's mining business is permanently installed in the Lange Voorhout
offices. The brand-new addition to the collection is his *Composition
1916 No. 4*, better known as the *Mine Triptych* because it has been
derived from sketches of a mine entrance (centre) and miners (side
panels), subjects Van der Leck observed on a trip to see company
activities in Spain and North Africa in 1914 in preparation for his
stained-glass composition. Not that this is any longer perceptible to
the uninitiated. The images have undergone what Van der Leck terms
doorbeelding (decomposition), another new term describing a process
by which the image is reduced to brightly coloured blocks and bands
– red, yellow, blue – against a white background, creating an openness
of form and clarity of visual organisation that he considers expressive
of the new age in its primal state.

Standing in front of Van der Leck's large, multi-panel painting, Van
Doesburg and Huszár do not debate its depiction of the commercial
interests of Müller & Co. but rather the artist's pursuit of what Van
Doesburg describes in a rapturous letter to Van der Leck as its 'univer-
sal qualities of life' which he perceives to be 'in harmony with the pure

019

020

021

022

023

019 Theo van Doesburg, Advertise-
ment for the art association
De Anderen, 1916. Collection of
the Gemeentemuseum Den Haag
020 Theo van Doesburg,
Composition 1 (Still-life), 1916, oil on
canvas, 67 x 64 cm. Kröller-Müller
Museum, Otterlo. Bowls, plates
and fruit are transformed by the
artist into triangles and circles in
a pyramidal composition set in
a grid of 64 squares. The artist plays
chess with the viewer, demanding
our concentration on abstract
spatial relationships.
021 The gallery of Helene Kröller-
Müller on Lange Voorhout, The
Hague, c. 1900. Photograph, Haags
Gemeentearchief. Accompanied
by the critic H.P. Bremmer, Kröller-
Müller takes trips to Paris, where she
buys works directly from artists to
assemble one of the finest collections
of modern art of the time, open to the
public on certain days of the week.

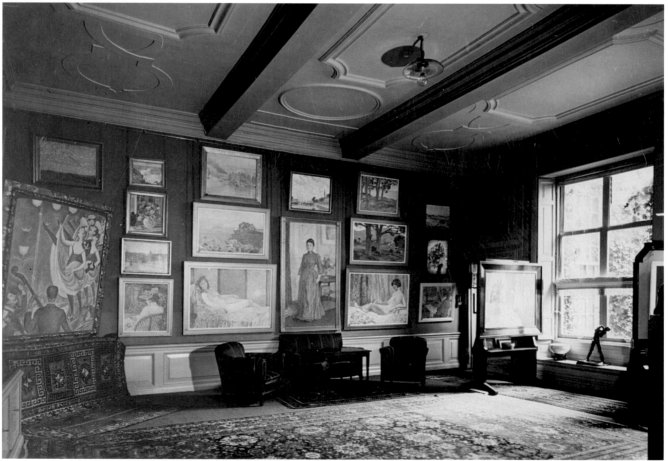

39

means of painting'. Huszár is a little more sceptical and finds it not as 'absolute' as the last paintings of Piet Mondrian that were to be seen in October in the Stedelijk Museum in Amsterdam, although both agree that Van der Leck has shown the potential of abstract art to create a new monumentality and that, as an artist, you should not 'shut yourself in the studio', as Huszár puts it. What they urgently need now is a journal to represent their interests and communicate their views directly to the public. The critic Bremmer, who gives Kröller-Müller lessons in art appreciation, has shown how you can do this in his monthly *Beeldende Kunst* (Visual Art); he illustrates art from different periods in it and, by comparing images in pairs, aims to teach people how to understand contemporary art. Van Doesburg has brought his camera to take pictures to illustrate the lectures he is giving, which have a similar intention. By the end of the New Year such images will begin appearing in a brand-new magazine, *De Stijl*.

024

022 Bart van der Leck, *The Mining Business*, 1914-16, stained glass, 370 x 210 cm. Kröller-Müller Museum, Otterlo. Made for the offices of Müller & Co. and representing the company's interests in shipping and mining, this Van der Leck window shows the office and the modern forms of communication at the centre of the enterprise.

023 Bart van der Leck, *Composition 1916 No. 4*, 1916, oil on canvas, 113 x 222 cm. Kröller-Müller Museum, Otterlo. The composition is based on the entrance to a mine (centre) and two miners (left and right), but Van der Leck has reduced them to a set of colours and lines that float in black and white space.

024 Theo van Doesburg, Interior at the house (?) of Helene Kröller-Müller, 1916 (?). Photograph from the collection of the Netherlands Institute for Art History (RKD), Archive of Theo and Nelly van Doesburg, The Hague.

41

Vilmos Huszár

(1884 Budapest – Hierden 1960)

One of the most loyal artists De Stijl could ever have wished for. As a native Hungarian, he has a fairly relaxed view of the strict separation between realism and abstraction that persists all around him. Settles in The Hague in 1906. There he mixes in chic but somewhat impoverished circles in which art is regarded as a means for artists to 'strive for ever greater things'. Artists are expected to defend this ambition both orally and in writing. In 1916 he sees Mondrian's work for the first time, and immediately becomes a devotee of his new painting. Even before he meets Van Doesburg that same year, he is consciously mixing painting, design and the surrounding environment. This brings him into contact with theatre (moving paintings) and with the world of advertising and design. Although he has no further contact with Van Doesburg after 1924, he remains sympathetic to De Stijl, as is particularly apparent after 1950, when he does not hesitate to reproduce a number of historically important works.

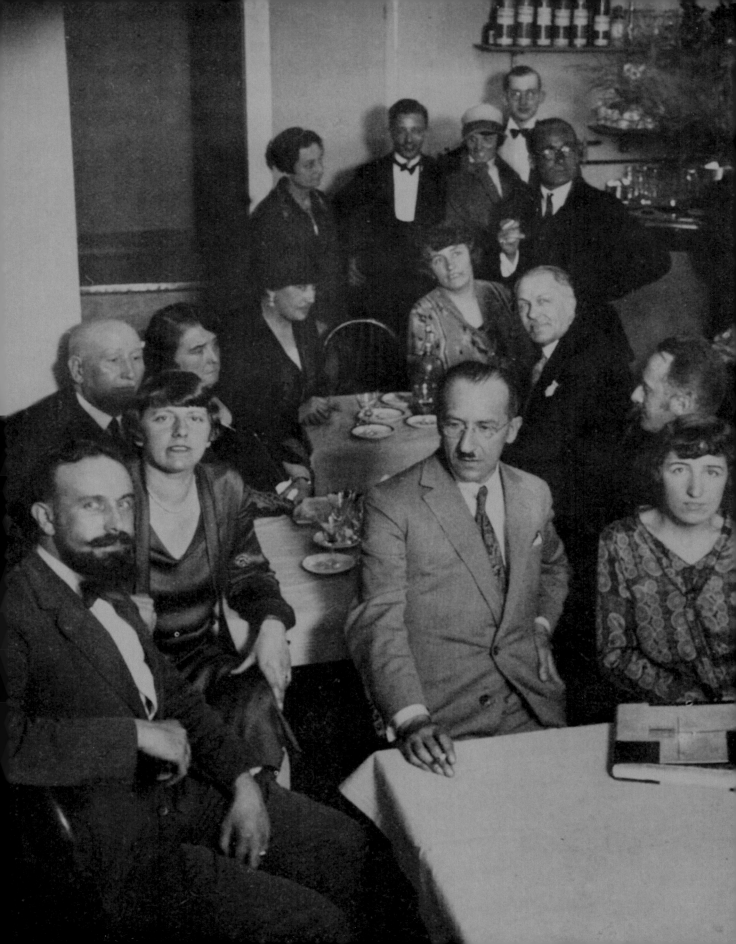

Vilmos Huszár
(1884-1960)

025

'What is a hammer to an artist? Its function: *hammering*. What is a saw to an artist? Its function: *sawing*. The painter has observed hammering as a vertical movement, sawing as horizontal. These two simultaneous movements are the visual motif on which he builds the entire composition. To visualise these two movements, the vertical hammering movement and the countervailing horizontal sawing movement, in space (since they occur in space) the painter has not positioned the planes of colour as positive elements in the painting (which would cause rigidity) but, thanks to the destruction of the background, an interaction takes place between positive and negative, that is between colour plane and the visual space. [...] Now the yellow is in the foreground; now it is in the background; now the red is in the foreground; now in the background etc. The rectangular visual space is full of movement, the sum of the vertical hammer movements and the countervailing sawing movements. [...] On seeing the hammering and sawing the artist psychologically experiences the movements. With the precise presentation of this process he forces the viewer to aesthetically experience the movements. This is the plastic transformation of reality. This is realism.'

025 Vilmos Huszár, *Hammer and Saw (Still life composition)*, 1917, oil on canvas in a wooden frame covered with oil paint, 31.5 x 53.5 cm. Gemeentemuseum Den Haag, acquired 1979.

Source

Theo van Doesburg, "'Hammer and Saw', still life composition by V. Huszár". (to accompany Appendix VII), *De Stijl*, I (1918) 3, pp. 35-36

'Alkmaar is in revolt', writes Theo van Doesburg to his musical friend Antony Kok (1882-1969) in September 1917. The reason? Apparently, people there are astonished by the daring colour designs he has produced for the new house of a local notary, J. de Lange. He has been after a major architectural commission ever since he met the architect J.J.P. Oud (1890-1963) in Leiden the year before. They are both totally committed to collaboration and have even set up their own association, De Sphinx (The Sphinx), to promote the idea. So far, Oud has only been able to involve Van Doesburg in making stained-glass windows for some of his buildings but he has given him a list of names of other architects he has met through his friend Berlage. One is Jan Wils (1891-1972), who has just set up his own office having worked as a draughtsman for Berlage for the previous couple of years.

026

Van Doesburg gives a full description of his plans for the building, which Wils has designed to echo the architecture of Frank Lloyd Wright, in a letter: all the doors are to be white with dark blue panels; the hallway is to be yellow and purple with a green dado rail; the doors of the dresser in the dining room will be blue framed by yellow; the drawing room is to be purple with green borders, while the living room is to have the same colours in reverse. The artist will really go wild in the bedroom of the notary's daughter, proposing white, red, green and blue features as well as a violet ceiling. Even the cellars and the wine racks will get the same treatment. Colours are not being chosen for their symbolic values but for their potential to create dramatic contrast. Van Doesburg can 'make paintings everywhere' with the ultimate aim that 'the house be released from its stability'. This is a completely different approach from the decoration of the domestic interior, which is seen no longer as an empty mould to be embellished with wallpaper, knick-knacks and carpets to stage the theatre of family life. Van Doesburg wants to disclose functions and to make the residents conscious of the way in which they live, in order that they will do so in a modern way.

027
028

Van Doesburg is writing his letter just after his return from Alkmaar where he has overseen the placement of a large stained-glass window in the stairwell of the house, the three sections of which are composed of coloured panes alternating between the primaries red, yellow and blue, and their contrasting secondaries green, purple and orange in a framework of clear glass and black lead-work. The effect is to 'free' the colour in space. He refers to the whole project, in German, as 'das colorierte Haus', perhaps evoking 'das gelbe Haus' by the German Jugendstil illustrator and designer Bruno Paul (1874-1968), the success of the 1914 Werkbund exhibition in Cologne. Van Doesburg has the yearbooks of the Werkbund in his library, in which this building is illustrated. He is probably already familiar with the theories of the German chemist Wilhelm Ostwald (1853-1932) who has been devising

026 Frank Lloyd Wright, *Design for the Robie House*, 1908. Frank Lloyd Wright Foundation, AZ/Art Resource New York/Scala Florence. The roof lines project horizontally, appearing to float, and draw the building out into the space around it.

027 Jan Wils, De Lange House, Wilhelminalaan, Alkmaar, 1917. View of the stairwell and *Stained-Glass Composition IV* by Theo van Doesburg. Photograph from the collection of the NAi, Wils archive, Rotterdam. The compositional rhythms of Van Doesburg's stained-glass windows can be experienced by a spectator in motion up and down the stairs, who, in the later words of the artist, is no longer standing before the art work but almost a very part of it.

028 Jan Wils, De Lange House, Wilhelminalaan, Alkmaar, 1917. View into the hallway. Photograph from the collection of the NAi, Wils archive, Rotterdam. Virtually no part of the house is left untouched by Van Doesburg's colour designs, and the entrance is traditionally an important place to show off, as Wils would write in his 1918 article on 'The Hall in the Private House' [*De hall in het woonhuis*].

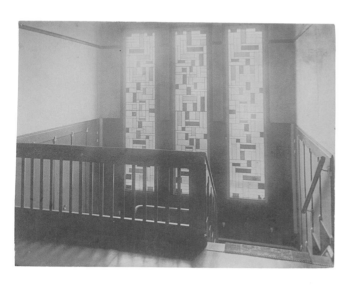

a rationalised colour scheme in association with the Werkbund, which will allow designers to harmonise colours according to a system of mathematical relationships. Van Doesburg also sees an association with music and suggests later that the repetition of a 'motif' throughout the window, put through processes of reversal and transposition, has similarities with Bach's musical compositions.

Van Doesburg plans not only to colour the entire interior but to use colour on the exterior as well. He wonders whether it will all be carried out according to his instructions. Surprisingly, given that J. de Lange will also use his house as an office, much of it is realised and the client appears to have kept the colour scheme intact until his death in 1940.

029

029 Jan Wils, De Lange House, Wilhelminalaan, Alkmaar, 1917. Front elevation. Photograph from the collection of the NAi, Wils archive, Rotterdam. The columns emphasise the play of vertical and horizontal elements, but by not reaching the architrave, they make it float free visually, as is also the case with the roof of the porch.

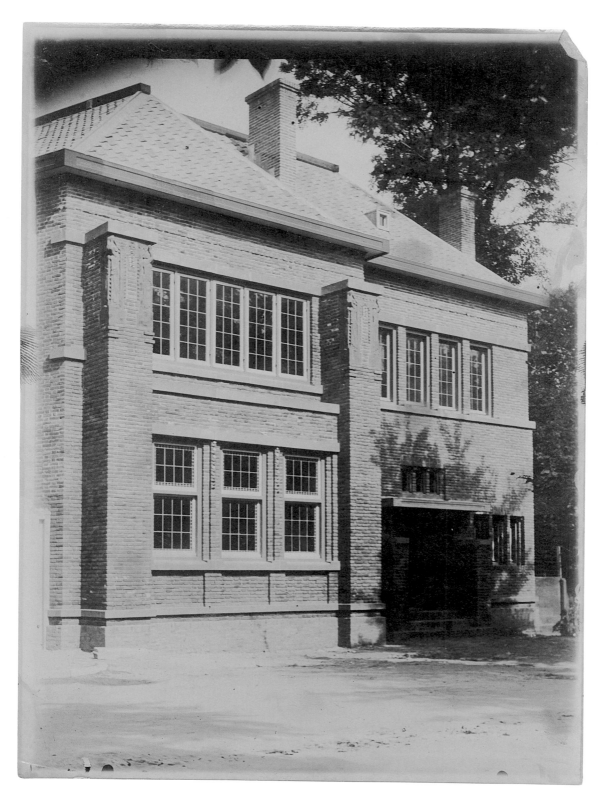

1917 **Theo van Doesburg**
 (1883-1931)

030 '…We went to the Thalia cinema yesterday evening, watched a terrific film! About some war profiteers at a ball with some bigwigs. I've never seen such burlesque dancing. All the more reason to call it absolutely visual. In maximum movement and light you saw people falling apart, into ever smaller planes which in the same instant reconstituted themselves into bodies. Continual death and rebirth in the same moment. The abolition of time and space! The destruction of gravity! The secret of 4-dimensional movement. Le Mouvement Perpétuel. What miracles American film achieves. How it disrupts closed volumes. What perspectives it opens up to the thinking mind. How can it reveal the secret of universal movement: the secret of the rotation of a body on a surface? Why does one seek to solve this with figures on paper? Enough of that. Go watch a film. Not a slow one where the flowing curves of bodies are the outer limit, a surface, but a rapid, angular, sharp-edged one that deconstructs bodies to planes, to flat fragments, to points, and which in this most marvellous of all games unfolds the secret of the cosmic structure, makes visible that which happens invisibly to everyone's body: destruction and reconstruction in the same instant.'

030 Theo van Doesburg,
Composition IX; Opus 18
(Decomposition of *The Card Players*),
1917-18, oil on canvas in a wooden
frame covered with oil paint,
127 x 117 cm.
Gemeentemuseum Den Haag,
gift of Nelly van Doesburg, 1935.

Source
Letter from Theo van Doesburg to
J.J.P. Oud, 11 June 1918, Fondation
Custodia, Paris

51

Antony Kok

(1882 Rotterdam – Tilburg 1969)

A friend of Theo van Doesburg since serving together in the army from 1914 to 1916. They begin a correspondence in which Van Doesburg tests out a variety of ideas and Kok divulges his ambition to write poetry. Together they dream of establishing a journal. Kok knows Lena Milius well and stays in contact with her even after Van Doesburg opts for Nelly. He works as an administrator for Dutch Railways, which gives him the opportunity to play piano and read books after lunch, returning to the office late in the afternoon. He also has green fingers and an extensive knowledge of plants. Financially supports many De Stijl artists and also gives Van Doesburg advice, and practical and financial help with *De Stijl*. Has unconditional faith in Van Doesburg and shares his ideals. Despite his sometimes deep intellectual input, he only ever plays a background role.

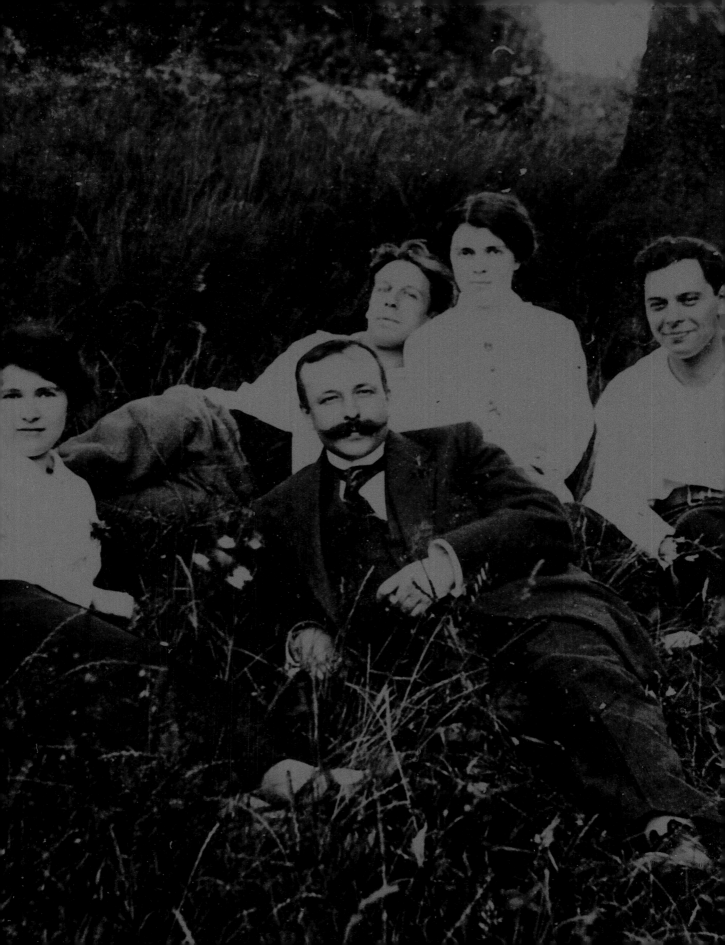

031

Berlage is still incensed about it in 1922. During a lecture in The Hague on 'Art and the Crisis', he shows a lantern slide of a Mondrian painting from the Kröller-Müller collection. Scornfully, he explains that the vertical stripes and planes represent the mood of a cherry orchard in blossom. 'Without explanation it is not possible to see what it depicts', says Berlage, 'and with an explanation it is still impossible'. Berlage simply cannot tolerate it. Either it is nonsense, or it is deadly serious. Because if Mondrian is serious, every stripe, every plane, even every brushstroke, must be carefully weighed up. And that is entirely possible, for Mondrian struggled with this and two other canvases throughout

032
033

1916. Every part had to be elemental, but they also had to combine to form a cohesive whole. This is completely different from the landscapes that Mondrian, like his fellow artists, was painting when he still worked in the old tradition. There, the focus on a certain part, like the light on the horizon, or a group of trees in the centre, was indicative of the whole. In March 1917, Mondrian writes: 'This year I have worked and searched a great deal. Much of the old had to change. I was searching for a purer image; that is why nothing was satisfactory. Now I believe I have again found a complete means of expression […].' In March he had wanted to exhibit at the Hollandsche Kunstenaarskring (Dutch Artists' Circle), but the exhibition did not go ahead because of the shortage of coal caused by the war. The galleries in the Stedelijk could not be heated. Mondrian is quite happy with the situation, for it allows

034

him to continue experimenting until May. In silence. Like a monk. Or like a scholar pondering a new theory. He corresponds with Van Doesburg about establishing a journal. Mondrian is keen, because there is a lot of confusion. He himself sees his new work as elemental and cohesive, as a *disentanglement* of traditional painting. Berlage sees it as a deterioration, and as lacking cohesion. Mondrian calls this art for modern man and modern society, 'nieuwe beelding' ('the new plastic'). As Van Doesburg describes, 'beelding' has deep meaning for those involved in De Stijl, different from its conventional associations with representation. Instead it refers to 'something supra-rational, alogical, inexplicable; depths rising to the surface, internal and external equilibrium, the fruits of victory in our creative battle with ourselves.' That is why this talismanic word from now on will be described always as 'new', as something coming into being. The only aspect of this definition to survive in its English translation as 'plastic' is the sense of 'giving shape to' or 'forming'.

To Berlage, this is not a contribution to the development of *gemeen-schapskunst*, of art for the community, by a community. Mondrian has lengthy discussions about the 'new plastic' with Bart van der Leck. The artists strongly influence each other, and discuss what Mondrian is writing. Mondrian gives his work neutral titles. The paintings of cherry blossom are called *Composition in Colour A* and *Composition in Colour B*. Cool and businesslike. It is not the cherry blossom that matters, but

031 Piet Mondrian, *Composition in Colour A*, 1917, oil on canvas in a white-painted wooden frame, 50.3 x 45.3 cm. Collection of the Kröller-Müller Museum, Otterlo. Berlage simply cannot fathom Mondrian's claim that he has captured the mood of a cherry orchard in blossom.

032 Piet Mondrian, *Composition in Line*, 1916 (first version), oil on canvas, c. 100 x 108 cm. This painting represents an early step on the developmental path that will ultimately lead to *Composition in Line*, 1917 (fig. 34). Mondrian works on it for a long time because he is in 'transition', as he puts it, to 'where it – in my humble opinion – will have to go – that is, toward the greatest possible generality in plasticity [*algemeenheidsbeelding*].'

033 Piet Mondrian, *Composition*, 1916, oil on canvas and wood in a two-step wooden frame, 119 x 75.1 cm. Collection of the Guggenheim Museum, New York, acquired in 1949. Mondrian wants this painting to be displayed under low light, so that the colour and line will achieve their full effect.

034 Piet Mondrian, *Composition in Line*, 1917, oil on canvas, 108 x 108 cm, in a receding white-painted wooden strip frame, stepped along both sides. Collection of the Kröller-Müller Museum, Otterlo. Mondrian makes many changes to the composition before arriving at a 'finished mode of representation' [*afgeronde uitbeeldingswijze*] that is acceptable to him.

© Mondrian/Holtzman Trust c/o HCR International, Virginia, USA.

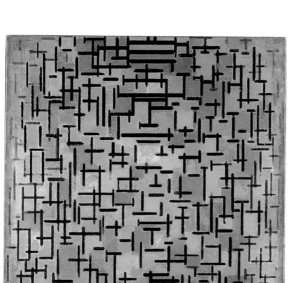

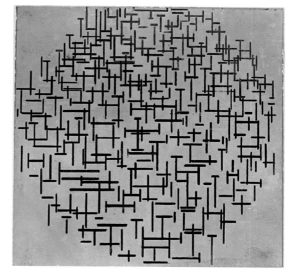

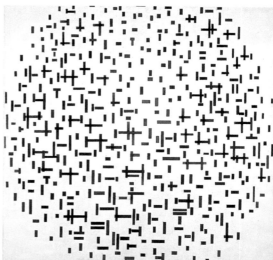

what it represents, the balanced ordering of paint, and what it evokes in the viewer. The painting is finished only when the rhythm is right, what we would now call the 'vibe'. Van der Leck also starts using neutral titles. But Mondrian also learns from Van der Leck, about the function of art in an interior and in society, and about the use of bright primary colours. Garish red. Bright orange. Deep blue. Against a clear white background.

035

036

In early May, Mondrian hangs three paintings in the Stedelijk: two small canvases either side of a large canvas hung much higher. A strange construction. It resembles an altarpiece like those found in old churches. Mondrian had used this form before in his *Evolution*, a triptych showing the development of the spiritual life. So is the arrangement of the paintings at the Hollandsche Kunstenaarskring also a reference to the religious? Mondrian is very enthusiastic about it and has a photograph taken of it to illustrate his first article in *De Stijl*, which is about to be published. '[...] I think the photo shows the work (that I exhibited) very well: in the next things I want to show something else, but the religious is encapsulated so well in this work etc. etc.; and the positioning of the three together is also very expressive of various things – wouldn't you agree?' So what precisely is the religious, in the combination of these three paintings? In his lecture, the art critic Bremmer had described a similar painting as a 'Christmas mood'. The public struggled to grasp it. Only the painter could know what the

037

work depicted. Mondrian reassured Bremmer in a letter. It was not about what it meant 'in the ordinary manner of representation'. 'If one really wants to depict the Christmas idea in an abstract way, one depicts calm, balance, the dominance of the spiritual etc.', so Bremmer was almost right. Theo van Doesburg was also enthusiastic, writing: 'In spiritual terms this work is paramount. The impression it makes is one of Calm; the stillness of the soul.' Van Doesburg was at that time

038

writing a psychoanalytical study on the painter Janus de Winter. In his animal and plant transformations, De Winter depicted 'crashing descent' as 'the direction of the human soul', whereas Mondrian was in search of the 'upward', the 'ascending'. Van Doesburg looked the artist up (see chapter 02). It turned out Mondrian was after something entirely different. He was on a quest for the spiritual in the tightly balanced, in pure order. The real key to the three paintings that hung at the Hollandsche Kunstenaarskring exhibition in 1917 can be found in Berlage's lecture where he mentions a cherry orchard. What is more significant to the emergence of Mondrian's unique manner of presentation than the *Evolution* triptych is the small sketch that Vincent van Gogh drew in a letter to his brother Theo of two paintings of a pale pink and a blue cherry orchard in blossom, with a peach tree between them). The sketch was published in a volume of the letters that

039

appeared in 1914. Artists read the piece, and this particular sketch became the subject of much philosophical discussion on the function

035 Installation of Mondrian's three contributions to the exhibition held by the Dutch Artists' Circle at the Stedelijk Museum in Amsterdam, May 1917. Photograph by Frits Hengelaar, Archive of Theo and Nelly van Doesburg, Netherlands Institute for Art History (RKD), The Hague. The combination of the paintings gives expression to the religious and the spiritual, according to Mondrian.

036 Piet Mondrian, *Evolution*, 1911, oil on canvas, three parts, each in a bronze-painted mahogany frame chamfered on the outer and inner edges, 178 x 85 (side panels) and 183 x 87.5 cm. Collection of the Gemeentemuseum Den Haag (© Mondrian/Holtzman Trust c/o HCR International, Virginia, USA). This triptych is by far the largest painting that Mondrian will ever produce, as well as one of the most fully conceived symbolic constructions.

037 Piet Mondrian, *Composition 10 in Black and White*, 1915, oil on canvas, 85 x 108 cm. Collection of the Kröller-Müller Museum, Otterlo (© Mondrian/Holtzman Trust c/o HCR International, Virginia, USA). Mondrian intends this to be an 'abstract-real representation', as he is calling his paintings at this time.

038 Janus de Winter, *Sensitive Portrayal of the Roar of an Engine*, 1916, oil on canvas, 67 x 91 cm. Collection of the Gemeentemuseum Den Haag, acquired in 1956. Janus de Winter becomes widely known in the Netherlands around 1915 for paintings in which he transformed his sensory experiences, visions and forms of thought into musical compositions of forms, lines and colours.

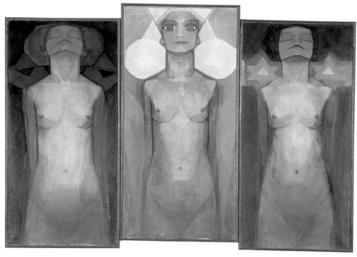

of art. The triptych gave love of life and of nature, and Vincent's love for his brother Theo and of art, a religious depth. Mondrian's two side pieces show the same pale pink and blue colour gradations. Mondrian translated this purpose into an abstract, 'new plastic', in which he generalised the specific statement into a declaration of love for art and society, in a 'new plastic', for a new age.

039 Vincent van Gogh, *Letter 597 to his brother Theo, from Arles*, Friday 13 April 1888. Collection of the Van Gogh Museum, Amsterdam (Vincent van Gogh Foundation). Vincent is painting a triptych for his brother Theo. These paintings, he writes, will 'in a sense make up for the happiness we lacked in the past'.

J'ai eu une lettre de Bernard avec des sonnets qu'il a fabriqués parmi lesquels il y en a qui sont réussis il arrivera à faire un bon sonnet ce que je lui envie presque.

Aussitôt le pont de l'anglais et la répétition de l'autre tableau le pêcheron secs seron envoi

Mon cher Theo, merci de ta lettre contenant les échantillons de toile absorbante. Serai bien aise de recevoir — mais cela ne presse aucunement 3 mètres de celle à 6 fr. —

Pour ce qui est de son envoi de couleurs il n'y avait que 4 gros tubes (de blanc) tandis que tous les autres tubes étaient (de blanc) des demi gros — S'il les a comptés dans les mêmes proportions c'est fort bien mais fais attention à cela —

4 tubes de blanc à 1 fr. mais le reste ne doit être qu'à moitié prix Je trouve son bleu de Prusse mauvais et son cinabre Le reste est bien Maintenant je te dirai que je travaille aux 2 tableaux desquels je voulais faire des répétitions Le pêcher rose me donne le plus de mal

Vergers rose pâle abricotiers — pêcher rose — Verger blanc Pruniers terrain violet à vert

Tu vois par les quatre cases de l'autre côté que les trois vergers se tiennent plus ou moins. J'ai maintenant aussi un petit poirier en hauteur flanqué également de deux toiles en largeur. Cela fera 6 toiles de vergers en fleur.

Je cherche actuellement tous les jours à les achever un peu et à les faire tenir ensemble

J'ose espérer 3 autres se tenant également mais ceux là ne sont encore qu'à l'état d'embryons ou de fœtus

Je voudrais bien faire cet ensemble de 9 toiles

Tu comprends qu'il nous est utile de considérer les 9 toiles de cette année comme première pensée d'une décoration définitive beaucoup plus grande (celle ci se compose de toiles de 25 et de 12) que serait exécutée d'après les mêmes motifs absolument l'année prochaine à la même époque.

Voici l'autre pièce de milieu des toiles de 12

terrain violet — dans le fond un mur avec des peupliers droits — et un ciel très bleu Le petit poirier a un tronc violet et des fleurs blanches un grand papillon jaune Sur une des touffes à gauche dans le coin un petit jardin avec bordure de roseaux jaunes et des arbustes verts un parterre de fleurs. — Une maisonnette rose.

Voilà dans les détails de la décoration de vergers en fleur que je le destinais.

Seulement les 3 dernières toiles n'existent qu'à un état provisoire le 3e représente un très grand verger avec bordure de cyprès et grands poiriers à pommiers Le pont de l'anglais pour toi marche bien et sera mieux que l'étude je pense

Suis bien pressé de retourner travailler. — Pour le Guillaumin si cela est possible c'est sûrement bonne affaire d'acheter. Seulement puisqu'on parle d'un nouveau procédé pour fixer le pastel serait peut-être sage de lui demander de fixer de cette façon en cas d'achat. Poignée de main à toi et à Koning

Vincent

040 'What I believed I could sense, the most important sign of life: breathing. This is not immediately visible life, but the life source of the future, the unformed word, everything that has been kept withheld and unsaid. And this breathing manifests itself in the latent. And with it comes *association*. The seed is the latent plant. And the destruction of the seed is the destruction of the latent – actually of new latency. And this victory of fresh withholding, this is lacking in too many painterly endeavours these days, which carry the battle cry of destruction. They produce shards, destroyed buildings, rubble and ruins for life, for new homes. That is why it is so unutterably significant that the return of withholding, of breathing, of new associations, of pulsating blood can be noted here and there in these eight works by Van der Leck.'

040 Bart van der Leck, *Composition No. 8*, 1917, oil on canvas in a wooden frame covered with oil paint, 134.8 x 169.6 cm. Gemeentemuseum Den Haag, long-term loan from private collection, 1988.

Source
A.M. Hammacher, 'Van der Leck. Voor de kunst – Nobelstraat', *Utrechts Provinciaal & Stedelijk Dagblad*, CXXIV, 23 March 1920

61

Georges Vantongerloo

(1886 Antwerp – Paris 1965)

After coming under bombardment in a fort on the River Maas near Liège in 1914, he flees to the Netherlands where he stops working as a traditional sculptor and begins reading philosophers such as Spinoza. His intuition leads him to seek not the material, not form, but light, the dissolution of form. Vantongerloo meets Vilmos Huszár and Theo van Doesburg. They work together on a completely experimental abstract form of art. He designs colour schemes, furniture and visionary urban environments. In the 1930s Vantongerloo begins to produce paintings with mathematical formulae as titles. They are the key to the precise divisions of the plane, the colours and relationships in the construction of his paintings and sculptures, and intuition is kept out of it as much as possible. He is highly vexed to be viewed as a De Stijl artist after 1945; he believes it was a brief period of only three years, after which he produced important work in the same spirit, but on an entirely individual basis.

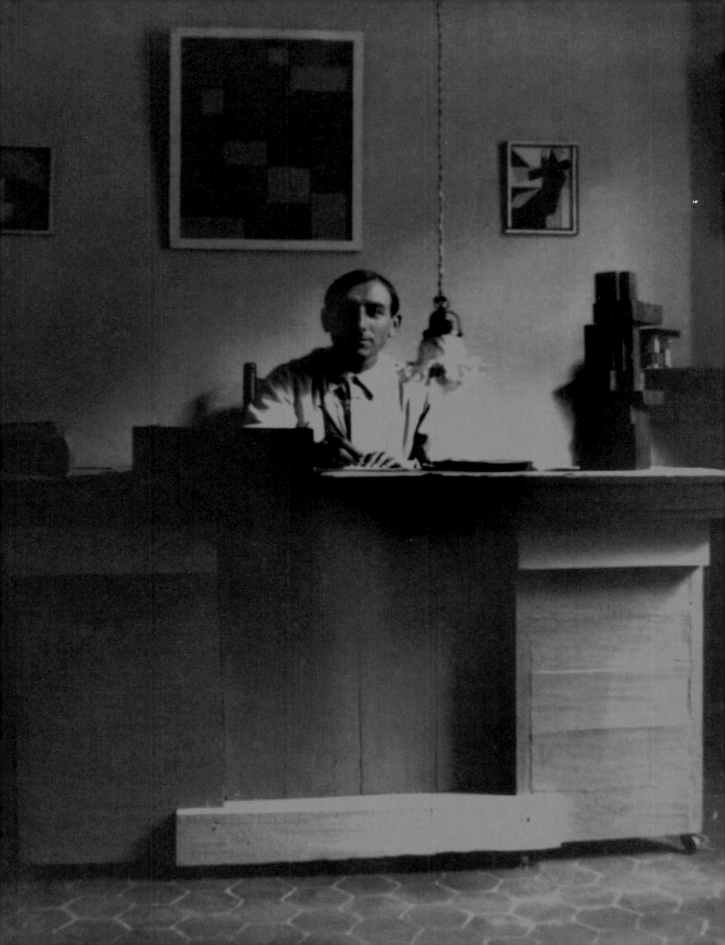

041

'[…] here is the first part of a new article. … […] I have shown it to
a few people (non-artists) who are now beginning to better under-
stand the matter, they say. So I just have to persist a while longer with
writing, wouldn't you say? I found your article [in *De Stijl*] against
Miss P. excellent. I also wanted to respond to what you wrote about a
universal plastic means. I prefer universal, as it suggests that images
derive from the universal, rather than the general. Schoenmaekers
correctly defined the general, I think, as the great contour, for example,
as the thing, manifesting itself. Abstract and universal transcend the
thing, move away from the particular. The univers. plastic means is
also, however, an even more general plastic means in the sense that
it can serve a general purpose.'

041 Piet Mondrian, *Composition
with Grey Lines,*1918, oil on canvas,
84.5 x 84.5 cm.
Gemeentemuseum Den Haag,
acquired from A.P. van den Briel
1956 (© Mondrian/Holtzman
Trust c/o HCR International,
Virginia, USA).

Source
Letter from Piet Mondrian to
Theo van Doesburg (10 May 1918),
Archive of Theo and Nelly van
Doesburg, RKD, The Hague,
135.39

1918 06 **By bike and by train**
An art movement in the new urban environment
called the Randstad

Home City Exhibition **Street**

Almost every one of them has a bike. And they take the tram and the train. 'Amice!' writes artist Theo van Doesburg from Leiden, to his new friend, the Belgian sculptor Georges Vantongerloo, who lives as a refugee 23 kilometres away in The Hague. 'Are you home on Whit Monday afternoon? If so, my wife and I will drop by, we'll come by bike or by train. If we can get away early enough we'll take a picnic, then we can spend an hour longer on our discussions.' The choice of bike or train will depend on the weather, for Van Doesburg believes 'it's always a shame to spend money on a train ticket'. So there's an element of

042

Dutch frugality too. But it is also very pleasant to cycle. In his letters to poet and De Stijl co-founder Antony Kok, Van Doesburg makes frequent references to it. And the family of Frans Vantongerloo, the sculptor's brother, who lives in Wassenaar, tell the story of how grandpa went cycling with Van Doesburg in spring, through the bulb fields at Lisse, to see the bright colours and beautiful contrasts.

It is not difficult to guess what all this cycling leads to: an enthusiastic exchange of ideas, idealism, dreams. It leads to fantasies about a new art, an art that no longer mirrors life, but produces it, like a factory produces objects. Not only houses – streets and whole cities would be redefined by art. And so De Stijl is born. A new movement in art. The two discuss contributions to the journal, and what path art should

043

follow in the modern age. They always meet at home, never in a café or at an art dealer's, as most avant-garde movements of the twentieth century did, in the major metropolitan centres such as Paris, Brussels,

044

Berlin and New York. The De Stijl artists live fairly close to each other: Mondrian and Van der Leck in Laren, Van Doesburg in Leiden, Huszár in Voorburg, Vantongerloo first in The Hague and then in Voorburg, Wils and Oud in The Hague and Van 't Hoff in Huis ter Heide, all places easily accessible by train, tram or bike.

This is, as it were, a decentralised organisation in a decentralised world. For this is the Randstad (Rim City), as the collection of villages and towns would be dubbed around 1928. Having originally been established in the seventeenth century, these towns and villages in the provinces of Noord- and Zuid-Holland, which even in the late nineteenth century had still been highly independent, had begun to burst their seams and converge on each other. In the early twentieth

045

century the outline of a horseshoe-shaped megacity begins to emerge. Though home to the highest population density in Europe, it is still a pleasant place to live, with the landscape of the Hague School ever on

046

the door-step. Jan Wils and J.J.P. Oud, De Stijl architects, soon start to concern themselves with the best way for the cities, towns and villages to expand, keeping both industry and nature within easy reach, while

047

ensuring that everyone can drop in on each other, as in a village. The polder model. The return journey sometimes gets a little out of hand as it grows late. 'We arrived home safely on Sunday', writes Van Doesburg

042 Leiden area, near Voorschoten, along the Vliet. Photograph, c. 1918, Collection of the Regionaal Archief Leiden.

043 The Café du Dôme in Paris, an early twentieth-century meeting place for artists, collectors, critics and writers, where they can swap the latest news. Photograph, Spaarnestad Photo, Haarlem.

044 Theo van Doesburg, *Composition (Seated Figure)*, 1918, oil on canvas in the original wooden frame painted black and white, 55 x 40 cm. Collection of the Triton Foundation.

045 Map of the 'Holland-Utrecht urban sphere of influence', which not long afterwards is dubbed the Randstad. Th. K. van Lohuizen, 'Concentratie en Decentralisatie', *Tijdschrift voor Economische Geographie*, vol. 16 (1925), pp. 341-350. Collection of the NAi, Th. K. van Lohuizen archive, Rotterdam.

046 Willem de Zwart, *Ships in the canal (the Trekvliet near The Hague)*, n.d., oil on panel, 14 x 18 cm. Collection of the Gemeentemuseum Den Haag, acquired in 1946. Until well into the twentieth century, paintings of this kind (either originals or reproductions) hang in every Dutch home, showing a nearby landscape.

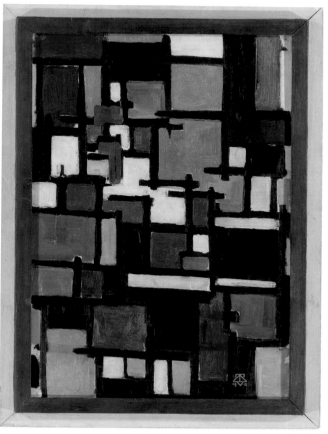

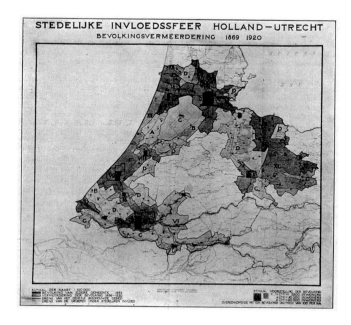

on 23 August 1918, 'after the tyre had been repaired in town. Will you visit us here again sometime?' He is already disappointed that the good weather is over. And so an avant-garde movement takes root, a typically Dutch affair, modest and small in scale, but with huge pretensions.

047 Jan Wils, *Design for the western extension plan for The Hague*, The Hague, n.d. Flat blocks of this variety become characteristic of city centres in the Randstad in the 1920s; they offer plentiful greenery and gardens, and the city limits and nearby countryside are within easy reach. Collection of the NAi, Wils archive, Rotterdam.

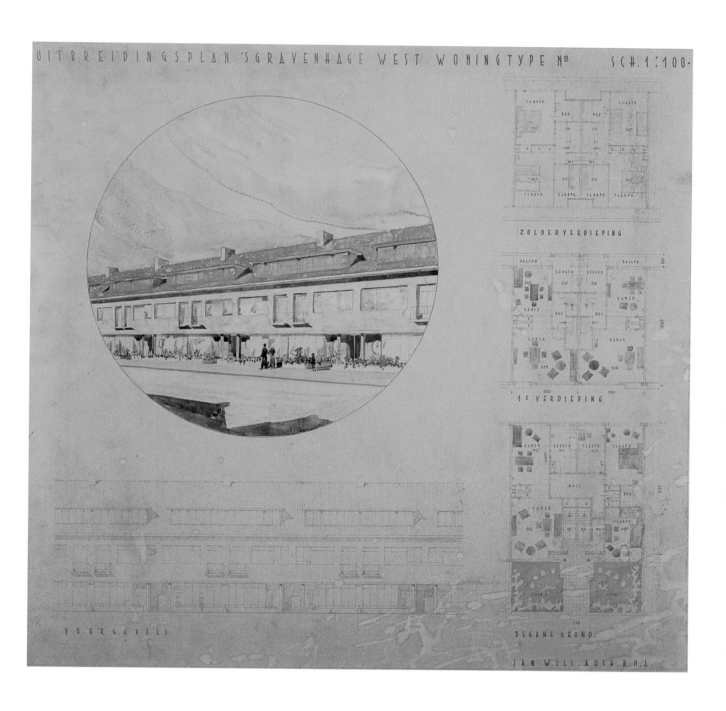

UITBREIDINGSPLAN 'SGRAVENHAGE WEST WONINGTYPE N° SCH. 1:100·

ZOLDERVERDIEPING

1E VERDIEPING

VOORGEVELS

BEGANE GROND.

JAN WILS ARCH· B.N.A.

1917 **Gerrit Rietveld**
(1888-1964)

048

'To the question of what role sculpture will play in the new interior, this piece of furniture, with its new form provides an answer: our chairs, tables, cabinets and other utilitarian objects are the (abstract-realist) sculptures in our future interiors. As regards its construction, Mr Rietveld writes us as follows: "in this chair I have attempted to make every component simple, in the most original form according to its use and material, the form that is the most receptive to harmonious relations with the rest. The structure helps connect the components in unmutilated form, so that one covers or dominates the other as little as possible, in order that the whole above all stands free and clear in space, and the form betters the material. These joints allow a large chair such as this to be constructed with slats of 2^5 x 2^6 cm".'

048 Gerrit Rietveld, *Red and Blue Chair*, 1917, made by: Gerard van de Groenekan after 1917, painted birch wood, 87.5 x 60 x 76 cm. Gemeentemuseum Den Haag, purchased from Truus Schröder of Utrecht, 1955.

Source
Theo van Doesburg, 'XXII. Aantekeningen bij een leunstoel van Rietveld', *De Stijl*, vol. 2, no. 11 (September 1919), p. 135

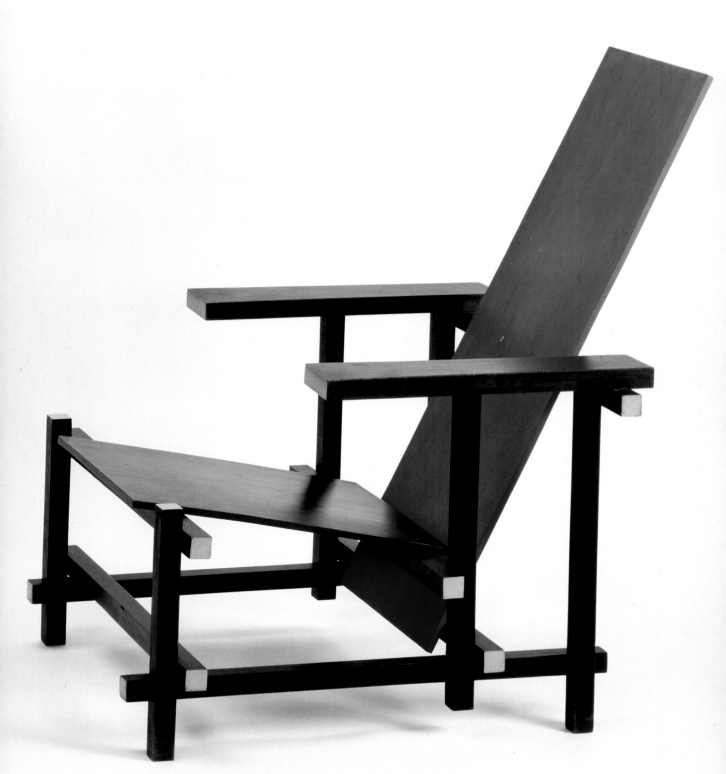

71

Robert van 't Hoff
(1887 Rotterdam – New Milton 1979)

At age 26, travels to America, where he meets architect Frank Lloyd Wright. He returns to the Netherlands with extreme socialist and anarchistic ideas. Seeks an aesthetic but also ideological forum in De Stijl. Supports the journal financially and contributes articles in 1918 and 1919. Has a tendency to place the new, abstract art at the service of the proletarian revolution. Breaks with Van Doesburg when he refuses to share De Stijl's address list with him. Goes his own way and attempts, on a small scale, 'to arrive at a true society without property, without overproduction etc.' Nor would there be any place for marriage and religion. In 1928 Van Doesburg accuses him of excessive individualism and a lack of focus on the new spiritual culture. Van 't Hoff is producing few designs. He continues to believe in the perfection of life, in megalomaniac projects for communes that never come to anything, and in the cell-like extension to his house in New Milton in the UK.

1918 **Vilmos Huszár**
(1884-1960)

049

'How often does one in the contemplation of modern art hear the remark: "they are nothing but blocks" or "anyone could paint that"? Here is a rectangular plane divided into rectangular planes of different sizes and shades. The lines dividing the planes do not extend across the entire plane either horizontally or vertically. The constant shifts in the position and dimensions of the planes even make it impossible to count how many rows there are across the length and breadth; consequently, the whole does not make a flat or rigid impression. Those planes express something; every plane has its fixed position and its particular shade determined by the maker's creative intuition. This creative intuition, which determines the content of the artwork – the aesthetic proportions – is controlled by the mathematical consciousness during the process of painting. […] This creates unity in diversity. In [this painting] harmony is not therefore harmony in the manner of nature, but harmony in the manner of art and in this case painting, i.e. in the consistently executed relationship of one plane to another, of one shade to another.'

049 Vilmos Huszár, *Composition in Grey*, 1918, oil on canvas in a wooden frame covered with oil paint, 60.3 x 44.9 cm. Gemeentemuseum Den Haag, acquired with the support of Vereniging Rembrandt, 2009.

Source

Theo van Doesburg, 'Over het zien van schilderkunst', *De Stijl*, vol. 2, no. 4 (February 1919), pp. 42-44

75

050

Robert van 't Hoff is a rather contradictory character. He comes from a well-to-do background and is engaged to a young aristocrat, Lady Ella Hooft from Zeist. He has spent the last few years building summer-houses in the countryside for wealthy business men but he is passionate about the possibility for a revolution in the Netherlands and devoted to anarchist and communist literature. He sees in De Stijl the spark that could set off radical change and supports the journal financially. He has also decided that when he gets married in 1918 he will live with his wife on a houseboat which he has designed himself. He names it 'De Stijl' and it really stands out from the others on the Loosdrechtse Plassen, with its sharp rectangular shape emphasised by horizontal banding, like a floating Frank Lloyd Wright building. The superstructure has been made by the Bruynzeel company, who are more used to supplying doors and floors, and Van 't Hoff is hoping that one of the De Stijl artists will provide a colour design for it; he is using the boat for regular gatherings and it should reflect the ambitions of the group.

051

052

At first Van 't Hoff approaches Van Doesburg but then decides that Van der Leck has greater experience and is a better man for the job. Van Doesburg and Van der Leck are arguing at the time about the inclusion of an article on the painter Peter Alma (1886-1969) in *De Stijl*. Alma is a friend of both Mondrian and Van der Leck. The conflict comes to a head over the 'diagonal destruction' in Alma's *The Saw and the Goldfish Bowl*. It is not radical enough, as it remains tied to representation, and fails to establish a relationship with the surrounding space. The image remains clearly legible and is not based on what Van Doesburg calls the 'great universal harmony'. Van Doesburg is in fact sceptical whether it is appropriate for the journal, as Alma uses representational motifs and diagonal lines in his paintings. Van Doesburg's intransigence and his decision to publish his own lengthy criticism of Alma in the June issue of *De Stijl* leads Van der Leck to distance himself more and more from the journal. In the summer Van Doesburg approaches his contributors to sign the first 'Manifesto of De Stijl'. Van der Leck declines to do so. He also decides against working on a houseboat called 'De Stijl' which Van 't Hoff might even use for a De Stijl exhibition Van Doesburg has been trying to organise for the autumn to coincide with the Manifesto.

053

054

055

Ultimately it is Huszár who does the interior design for the houseboat 'De Stijl'. Van 't Hoff has a carpenter, Gerrit Rietveld (1888-1964), make a chair for the main cabin to his own design. In many ways the house-boat is one of the earliest examples of De Stijl collaboration between painters, architects and designers but it exposes deep anxieties and tensions within the group. Van Doesburg suspects Huszár of double dealing and writes to Oud that in his view the unity of De Stijl 'is internally broken, broken for good'. At the very moment at which De Stijl is

050 Robert van 't Hoff (in collaboration with Ru Mauve), Verloop Summer House, Huis ter Heide-Bosch en Duin, 1914-15. Photograph from the collection of the Netherlands Institute for Art History (RKD), Archive of Theo and Nelly van Doesburg, The Hague.
051 Robert van 't Hoff, Houseboat 'De Stijl', 1917-18, Van 't Hoff archive, NAi, Rotterdam. The orthogonal lines of the good ship 'De Stijl' stand out against the curved bows of its neighbours on the Loosdrechtse Plassen.
052 *De Zaag en de Goudvischkom* (The Saw and the Goldfish Bowl) by Peter Alma, as reproduced in *De Stijl*, first volume, no. 8.
053 Peter Alma, *The Saw and the Goldfish Bowl*, 1918, oil on canvas, in a white-painted wooden strip frame right against the painting, 65.7 x 102 cm. Collection of the Amsterdam Museum, Amsterdam.

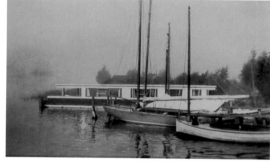

BIJLAGE XII VAN „DE STIJL", EERSTE JAARGANG No. 8. DE ZAAG EN DE GOUDVISCHKOM. P. ALMA

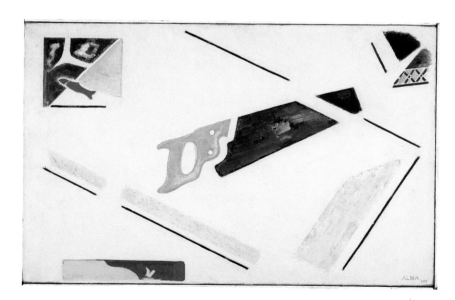

77

056

publicly presented as a coherent group with a common agenda, with
a manifesto declaring the end of individualism and the urgency of
collective effort, its contributors are already struggling to pull together.

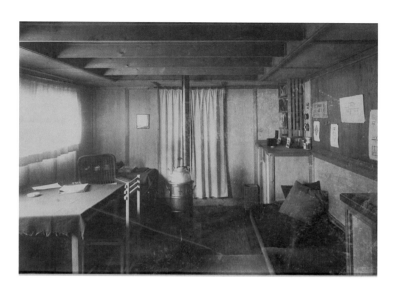

057

A huge row erupted in Van Doesburg's kitchen in Leiden in early August 1918. Vantongerloo was upset for days. Jan Wils was there, as well as Huszár and Van Doesburg, plus wives and girlfriends. Huszár brought up the little drawings Vantongerloo had included in his first article in the recently published issue of De Stijl. Huszár thought the technique was silly, completely ridiculous, because they were based on a circle, while that was precisely what De Stijl was against. But there was more to it, of course. Huszár regarded Vantongerloo as an intruder, who was unaware of the close inner bond between theory and practice in De Stijl. Vantongerloo attempted to justify himself in a letter sent to Van Doesburg around 18 August. He had merely wished to make a modest contribution to the debate: the article was a first attempt, the drawings were illustrations, and he had 'done [everything] consciously and off my own bat' to give a 'small impression' of the potential of his art. 'The images I provide for de Stijl are the living proof of that', he assured Van Doesburg.

058

Mondrian was not present. The movement's theoretician was in Laren, tinkering with his 'new plastic'. He knew what he wanted, he had the correct 'plastic means' at his disposal – the primary colours red, yellow and blue, and grey, black and white, presented in the form of rectangular planes – but he too knew that an artist does not get far with knowledge and ideas. It was all about the execution. Despite his years of experience, and fabulous technique, he had yet to find the expressive results he sought. Compared with his paintings, which exude simplicity, his theories were murky and confused, larded with curious jargon ('colour brought to determination') and with much circumlocution that, while suggesting depth, made them difficult to comprehend.

059
060
061

Van Doesburg, Wils, Huszár and Vantongerloo revered him – they were all almost a generation younger. They saw in Mondrian the true manifestation of their mystical ideas about the invisible becoming visible in an artwork free of depiction. Mondrian knew how to refashion art into a tool that no longer harked back to the past but forged a modern harmony between the material and the spiritual in the harried fragmentation of everyday life. The artwork was the living proof, but surely the theory was too. The journal De Stijl ensured this was the case.

Vantongerloo followed his example. He saw little point in continuing to produce neoclassical sculptures, mainly marble busts of generals and noble ladies, so fled to the Netherlands where he divided his attention between Spinoza's Ethics, Van Gogh's letters, and Schoenmaekers' theories. He was searching for a theoretical foundation for a new art. His first article in De Stijl was entitled 'Réflexions sur l'art'.

057 Illustrations accompanying Georges Vantongerloo's first article in De Stijl, vol. 1, no. 9 (July 1918), p. 99. Vantongerloo finds few supporters for the understated style in which this nude is drawn and the visual transformation to which he subjects it. Rare books collection, Gemeentemuseum Den Haag.
058 Georges Vantongerloo, Interrelation de volumes (Interrelationship of volumes), 1919, stone, 12.0 x 12.0 x 18.0 cm. Collection of Chantal and Jakob Bill, Adligenswil. 'Proceeding from force, it is the sphere or the point that unites everything,' Vantongerloo writes to Van Doesburg in June 1918. 'Time and space, duality is nowhere and everywhere. [Creative force] no longer creates the object, but passes out of itself and re-creates.'
059 Georges Vantongerloo, Study of the Pietà after a reproduction of a painting by Rogier van der Weyden (gv 23b - 1-4 and -6), c. 1920, pencil, indian ink and gouache on paper, photographic reproductions, each 21 x 31 cm. Collection of Chantal and Jakob Bill, Adligenswil. In 1921 Vantongerloo adopts an analytical approach to the phenomenon of abstraction. Starting from a painting by Van der Weyden that is generally considered to be extremely 'spiritual', he creates an abstract composition, just as a mathematical formula produces an outcome.
060 Georges Vantongerloo, Pietà, Étude II, 1920, oil on canvas, 19 x 26.5 cm, Fondazione Arp, Locarno.
061 Georges Vantongerloo, Variation on Composition in Indigo and Violet (minor 7th), 1921, oil on canvas, 19.5 x 28 cm. Collection of Chantal and Jakob Bill, Adligenswil.

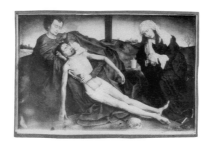

He had always needed to subject his own sculptures to mathematical theories, and to reduce the creative element in the work of others to mathematical formulae. So, as soon as he saw Mondrian's first painting, he again set off in search of a mathematical foundation to his work. And from 1919 onwards he based his own paintings on mathematical calculations, with mathematical concepts like parallel lines or the concept of the infinite guaranteeing depth. This was a project which, in the 1920s, would assume formidable proportions.

From 1920, he also threw himself into an intensive discussion with Van Doesburg and Mondrian about the scientific basis for the use of colour in De Stijl. Vantongerloo wanted to use the colours of the spectrum as the basis. Mondrian was against this. On no account was there to be any mixing. The spectrum colours expressed the 'old harmony' and were too closely associated with nature. But Vantongerloo persisted, wrote an article, and Van Doesburg was eventually forced, after a great deal of discussion, to bluntly reject the piece. Vantongerloo stuck to his guns. 'I shall not insist', he said, 'though I am certain that you will come round to my way of thinking some time. This is certain, because only that which is true persists. That 2 x 2 = 4 cannot be denied, and that pure mathematical relationships between mathematical colours are related to unity in a purely aesthetic fashion cannot be held to be non-universal or held against De Stijl.'

062 Pages 30 and 31 of *L'Art et son avenir*, the book that Vantongerloo writes about his guiding principles in 1924, and a few examples of the many pages of mathematical calculations made by Vantongerloo when he analyses a work of art or prepares to create one. Vantongerloo archive, Zumikon.

063 Georges Vantongerloo, *Composition on the Basis of the Hyperbola with Perpendicular Intersecting Asymptotes, xy=k*, 1929, wooden frame with glass negative, 18.0 x 25.0 cm. Collection of Chantal and Jakob Bill, Adligenswil. 'One must strive unceasingly towards the infinite', Vantongerloo will write as the epigraph to a catalogue as late as 1943. In the late 1920s he puts a great deal of time into compositions and constructions based on this formula.

064 Georges Vantongerloo, *Aéroport: type A, series B, for a private individual*, 1928, silvered copper, 30.0 x 15.0 x 12.5 cm. Collection of Chantal and Jakob Bill, Adligenswil. Vantongerloo believes that the development of civil aviation is essential to the march of progress. The bottom level contains a parking garage and a bank with lifts, the shaft holds offices, and the top level includes a private apartment, hangars and a landing area.

065 Georges Vantongerloo, *Design for a bridge on the basis of the hyperbole with perpendicular asymptotes, xy=k*, 1928, pen and black ink, partial wash, on paper, 78.0 x 261.0 cm. Collection of Chantal and Jakob Bill, Adligenswil. 'My work is not really commercial and is intended for a later generation', Vantongerloo writes in 1964, aware of the utopian nature of his proposals.

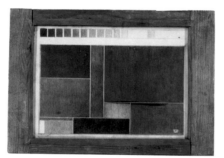

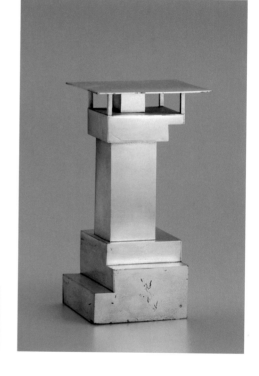

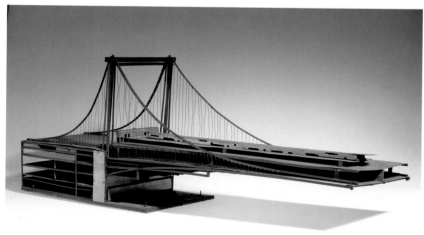

Evert Rinsema
(1877-1947)

066 'You once wrote to me: A child also destroys! And yet it is not in fact destruction. I understand destruction by man and child as follows: To destroy like a child does, without disturbing its inner harmony, is not to destroy; to kill like a man who thinks to kill is not to kill. It is to kill without killing; it is to kill without experiencing the emotion of killing [...]. A child actually destroys out of self-preservation, to preserve its activity. The child destroys what it builds because it does not know how to contemplate its work. It does not know how to elevate its work, to calmly elevate. And so the child always destroys immediately. Work that is finished is altogether wrong in the child's eyes. The Italian architect was correct in saying that every generation has to build its own cities. In my next letter I shall write to you of something curious, of the ascent of shades.'

066 Evert Rinsema, *Armchair*, 1919, painted wood, 106 x 75.5 x 70 cm. Gemeentemuseum Den Haag, acquired from the Rinsema estate in 1963.

Source

Letter from Evert Rinsema to Theo van Doesburg, 21 September 1919, Archive of Theo and Nelly van Doesburg, RKD, The Hague

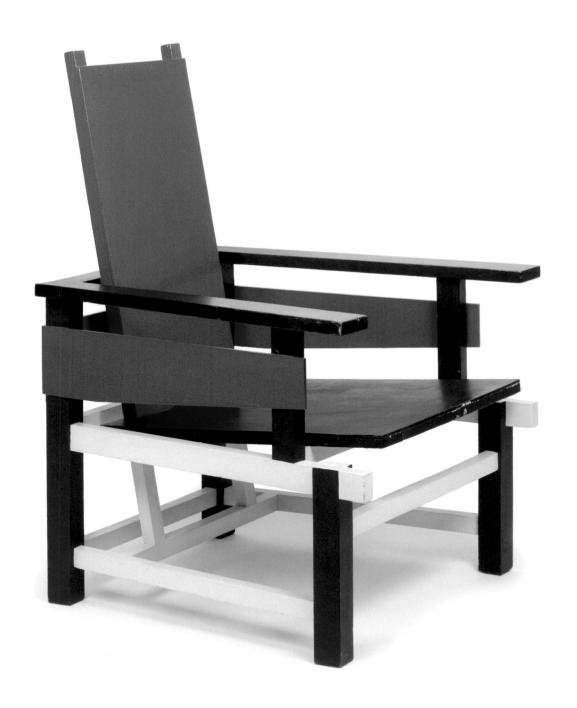

Modernity makes its mark on fashion, too. Anyone seeking to escape the dictates of Paris fashion can purchase their clothes at Metz & Co. in Amsterdam. There, Joseph de Leeuw (1872-1944), director of Metz, introduces Liberty fabrics and creations from London. Metz's customers are generally progressive women who want to use the way they dress to make a statement about their attitude to life: 'It was a matter of principle. The intellectual girls from the turn of the century ostentatiously rejected "bourgeois" fashion – all ostrich feathers, jet and whalebone. That was fashion produced by capitalist profit-seekers and, furthermore, it was unaesthetic, an adjective that reflected the greatest possible contempt. Apart from Liberty gowns they also wore Liberty hats. They were also highly principled hats, […] and they did not go out of fashion. […] It was anti-fashion, a protest; a woman who bought her clothes at Metz before the First World War thereby showed her progressive character.'

For some time, Liberty's of London has been catering for the demand for alternative fashion, selling aesthetic clothing. In 1884 the department store establishes a special 'dress department' for the purpose, managed by architect E.W. Godwin. The clothes are developed in accordance with reformist ideals, and can therefore be worn without a corset. Collaboration with artists ensures the clothes are aesthetically based, often in an Art Nouveau style. The silks are specially painted for Liberty's in 'artistic colours', in an entirely different palette from the aniline dyes commonly used in Paris fashion. The Amsterdam firm Metz & Co. sees how Liberty fashion meets current demand and ensures it becomes the 'Sole agents in Holland for Liberty & Co Ltd. of London'. Although Metz derives most of its turnover from selling fabrics, it also sells complete Liberty interiors, with coordinated fabrics for both clothing and soft furnishings. Liberty clothes are typified by refined artistic materials, often adorned with artistic embroidery.

The desire for modern clothing is closely associated with new ideas about hygiene, health, functionality and women's changing social status. While trendsetting Paris fashion keeps women imprisoned in their corsets, reform movements in several European countries and in America launch a counteroffensive. More freedom of movement and a fashion silhouette with no need of a corset is their creed. In 1908, French couturier Paul Poiret eventually presents a range of gowns to be worn without a corset, in line with the ideals of the various reform movements. The 'Association for the Improvement of Women's Clothing' [Vereeniging ter Verbetering van Vrouwenkleding, or V.v.V.v.V.] is established in The Hague in 1899, in response to a national exhibition on women's labour in 1898. Progressive women like Aletta Jacobs, the first female doctor in the Netherlands, and also women from well-established Hague and Amsterdam families, join the association. It soon establishes a college to teach the design of women's and

067 Liberty & Co, *Lounge suit (jacket, skirt, blouse and undersleeves)*, c. 1906-07, separate undersleeves, wool, printed Liberty silk, embroidery and smocking, London/Amsterdam. Worn by Mrs H.W. Zeverijn-Wichers (1869-1912).
068 Metz & Co./probably Liberty, *Blouse*, c. 1905-10, Liberty silk, silk embroidery. Worn by Mrs H.W. Zeverijn-Wichers (1869-1912).
069 Liberty & Co., London, Paris/Metz & Co, *Evening cape with hood (detail)*, c. 1905-15, silk satin, silk embroidery.
070 Metz & Co./probably Liberty & Co., *Summer dress*, c. 1910, silk, reform style, silk smocking and embroidery.
071-073 Fashion print with dress, in the catalogue *Liberty's Dress and Decoration*, 1905.
074 Alfred Mohrbutter, design for tea gown, c. 1900.

067

068
069
070

071
072
073
074

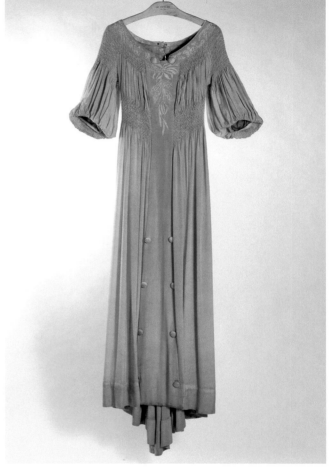

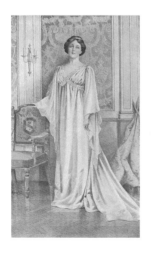

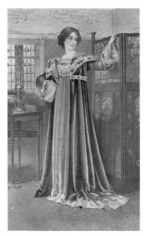

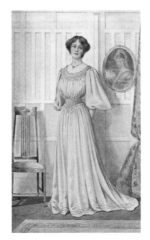

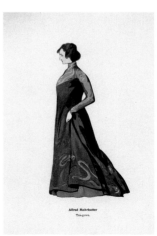

075
076 children's clothing, the Vakschool voor Vrouwen- en Kinderkleding, which opens in 1909. One of the teachers is Corrie Berlage, daughter of the architect Berlage, who specialises in the art of decorating women's clothing and teaches drawing and design.

077
078
079
080
081
082
083
084
085
086
087
088
090 In the Netherlands, a number of decorative artists are working on new forms of decoration for clothing. Chris Wegenrif and his wife Agathe focus on batik, for example, which contrasts sharply with the lace and ribbons that adorn traditional Paris fashions. Is Piet Zwart referring to their work when he writes in the journal *De Cicerone* in 1918 that 'almost all applied artists working on textiles are busy using' batik? Zwart himself is also working on modern decoration for children's clothes, and he is known to have produced a few designs for women. He exhibits children's clothes of his own design, made and embroidered by his first wife, Rie Zwart-Ketjen. The embroidery has an oriental feel, reminiscent of the Wiener Werkstätte. Work by this group of artists is presented at a show in Amsterdam in 1913 and 1917. Zwart also designs a number of fabric and wallpaper motifs in a Wiener Werk-stätte style, though they are more linear, anticipating his later work.

075 Marie Faddegon (design), Occupational School for Women's and Children's Clothing (execution), *Dress*, 1913, Liberty silk, embroidered with glass beads, silk cording. Worn by Bastiana Schot.

076 Marie Faddegon (design), Occupational School for Women's and Children's Clothing (execution), *Dress (detail)*, 1913, Liberty silk, embroidered with glass beads, silk cording. Worn by Bastiana Schot.

077 Marie Faddegon (design), Dress from the collection of Bastiana Schot, in: *Onze Kleeding*, 1 May 1913, vol. 14, no. 5.

078 Eugénie van de Wall Perné, Silk crêpe evening gown made of simple rectangles of fabric, in: *Onze Kleeding*, January 1916, vol. 17, no. 1.

079 Agathe Wegerif-Gravestein, *Front of tunic*, 1915, silk velvet with batik, 131 x 88.5 cm.

080 Agathe Wegerif-Gravestein, *Front of tunic*, 1915, silk velvet with batik, 122 x 94 cm.

081 Bertha Bake, *City of Dreams, wall hanging*, 1932, batik on cotton, 126 x 83 cm.

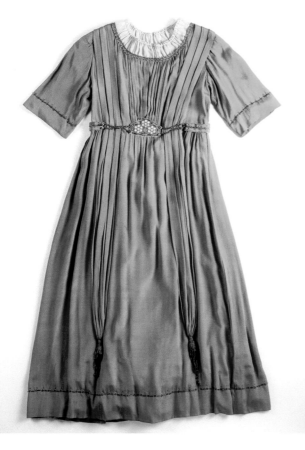

Fig. 1. Avondjapon van zijden crêpe.
Beschr. zie blz. 13.

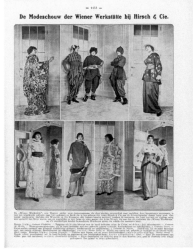

082 Piet Zwart, *Design for a reform dress*, 1917, pencil on paper, 27 x 15.5 cm.

083 Rie Zwart-Ketjen in reform dress, c. 1917.

084 Piet Zwart, *Design for embroidered shoulder yoke for a child's dress*, c. 1916, watercolour on paper, 46.7 x 71.6 cm.

085 Piet Zwart, *Child's dress (detail)*, c. 1915-18, linen embroidered in wool.

086 Piet Zwart, *Child's dress*, c. 1915-18, linen embroidered in wool.

087 Designs by the Vienna Workshop exhibited in a fashion show at Hirsch, Amsterdam, November 1913, in *Het Leven*, 11 November 1913, vol. 8, no. 46.

088 Piet Zwart, *Design for crushed velvet*, indian ink and watercolour on paper, 32.8 x 24.7 cm.

089 Piet Zwart, *Textile design*, 1917, indian ink and watercolour on paper, 60.5 x 45.3 cm.

090 Piet Zwart, *Textile design*, 1916, indian ink and watercolour on paper, 30.9 x 21.5 cm.

91

How the successful collaborations and stumbling-blocks give shape to De Stijl

In November 1918, amid the relief at the end of the First World War, the *Manifesto of De Stijl* appears, promising better times and declaring that 'the war is destroying the old world and its contents' to make way for a 'new consciousness'. The ex- soldier Van Doesburg has already taken the chance to reinvent himself, rename himself even, and create a whole new artistic identity. Another co-signatory of the manifesto, the architect Robert van 't Hoff (1887-1979) has been inspired by the Russian Revolution to join the Communist Party and campaigns for a Communist government in the Netherlands. In 1918 he receives a commission to remodel a family house in Laage Vuursche, close to Utrecht, for the anti-militarist ex-pastor Bart de Ligt (1883-1938), who has recently married. De Ligt was the gadfly of the Dutch army through-out the war; he was imprisoned briefly in 1915 for his views, his writ-ings are prohibited to members of the army and he is even banned from several provinces of the Netherlands altogether.

To demonstrate the commitment of De Stijl to social reform, Van 't Hoff recommends that De Ligt visit *De Vonk* (The Spark) in Noordwijkerhout, a holiday home for poor children designed by J.J.P. Oud with interior and exterior colour designs by Van Doesburg. De Ligt is bowled over by the building and asks if Van Doesburg can produce colour designs for six rooms in his house. An intense friend-ship is quickly established and Van Doesburg attends a lecture course De Ligt gives in Leiden. In 1919 De Ligt sets up the *Association of Revolutionary Socialist Intellectuals* (Bond van Revolutionair-Socialis-tische Intellectueelen) for which Van Doesburg designs typography. The Association is highly idealistic. The socialist campaign for inter-national brotherhood is paramount. The guiding principles are anti-militarism and free thinking. Education is essential. The Humanitarian School in Blaricum, run by the Christian anarchists to whom Bart de Ligt was also sympathetic, is one of the nests to which these utopianists entrust their offspring. Piet Mondrian's brother Louis teaches there. And Mondrian spends time with one of his fellow teachers, D. Rijpma. Though Mondrian has long sympathised with socialist ideas, he encourages Van Doesburg to keep some distance between De Stijl and the Bolsheviks and anarchists, who will, in his view, not advance the cause of art. During one of his brief visits to the Rijpma family, in March 1919, his bike is stolen, even though he had left it against the wall at the back of the house in order to conceal it from passers-by. This will have confirmed to Mondrian the fact that pure and equilib-rated relationships exist only in painting.

The unexpected illness of one of De Ligt's children leads to the family's sudden move from Laage Vuursche to the healthier air of Katwijk in 1919. Van Doesburg's extensive colour schemes are left unrealised but he is able to remodel one room in their new house in an even more experimental way, including furniture by Rietveld. Van Doesburg calls

091 Robert van 't Hoff setting out hiking, 1927. Photograph, private collection, England.

092 Former pastor Bart de Ligt, c. 1917. Photograph from the collection of the International Institute of Social History, Amsterdam.

093 View of *De Vonk*, 34 Westeinde, Noordwijkerhout. Vintage photo-graph collection, T. Stuhlen.

094 J.J.P. Oud, *De Vonk holiday home*, 1917-18, hallway with tiles designed by Theo van Doesburg.

095 Picture postcard of Villa Allegonda in Katwijk, c. 1917. J.J.P. Oud bases his design for the villa on the ideas of the visual artist Harm Kamerlingh Onnes, who has just been to North Africa. What will later be lauded by critics as an early example of Cubist architecture is in fact inspired mainly by North African models. Photo from the collection of Annemarie Kingmans, Valkenburg (South Holland).

096 The primarily 'Moorish' architecture style of Villa Allegonda resurfaces in the interior design, conceived by Kamerlingh Onnes and carried out by ceramist W.C. Brouwer. Brouwer has a profound influence on Oud and his quest for 'beauty by and for all'. Photo from the collection of Annemarie Kingmans, Valkenburg (South Holland).

097 Theo van Doesburg, letterhead design for the *Bond van Revolutionair-Socialistische Intellectueelen* (Union of Revolutionary Socialist Intellec-tuals), 1919-20, pencil, indian ink and white gouache on tracing paper, Centraal Museum, Utrecht.

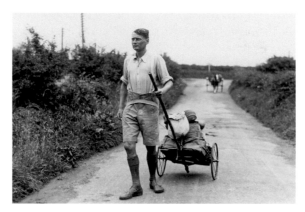

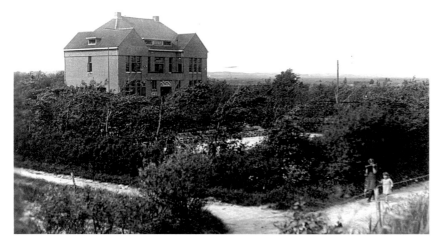

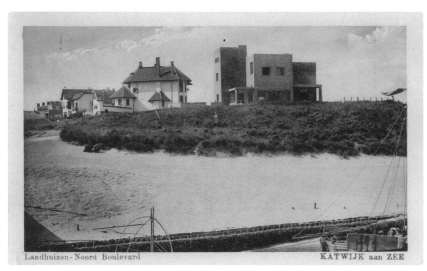

Landhuizen-Noord Boulevard KATWIJK aan ZEE

BOND VAN REVOLUTIONNAIR-SOCIALISTISCHE INTELLECTUEELEN

it 'painting in three dimensions'; not only the walls but the ceiling are covered with an elaborate composition of interlocking and free-floating planes in blue, green, orange, black and white. The 'old world' of the Dutch interior with its heavy carpet, tablecloths and lampshades is swept away to be replaced by a bright, transparent space which can be seen 'all at once', as Rietveld comments on his visit in early 1920. De Ligt's resistance to war and the military has made him not only an ardent opponent of the capitalist state but a supporter of women's rights as well. Van Doesburg's designs for his house represent to him a whole new way of living, with new social and familial relationships.

099

100

098 Theo van Doesburg, *Colour design for a room in the house of Bart de Ligt*, Katwijk aan Zee, 1919-20, collage and gouache on printed material, 26.1 x 21cm. Netherlands Cultural Heritage Agency, Amersfoort. Van Doesburg uses the image of the room he designed for Bart de Ligt as a propaganda statement for De Stijl; he later applies the colours red, yellow and blue to an earlier photograph for publication in the French journal *L'Architecture Vivante* in 1925. The original scheme used green and orange with blue.

099 Jan Sluijters, *The Painter's Family*, 1922, oil on canvas, 160 x 157 cm. Collection of the Gemeentemuseum Den Haag, acquired in 1923. Sluijters depicts his family in a world full of carpets and curtains where life revolves around the living-room table.

100 Poster for an outdoor gathering in The Hague to commemorate the establishment of the International Anti-Militarist League in 1904 and the outbreak of world war in 1914, designed by Chris Lebeau, printed by Drukkerij Lankhout in Delft, 1924, lithograph, 139.8 x 93.8 cm. Collection of the Gemeentemuseum Den Haag, acquired in 1966.

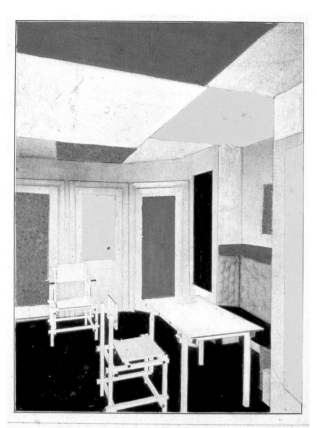

THEO VAN DOESBURG. PROEVE VAN KLEURENCOM-
POSITIE IN INTÉRIEUR (1919). MEUBELEN VAN G. RIET-
VELD. BIJLAGE XIV VAN ,,DE STIJL" 3E JAARGANG No. 12.

1919 Piet Mondriaan
(1872-1944)

101

'Last week I had Mondrian here for the day. There was plenty of long, deep conversation, just like last Sunday with Kok. Mondrian's theosophical confessions have made me look at him differently. […] In brief, he believes that after our work, there can be nothing else. This work is the culmination, the pinnacle of representation [*beelding*] – and beyond – the 6th sense. *La peinture est finie!* [Painting is finished!] Mondrian says, 'When I look through the canvas – when I pass through a wall – what will be left to see on that canvas or that wall?' I defended the idea that we were a transition, just like Cézanne to us – from us to something different. Everything is *en mouvement perpétuel* [in perpetual motion]! In truth, Mondrian is a dogmatist. The 4th Dim[ension] is something he can't quite cope with in his dogma. I attempted to prove to him that seeing in non-3-dimensional terms has enormous hidden potential, because of the constant arising of new moments of expression in the mind. He agreed that, indeed, I had risen to a higher level in my working methods and my mode of thought, but said that I would realise that the Plane was the only and absolute consequence of all *beelding*. That was why he felt that my latest work, *Rag-time*, easily had more immediate spiritual impact than my large flat compositions, but it could not be ruled out that the latter would better convey the absolute in the long run. He is indifferent to many subjects, like architecture, communism, etc. […] Maybe he needed to go to Paris to find new possibilities in his work… A fresh look. His latest works have no com-position. The division of the plane is in a single size. That means ordinary rectangles of equal dimensions. Contrast is achieved solely through colour. I think it's not entirely consistent with his theory of abolishing position and size. This is equality of position and size, also progress par excellence. And constructive.'

101 Piet Mondrian, *Composition with Grid No. 9: Chequerboard: Composition, Light Colours*, 1919, oil on canvas, 86 x 106 cm. Gemeentemuseum Den Haag, bequest from Slijper 1971 (© Mondrian/Holtzman Trust c/o HCR International, Virginia, USA).

Sources

Letter from Theo van Doesburg to J.J.P. Oud, 19 April 1919, Fondation Custodia, Paris; Letter from Theo van Doesburg to J.J.P. Oud, 24 June 1919, collection of the Netherlands Institute for Art History (RKD), The Hague, Archive of Theo and Nelly van Doesburg

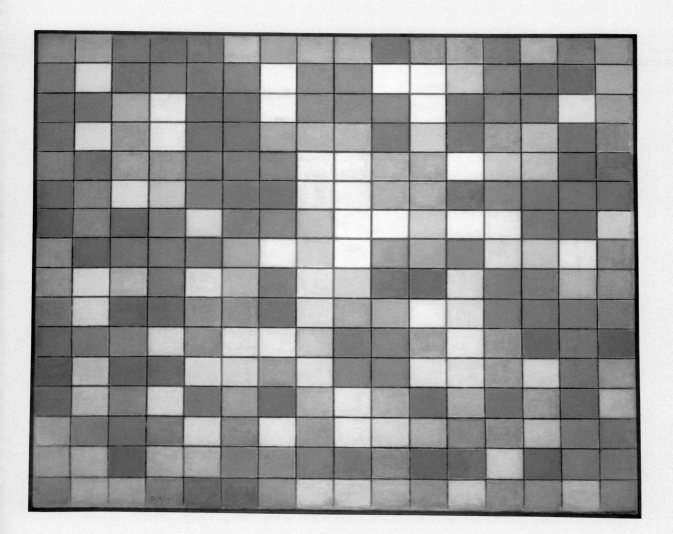

Piet Zwart

(1885 Zaandijk – Voorschoten 1977)

An all-rounder who, under the influence of events in Russia, wants to abandon the languid world of Dutch society for the chance to work on the 'new form of life'. Remains in the Netherlands because he must have instinctively felt that he would rather be an innovator than an interpreter. He shows absolutely no modesty. He soon realises that he can make major steps that might lead to such innovation in advertising, design, typography, interior design and fashion. Works with Wils and with Huszár. Argues with Van Doesburg even before he meets him. As a designer, he sees the revolutionary value of many foreign artists at an early stage, and manages to transpose and master their discoveries and innovations. He does so with quite brilliant ease, cheery and full of humour, making no attempt to disguise the source of his borrowed ingredients. His most famous design – the Bruynzeel kitchen – represents a major step forward in standardisation and ergonomics.

102

103
104

In February 1919, the Haagsche Kunstkring (Hague Art Circle) stages an architecture and applied art exhibition in its rooms at Lange Houtstraat 7. Both Huszár and Wils take part, the latter showing some of his designs for the transformation of the café-restaurant De Dubbele Sleutel in Woerden, on which he has been working together with Van Doesburg. Huszár sparks a furious debate with his lecture about monumental art. He uses a comparison of works by Bart van der Leck and Richard Roland Holst, such as he recently published in *De Stijl*, to demonstrate that Roland Holst does not make monumental art, a challenging statement indeed given Roland Holst's artistic celebrity, his many wall paintings in public buildings and the fact that he has just given his inaugural lecture as new professor of art history at the Rijksakademie in Amsterdam on 'ethical factors in monumental painting'. Huszár's view polarises the audience into camps, one favouring *De Stijl* and the other the journal *Wendingen* (Turnings) with which Roland Holst is associated. The debate is so intense it has to be carried on a week later. The curved line is provoked into open war by the straight line, which draws up in the name of autonomy and claims the reign of monumentality. The first battle does not resolve the question and a counter-lecture is proposed, to be given on 6 March by the young designer Piet Zwart, whose socialist views make him sceptical of the independent status given to art and the straight line by Huszár. For his part, Huszár disparages Zwart as someone working in a 'Viennese Style', old-fashioned and overcomplicated.

Despite their differences, the encounter between Huszár and Zwart in the Kunstkring demonstrates to them that they are not so far apart from each other as they thought, both conceptually and geographically. They both live in Voorburg, close to Wils' architectural office, where shortly afterwards Zwart begins work as a draughtsman. Across the road from Huszár lives the Bruijnzeel family. Cornelis Bruijnzeel (1875-1956) is the owner of a wood manufacturing business in Rotterdam, producing wooden products, like doors, panelling and floors. He is very advanced in his thinking about modern production methods. It is maintained that, in 1901 on a visit to the United States, he had vehement discussions about the positive aspects of assembly lines and mass production with a certain Henry Ford, in Detroit. Bruijnzeel is also a member of the Kunstkring and takes a keen interest in creativity and contemporary art. He has already commissioned Huszár to make a stained-glass window for his house. Huszár has designed a full-page advertisement for Bruijnzeel's wooden flooring, which gets printed in the first issues of *De Stijl*, and a company stand for the Jaarbeurs (Annual Trade Exhibition). Now Bruijnzeel asks Huszár to redesign the bedroom of his two sons, Cees and Wim. They have both finished school and are away travelling in Europe and North America, gaining valuable experience of modern production methods which they will put to use on their return when they take over parts of the business

105

106

102 Piet Zwart, Proof of the catalogue cover for *Kunstkring, Afdeeling 1 en 2, Schilderkunst, beeldhouwkunst, grafische kunst, kunstnijverheid, bouwkunst*, accompanying an exhibition by the Haagsche Kunstkring (Hague Art Circle) in de Grafelijke Zalen at the Binnenhof in The Hague, 1917-18, lithograph, executed by Drukkerij Lankhout, 33.5 x 31.8 cm. Collection of the Gemeentemuseum Den Haag. Between 1917 and 1920, Piet Zwart finds himself torn between a passion for the richly ornamental style of the Vienna School and the rigour of Berlage. He is greatly intrigued by the clarity of a new style that seems to be emerging here and there.
103 Theo van Doesburg, *Destructive Composition III, Drawing VI (colour design for the front of the buffet for the hotel-café-restaurant* De Dubbele Sleutel *in Woerden)*, September/December 1918, indian ink and gouache on tracing paper, 25.5 x 40 cm. Collection of the NAi, Wils archive, Rotterdam. According to the architect Huib Hoste, Van Doesburg's colour scheme for the interior of the café will 'pull apart' what its architect, Jan Wils, constructed. Hoste concludes that the result is likely to be a very pleasant café to visit.
104 Theo van Doesburg, *Destructive Composition III, Drawing VII (colour design for the front of the buffet for the hotel-café-restaurant* De Dubbele Sleutel *in Woerden)*, September/December 1918, indian ink and gouache on tracing paper, 14 x 20 cm. Collection of the NAi, Wils archive, Rotterdam. Van Doesburg uses black, white, Veronese green, orange, blue and grey to make the interior 'dissolve' into colour.

105 The inside of the cover of *De Stijl*, with an advertisement for parquet floors from the firm of C. Bruijnzeel & Zonen in Rotterdam, based on a design by Bruijnzeel's neighbour in Voorburg, Vilmos Huszár. After the sixth issue, this advertisement no longer runs, and in the eighth issue, the joinery and carpentry works Timmerfabriek Gebr. Van Malsen in The Hague is persuaded to advertise its services on the inside cover.

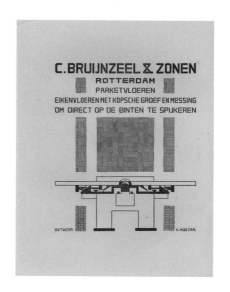

from their father. Not only does Huszár conceive of the entire room as a unified 'space-colour-composition', he makes use of a famous artistic source to justify his choice of vibrant colours such as yellow, blue and red for a bedroom. It is like Van Gogh's painting of his bedroom in Arles; as Van Gogh wrote to his brother, the bright colours, which are arranged in complementary relationships (red and green, blue and orange, yellow and violet), convey a feeling of rest, contributed to also by the solid, simple furniture.

Before the room is completed, the furniture for it is destroyed in a fire at the Rotterdam factory where it is being stored. It is remade in cheaper wood which Huszár takes the chance to paint as well. The fire also provides an opportunity for updating the business and Bruijnzeel commissions Wils to design a new factory in Zaandam for the manufacturing of doors, the running of which is taken over by the oldest son, Cees (1900-1980), while Wim (1901-1978) will manage the flooring side of the company. Wils also designs a house in Zaandam for Cees who is soon to get married. Cees obviously likes what Huszár has done to his old bedroom as he asks him to design colour schemes to be used throughout the house. Zwart also participates by designing new furniture. Appropriately for the house of a man running Europe's most up-to-date wood-finishing company, Zwart creates chairs, cabinets and tables made from simple planks slotted together in a cubic fashion. If there was any doubt about who won the Kunstkring debate, the money seems to be going with *De Stijl*'s straight lines rather than *Wendingen*'s curves.

106 The boys' bedroom for the Bruijnzeel family in Huize De Arendshoeve, Voorburg. The furniture designer is Piet Klaarhamer and Vilmos Huszár is responsible for the colour design. There are notes on the photograph by Huszár. Photograph (gelatin silver print), 21 x 27.9 cm. Collection of the Gemeentemuseum Den Haag, acquired in 1987.

107 Vincent van Gogh, *The Bedroom*, sketch in letter 705 to Theo van Gogh, 16 October 1888, pen and ink on paper, 13 x 21 cm. Collection of the Van Gogh Museum Amsterdam (Vincent van Gogh Foundation). Van Gogh writes that the colours in his new painting should suggest rest or sleep. 'In short, looking at the painting should *rest* the mind, or rather, the imagination… The solidity of the furniture should also now express unshakeable repose.'

108 Jan Wils, *Presentation drawing of the entrance to the C. Bruijnzeel office building and door factory in Purmerend*, 1920, pencil and gouache on paper. Collection of the NAi, Wils archive, Rotterdam. This is a highly advanced factory, modelled after American examples of mechanisation and efficiency. It is one of the first in Europe with an assembly line.

109 The sitting room at Huize de Stormhoek, designed by Piet Zwart in collaboration with Vilmos Huszár, who was responsible for the colour design, c. 1924. Photograph from the collection of the Gemeentemuseum Den Haag. The carpet is a gift to Mrs Bruijnzeel from the Board of Supervisors, because she always provides the sandwiches at meetings.

107

108

109

110 'For if it is the task of the artist to depict reality, imitate life as it really is, then he will have overshot the target even before he begins. Because, as Spinoza said, reality is perfection, and I do not see what an artist – in striving for such perfection – could do any better, apart from bidding farewell to art. Quite apart from the fact that he would have long been beaten in his quest by the engineer who builds a machine. An inventor is also a creator, and an artist is first and foremost an inventor, but so far I believe that – though there are similarities – one creation cannot be regarded as equal to another. But a machine bears similarities to a work of art. All the parts of an engine, for example, are ordered according to the will of a single person, the designer/engineer, who gives new life, or a new effect or movement, to the dynamics of all those parts working together. The way a machine is built is similar to the creation of a work of art. And if we also consider the effect of the machine on those who view it, we again see similarities with a work of art.'

110 Gino Severini, *Still Life with Violin and Music*, 1919, oil on canvas in a wooden frame painted white, 76.3 x 92.5 cm. Gemeentemuseum Den Haag, long-term loan from Wibbina Stichting, 1955.

Source
Gino Severini, 'La peinture d'avant-garde', *De Stijl*, vol. 1, no. 2 (December 1917), pp. 18-19

Jan Wils
(1891 Alkmaar – Voorburg 1972)

Fascinated by the ideal of unity between society and art, and believes architecture brings harmony to life. Architecture is spatial art, and Berlage and Frank Lloyd Wright are shining examples lighting the way to a modern future. Boundaries must be erased. Down with the Dutch tendency to pigeonhole. It is therefore inevitable that he should meet Huszár and Van Doesburg. In 1919 Wils underpays Van Doesburg for a commission. A huge row ensues. Nevertheless, Wils continues to believe in the use of modern materials applied in a clear and honest way in a form that gives precedence to spatial function. He falls out of fashion just at the moment when other architects start to use his language to greater effect and success. He continues to cling to his conviction that an architect is not a visionary – as Van Doesburg would have it – but rather a hard worker who, in the struggle for the modern, attempts to straighten things out for himself and for his public.

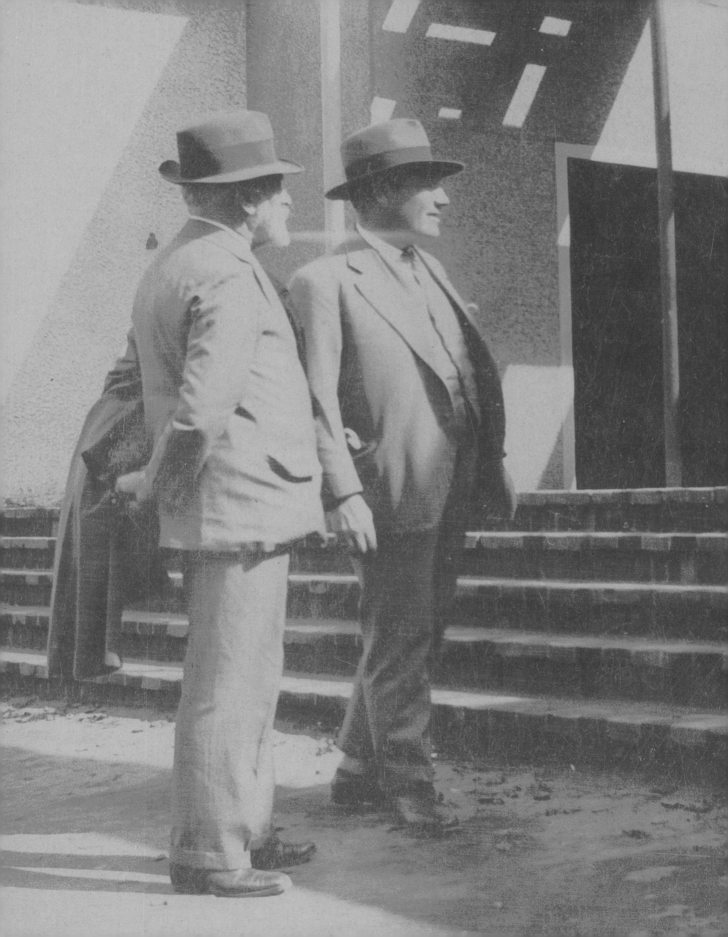

1920 11 **A promising scheme**
**The enthusiastic response to the Papaverhof houses
in The Hague**

Home **City** Exhibition Street

In 1917, The Hague develops plans for 'garden cities', for those 'of slender means'. The social-democratic city council responds enthusiastically. But there is also criticism. The young architect Jan Wils writes that the plans will soon become obsolete.

Another concern is the high cost price of the homes. The housing associations phlegmatically appoint their own architects. The plans are rejected. Then, Jan Wils seizes his opportunity. He designs a residential district in the form of a double horseshoe, with a large communal garden in the centre, and with a nod to the work of Frank Lloyd Wright (1867-1959) and Peter Behrens (1868-1940). But he also does something new. The front façades are set back in pairs. Every house has its own front garden. Wils also includes apartments – bringing down the cost price of each home – with electrically controlled front-door locks, a simple intercom for each home, a small lift, cellars and bike storage. Modernity was making its presence felt. 'In short, a promising scheme', was the view of the housing association.

Jan Wils also chose innovative exteriors. Gone was the traditional gable end, which shielded the inside of the home from the outside world. The *outer* proceeds logically from what the *inner* dictates in terms of volumes and forms. And this arrangement in itself is based on rational arguments: efficiency, fairness, hygiene and openness. Construction thus becomes the stacking and ordering of bodies, forms and spaces. He lays pipes together in channels serving several homes. The compact design allows plenty of space for a large communal garden. Wils has door and window frames painted blue, yellow, black, grey and white. This is striking, and evokes a lively rhythm.

By the time the homes are completed in 1922, Jan Wils has long since withdrawn from De Stijl. Yet Van Doesburg continues to cite the Papaverhof as an extraordinary example of De Stijl architecture. He has even put his name down for one of the houses, with his wife Lena Milius. He will never actually move with her to 18 Klimopstraat, however, for he leaves her for another woman, the young pianist Nelly van Moorsel, who over the next few years will have a major influence on Van Doesburg in all kinds of groundbreaking activities that will enrich De Stijl.

Lena continues to manage the editorial work and accounts of *De Stijl* from her Klimopstraat home, however. The house also serves as the base for the Dada tour Theo van Doesburg organises just before the divorce becomes final in 1923. Lena goes to stay with friends for the duration. The first performance by Schwitters, Van Doesburg and Nelly van Moorsel at the Haagsche Kunstkring on 10 January is a resounding success. The audience goes crazy. Van Moorsel's father is deeply embarrassed, but Berlage is there too, and he calls Nelly a 'stupendous girl'.

111

112

113

114

115

116

117

111 Jan Wils, Perspective drawing for the Daal en Berg district (De Papaverhof), The Hague, 1919-20, pen and ink on paper. Collection of the NAi, Wils archive, Rotterdam. Wils arranges the houses in a circle around a central park, making the small estate a closed, integrated whole in a natural, village-like setting.
112 Daal en Berg (De Papaverhof) shortly after its completion, 1920. Collection of the NAi, Wils archive, Rotterdam. When the design is included in an exhibition of middle-class housing, commentators feel that it is too chaotic, with 'an excess of glass and other disruptive elements'. Some feel that it is too much like 'the less refined work of the American Wright'.
113 Jan Wils, Floor plans for middle-class housing in Daal en Berg (De Papaverhof), 1919, collotype on paper. Collection of the NAi, Wils archive, Rotterdam. Although Wils's innovative design is meant to bring his ideas about design to a wider audience, the influence of the Papaverhof remains limited.

MIDDENSTANDSWONINGBOUW "DAAL EN BERG" 'sGRAVENHAGE TYPEN A EN H SCHAAL 1 OP 100

③ TYPE H

FUNDEERING · BEGANE-GROND · VERDIEPING

K = KELDER
H = KOLENHOK
W = WOONKAMER
O = ONTVANGKAMER
P = PORTAAL

N = KEUKEN
T = TOILET
S = SLAAPKAMER
B = BADKAMER
O = LICHTOPPERVLAK

TYPE A

FUNDEERING · BEGANE-GROND · VERDIEPING

DE ARCHITECT

BIJLAGE X VAN „DE STIJL" TWEEDE JAARGANG No. 5, HOTEL: „DE DUBBELE SLEUTEL" WOERDEN, ARCHITECT JAN WILS.

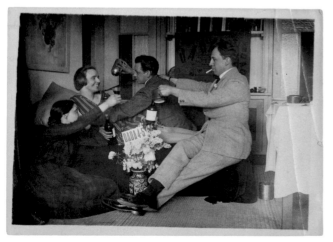

114 Jan Wils, Front elevations for middle-class housing in Daal en Berg (De Papaverhof), 1921, collotype on paper. Collection of the NAi, Wils archive, Rotterdam. Rhythm and repetition play a central role throughout the plan for the district, while individual house fronts are designed to break up monotony and offer maximum scope for a 'cubic' mode of construction in which contrast and harmony are free to collide.

115 Appendix X to the March 1919 issue of *De Stijl*. Robert van 't Hoff writes an accompanying article in praise of 'free, architectural solutions in a modern spirit', in which interior spaces 'logically and plastically project themselves outwards'.

116 From left to right: Hans Richter, Theo and Nelly van Doesburg in Berlin, in April 1922, photograph (gelatin silver print), collection of the Netherlands Institute for Art History (RKD), Archive of Theo and Nelly van Doesburg, The Hague. Bauhaus students such as Hans Vogel, Bernard Sturzkopf and Peter Röhl are now taking the De Stijl course, Van Doesburg's vehicle for establishing a base of operations in Weimar, with Van Eesteren as his assistant.

117 From left to right: Helma Schwitters, Nelly van Doesburg, Kurt Schwitters and Theo van Doesburg in the apartment of Lena Milius, one of the recently completed homes in Klimopstraat in The Hague, in January 1923. Photograph (gelatin silver print), collection of the Netherlands Institute for Art History (RKD), Archive of Theo and Nelly van Doesburg, The Hague. Milius moves there on her own in June 1922, after the break-up with Van Doesburg.

Chris Beekman
(1887-1964)

118 'Van 't Hoff – Beekman etc. have great expectations of the folk at *De Tribune* [a communist paper] but I say to them: their political consequences do not keep pace with their artistic convictions. They take as their criterion – or so I read some time ago in *De Tribune*: Art must be subordinate to the mass and relations of production! As if art can ever be subordinate. And these are the demands of people who set themselves against any kind of subordination! They are too immature to receive the new in the plastic, and what we must join together in doing is to work on inner preparation. There is much to do and to <u>say</u> towards that. If those folk who have withdrawn from our movement stand purely as artists, they cannot but clash with the aesthetic views of our most progressive politicians.'

118 Chris Beekman, *Composition*, 1920, oil on canvas, 48 x 28 cm. Gemeentemuseum Den Haag, acquired from the artist in 1956.

Source
Letter from Van Doesburg to Antony Kok, 9 December 1919

115

J.J.P. Oud

(1890 Purmerend – Wassenaar 1963)

Has difficulty finding his way as a young architect, until he sees the work of American architects in a slide show at Berlage's home one evening. Becomes captivated by ceramicist Willem C. Brouwer, who is a zealous advocate of a society based on traditional arts and crafts. He helps Van Doesburg establish *De Stijl*. From the very outset, the two of them wrangle over the question of the role of colour in architecture. Realises progressively more innovative architecture projects for Rotterdam city council, shaping his ideas about De Stijl, but gradually turns away from collaboration with artists because he believes a pure architecture is a better way to achieve a spiritual revolution. Believes theorising about architecture is nonsense; only 'subordination to the task' can guide the design process. This leads him, in the 1920s, to a highly radical form of functionalism based on how people use buildings on a daily basis. Exhibitions in the United States ensure he comes to be regarded as one of the four pioneers of modern architecture.

1920 12 **Housing and collectivity**
Oud and Van Doesburg and their almost invisible solutions
for the Spangen apartment blocks in Rotterdam

Home City Exhibition Street

Is it an aesthetic question or a practical one? Oud tries to explain his decision to paint rather than paper the walls of the apartments he has just had built in the Spangen district of Rotterdam. His article in *Bouwkundig Weekblad* (Architectural Weekly) in 1920 shows nothing of the exterior of the building, concentrating instead on the interior: a single photograph of a living room in a typical flat, complete with Rietveld furniture. Painting the walls is cheaper to do in the first place but the bright yellow that Theo van Doesburg had selected is likely to dirty quickly. A patterned paper would be far more effective in concealing marks. However, the condensation caused by washing and cooking in a small apartment can cause wallpaper to peel. While Oud ponders solutions to these dilemmas, Van Doesburg is far less concerned with how people *do* live than how they *should* live. He has tried to keep his design as simple as possible but asks for more artistic licence regarding the fireplace which he wants to be at least two colours to prevent the inhabitants hanging their 'trash' in front of it. Cryptically, he calls the whole ensemble a 'late summer pastoral' in reminiscence of the countryside he has seen on a recent trip to Tilburg.

Van Doesburg is growing ever more impatient with Oud's pragmatism. Ever since he took the job with the municipal housing office in 1918, Oud has struggled to keep to the idealistic view of De Stijl. He did not even sign the Manifesto of De Stijl. What has happened since those days in Leiden when they walked together each evening planning the new movement together? But Oud's role in the municipal authority is complex; he has to negotiate with local politicians to initiate mass housing projects and also with housing associations and private contractors to get them built. Nobody is in doubt that Rotterdam needs lots of new housing and private construction is at its lowest point in years, an effect of the economic difficulties and material shortages caused by the war. The Housing Department only came into existence in 1916 and Spangen is one of its first major projects. It is intended for the large numbers of workers required for Rotterdam's development; construction is currently ongoing of the Waalhaven, which will be the world's largest and deepest excavated dock.

While Oud is completing his initial section of the Spangen development – the outer sections of two large housing blocks incorporating a total of 242 apartments – all of the controversy is being drawn by a neighbouring block designed by Michiel Brinkman which uses an experimental gallery to provide the inhabitants of the upper storeys with their own front doors on a street in the air. He has also included common bath and laundry facilities. There is a lot of opposition to this new form of collectivism. Some say that the flat roofs of the blocks are unDutch, others that actually the old courtyard-style houses ('hofjes') were better. While the debates rage away, Oud manages to express collectivity in a different way, less visible to the conservative politicians

119 Photograph of a model interior in J.J.P. Oud's Spangen block no. IX with sideboard (fig. 131), upright chair and armchair designed by Rietveld, 1920. The black-and-white photograph cannot really do justice to this collaboration between an architect, artist and furniture maker; we cannot see the yellow walls that Van Doesburg conceived or the blue and grey tiles on the fireplace. The finest colour composition for the most ordinary of homes.
120 Probably by a student of Theo van Doesburg, *Colour design for a Spangen interior*, 1918, 18.5 x 26.5 cm, pencil and gouache on paper. Centraal Museum, Utrecht. Everything 'big and bright', as Van Doesburg explains to Oud in a letter, perfect for 'standardisation', but still in proportion and concerned with achieving a 'correct balance'. This does not stop Oud from leaving out the red, though.
121 Theo van Doesburg, *Colour design for a Spangen interior*, 1919, 26.5 x 100 cm, pencil and gouache on paper. NAi, Rotterdam.
122 Municipal housing office, Rotterdam, 1918. Oud, 1st row, 5th from right. Photograph from the collection of the NAi, Oud archive, Rotterdam.
123 Michiel Brinkman, Spangen housing block, Justus van Effenstraat, 1918-20, Gemeentearchief Rotterdam.

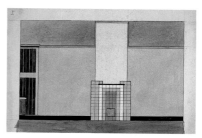

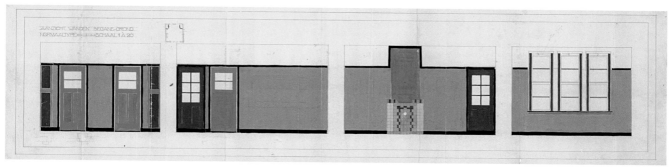

124
125

126
127

128
129
130

who run the city at the time. Van Doesburg not only designs colour for the interior but exterior as well, a rhythmic pattern of yellow, green and grey for the doors and occasional black window frames. He also designs stained-glass windows for lights over the doors. Furthermore, Oud has persuaded the architects responsible for the inner sections of the blocks, intended for middle-class residents, to carry over details of plinths and cornices in order that, despite being designed separately, the different sides are seen as a unity. The principles of massification and standardisation Oud pursues at Spangen relate to his very first article in the first issue of *De Stijl* on 'The Monumental Cityscape' (Het monumentale stadsbeeld). Aesthetic and practical concerns do not have to be at odds with each other.

124 Theo van Doesburg, *Composition XVII*, 1919, tempera and oil on canvas, 50 x 50.5 cm. Collection of the Gemeentemuseum Den Haag. 'It's a lovely thing,' Van Doesburg writes to his friend Antony Kok. 'Yellow, grey, red and bluish-green. It was because of Groesbeek. Because of the wheat, the fields, the taut flat fields and the grass. The grey sky and the lark, the lark *on the inside.*'

125 Theo van Doesburg, *Colour design for exterior of Spangen blocks I and V*, 1919, pencil and gouache on a phototype print, 93 x 142 cm. NAi, Rotterdam.

126 Theo van Doesburg, *Stained-Glass Composition VIII*, 1918, 34.5 x 81.5 cm, stained glass. Nationaal Glasmuseum, Leerdam.

127 Theo van Doesburg, *Stained-Glass Composition IX*, 1918, 34.5 x 86.5 cm, stained glass. Stedelijk Museum de Lakenhal, Leiden.

128 J.J.P. Oud, Design for a housing complex on beach promenade as published in the first issue of *De Stijl*, October 1917.

129 J.J.P. Oud, Design for a housing complex on beach promenade, elevation and floor plan, 1917.

130 J.J.P. Oud, 'Het monumentale stadsbeeld', *De Stijl*, vol. 1, no. 1 (October 1917), p. 10.

Perspectiefkrabbel Huizencomplex
Strandboulevard door J. J. P. OUD.

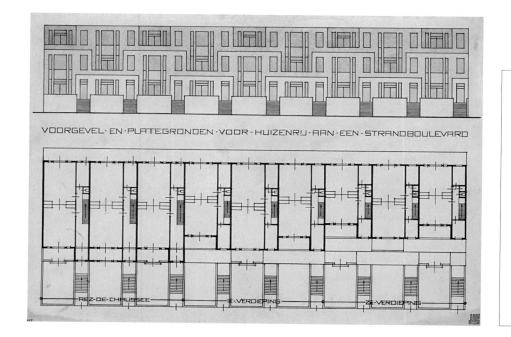

VOORGEVEL · EN · PLATTEGRONDEN · VOOR · HUIZENRIJ · AAN · EEN · STRANDBOULEVARD

REZ-DE-CHAUSSÉE 1e-VERDIEPING 2e-VERDIEPING

HET MONUMENTALE STADSBEELD.

DOOR J. J. P. OUD.

121

1919 **Gerrit Rietveld**
 (1888-1964)

131 'Sent sideboard and a chair this morning; however, I have a feeling
 that it is no blessing to mankind – Just look at them carefully, and tell
 me your impression [...] Respond quickly as to whether it would not be
 better to regard such things as studies, which at most will influence
 your normal work. That is actually how I see it. Anyway, have a good
 look yourself. Above all, do not allow it to be forced on anyone.'

131 Gerrit Rietveld,
Sideboard, 1919, executed by:
Gerard van de Groenekan, 1972,
painted birch wood,
100 x 120 x 45 cm.
Gemeentemuseum Den Haag,
purchased from Gerard van de
Groenekan 1972.

Source
Letter from Gerrit Rietveld to
J.J.P. Oud, 4 May 1920, NAi,
Rotterdam

132

By the time Theo van Doesburg arrives home from his exploratory visit to Brussels and Paris in March 1920, he is the Dutch representative of *La Section d'Or* (The Golden Section), the international association of Parisian Cubists established by sculptor Alexander Archipenko and painter Leopold Survage. Van Doesburg may organise exhibitions in the Netherlands, but he does not have an entirely free hand in selecting contributors. 'Paris' rules that only Huszár, Mondrian and Rietveld may not participate. Rietveld is unable to participate anyway, but other

133

than that, this is the first time De Stijl artists exhibit their work together, first in Rotterdam and then in The Hague, Arnhem and Amsterdam. Georges Vantongerloo is angry at being excluded, but Van Doesburg tries to defend himself by pointing out that Vantongerloo is Belgian, while he is only responsible for the Dutch participants.

The De Stijl artists must have stood out as *different*, from a distant outside world that had nothing to do with that of the largely French and Italian group. Visitors flock to the opening in The Hague and Van Doesburg writes in enthusiastic terms to the still-disgruntled Vantongerloo that there was 'much opposition' to his introductory speech. 'The public, in which include all those daft rotters, the *artistes*, still understand as little of it as they did 10 years ago.'

Van Doesburg was also concerned with the response of the most important artists. 'Toorop wrote that he would so have liked to have been at the opening, because he would have liked so much to speak with me! So I visited him yesterday with the vague illusion that he might be persuaded of the new insights. But he was worse than I anticipated. He is firmly rooted in the ethereal, chimerical ideas of Medieval Mysticism, is too attached to appearance to ever relinquish it. […] He is full of enthusiasm for my endeavours and those of De Stijl and agreed with my ideas. He is still searching and, as he says himself, is very much "back and forth". It is difficult to find the way in the mist. The thicker the mist, the more difficult. Only those who perpetually destroy what is behind them to rebuild themselves for the future can arrive at the new and the true.'

134

The letter signifies another moment of rupture, the further disintegration of the ties with symbolism and *gemeenschapskunst* out of which De Stijl grew. Events are unfolding just as Van Doesburg describes: anyone who looks forward is wise not to look back too much.

Dutch critics disagree entirely, passing a negative judgement on the new group 'which speaks out in the stern little party magazine' *De Stijl*. They are described as fanatics, as revolutionaries using dull formulae. Of course one understands their desire to abolish painting as a separate creative process and allow art to merge with architecture, but the current proposals simply do not attain the level of Gothic art,

132 *Flat torso* by Alexander Archipenko, 1914, photograph, Van Doesburg archive (gelatin silver print). Collection of the Netherlands Institute for Art History (RKD), The Hague. Theo van Doesburg regards Archipenko as one of the 'most profound creators of the new age'. Archipenko and Picasso are the only non-Dutch artists who will ever be invited to contribute to *De Stijl*. Van Doesburg approaches them almost immediately after the magazine is founded.

133 Theo van Doesburg, Poster design for the *Section d'Or* exhibition, 1920, indian ink on tracing paper, 65 x 62.5 cm. Collection of the Centraal Museum, Utrecht, on loan from the Van Doesburg archive, 1999. Van Doesburg makes use of a smaller version of a typeface that he designed in 1919 for Lettergieterij Amsterdam. This typeface will later become well known, especially in Germany, after being adopted by renowned designers and typographers.

134 Vilmos Huszár, *Design for a space-colour composition for a bedroom*, 1920. This photograph is published in the popular magazine *Het Leven* with an article on the 'International Cubist exhibition' at the Stedelijk Museum in Amsterdam, as the press has decided to call the *Section d'Or* show. Photograph, Spaarnestad Photo, Haarlem.

135 Chris Beekman, *Composition*, c. 1919, watercolour on paper, 51.8 x 29.2 cm. Collection of the Gemeentemuseum Den Haag, acquired in 1975. Beekman has very close working relationships with Huszár, whose compositions involve planes that appear to overlap somewhat, and with Van der Leck, who has

previously raised the issue of front and back. He believes that every visual element should be equal in value, just as in the new, socialist order all people are equal. Van Doesburg believes that Beekman's thinking is sound: the age of private property and disconnected individual paintings has passed. Like Neoplasticism, 'the Russian Revolution demands the whole and not a part'.

136 Robert van 't Hoff, *Villa Henny*, Huis ter Heide-Bosch en Duin (Gemeente Zeist), 1916, Collection of the Netherlands Institute for Art History (RKD), The Hague. Despite its predictable, strictly symmetrical design, this villa will become known as the leading example of De Stijl in architecture. This is partly because of all the ultramodern technological features (such as ventilation through small panes that slide up into the wall), but also because of the construction process, in which the distinction between 'master and servant', between client, architect and builder, has vanished completely.

137 Collected works of Robert van 't Hoff in a chest made by the architect in 1951, collection of the NAi. Van 't Hoff's aversion to self-promotion and his radical social views lead him to make a very rigorous selection from his œuvre ('only that which has influenced the course of events') and to gather those designs together on panels that he can slide into a wooden chest stencilled with his initials, RH.

135 which truly was *by* and *for* the community. At the same time, De Stijl
136 artists like Robert van 't Hoff, Peter Alma and Chris Beekman tend to
137 feel that art should serve the cause of the world communist revolution
being preached from Russia. Van Doesburg and Mondrian resist this.
'I think that if we do not keep De Stijl entirely separate as a separate
movement, we will have to distance ourselves from those folk later',
Mondrian warns Van Doesburg from Paris. The utopian elements
of the movement's ideas radicalise and for a time, De Stijl at least
138 appears to merge seamlessly with Dada, the movement that preaches
absurdism.

138 Letter from Theo van Doesburg
to Georges and Tiny Vantongerloo,
16 July 1920, pen and ink on
paper, Angela Thomas Schmidt,
Vantongerloo archive, Zumikon. It is
noteworthy that Van Doesburg not
only discusses his latest work and his
encounters with other artists freely
and openly, but also describes the
Section d'Or exhibition in The Hague
in terms of public interest, writing
that there was 'a large crowd' and
that his introductory talk met with
'a great deal of opposition'. He is
also clearly interested in the number
of visitors.

I.K. Bonset

(1920 unknown – Davos 1931)

Born in May 1920, when he begins to publish nonsense poems in *De Stijl*. When he joins the journal, he brings a Dadaist streak to it, at the request of his alter ego Van Doesburg. Nonsense is not only permitted, it is required, since 'nonsense' conceals a deeper meaning. And so it is. Poems no longer refer to anything. The image and sound are the meaning. Bonset takes up arms against the ponderous poetry that has an exclusive claim on the country. He champions a form of poetry that precisely recounts free, everyday thoughts. Strongly oriented towards anti-individualism, to Van Doesburg he is entirely suited to De Stijl, which also strives for an art that transcends individualism. Mondrian is impressed, and wonders who Bonset really is. All is not revealed until 1924.

JE SUIS CONTRE TOUT ET TOUS — I. K. BONSET · DADA

139 'My dear Oud!' Van Doesburg writes on 24 February 1920. 'Piet is sitting opposite, working on a column on boulevards. It took all my powers of persuasion to induce him. [...] Luckily, he has been inspired

140 by Boulevard des Capucines, where this afternoon we contemplated the immense machine that is Paris. It was glorious summer weather, we were sitting outside. An enormous film! It was the busiest time. [...] As painters in the past drew each other's attention to certain *accidents* in a peaceful landscape, we did the same with certain tense move-ments or the momentous beauty of a modern shop window with its

141 taut expanses of reflective glass and iron. [...] Paris appears to be a highly complex machine, but when one understands the structure it is marvellous how quickly one becomes one with it.'

Mondrian is keen to see how the New Plastic (already visible in its complete form in painting, and thus capitalised, a real art movement) might be dissolved into literature and other arts. Van Doesburg manages to get the piece, entitled 'The *grands boulevards*' ['De groote

142 boulevards'], published in *De Nieuwe Amsterdammer* on 27 March. A fragmentary multitude of images prompts a meticulous account of the experience. The jumble of impressions moves and collides in time and space. Fragments draw attention: a Parisienne's shoe, a scrap of newspaper, part of a portly gentleman. One's normal grip on reality becomes foggy; other realities emerge. Skewed definitions. The image of the 'Parisienne' is a beacon that interrupts the mael-strom of impressions here and there. 'Does everyone see the images as "broken" and does everyone "automatically" perceive the parts?' the writer wonders. A contemplative tone creeps into the second part of the text. Why does language always have to *describe* (*beschrij-*

143 *ven*, *om*schrijven), like art, which has to *depict* (*af*beelden)? If life is realistic, why should art not be realistic, and simply present a plastic expression (*beelden*)? Show what really fascinates our perception. But is a kaleidoscope constantly changing? A moonlit night – such

144 as Mondrian often painted in the past, in another life – also always makes the same impression. The boulevard is a 'thought concentrator' and this requires another art that shows the fragmented, the dis-integrating.

The publication is not enthusiastically received in the Netherlands. 'Boulevard life – a huge clockwork mechanism, one big solar system – makes you a Dadaist in the end or, in short, muddleheaded', that is true. But to present only the bare flow of thoughts, is that art? The famous writer, Lodewijk van Deyssel, feels compelled to write a critique in the reputable Dutch periodical *De Nieuwe Gids*, which prompts Mondrian to further contemplation and writing. 'I believe I have found a solution to literature as N.P. and would like to hear your opinion', he writes to Van Doesburg in June. 'What it briefly amounts to is that it appears to me that the word and the sentence can be deepened only

139 Theo van Doesburg, *Self-Portrait in the Mirror*, with Nelly van Doesburg, 1921, photograph (gelatin silver print). Netherlands Institute for Art History (RKD), Archive of Theo and Nelly van Doesburg, The Hague. Taken in Piet Mondrian's studio in Rue de Coulmiers in Paris, a regular pied-à-terre for Van Doesburg and his wife when visiting the City of Light.

140 A sidewalk café on Boulevard des Capucines, Paris, c. 1920, still from a cinema film from the period. Since the mid-nineteenth century, when the French poet Charles Baudelaire described the boulevards as the apex of modernity, the chaos and crowds have exerted a strong pull on the growing, prosperous middle class, who believe that the modern way to spend one's leisure time is to stroll around and sit at street cafés.

141 Piet Mondrian, *Composition in Red, Black, Yellow, Blue and Grey*, 1921, oil on canvas, 80 x 50 cm. Collection of the Gemeentemuseum Den Haag, purchased by Charley Toorop in 1955 (© Mondrian/ Holtzman Trust c/o HCR Inter-national, Virginia, USA.). Charley Toorop becomes acquainted with Mondrian in Domburg, through her father. When she goes to live in Paris in 1920, Mondrian helps her to find an apartment.

142 Piet Mondrian's piece 'De groote boulevards' (The grands boulevards) in *De Nieuwe Amster-dammer*, 27 March 1920. In this experimental text, Mondrian tries to apply the principles of Neoplasticism ('show what truly fascinates percep-tion') to the field of journalism, by giving a direct description of concrete reality.

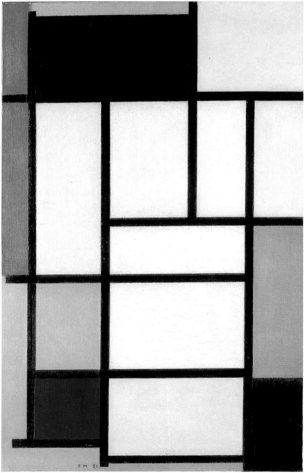

by placing its opposite [tegendeel, 'counterpart'] immediately next to it.' He is not yet entirely convinced as to how this might turn out, but one thing is certain: 'I can slowly but surely see what great work we are doing and have done already, Does! Your friend, Piet-Dada'. How it turned out we will never know. It will have resembled a *neoplastic painting*, as Mondrian now calls his art. He had long been in search of a French translation for his 'Nieuwe Beelding'. 'Plastique' in French not only means sculpture (form and material), but also 'plastic' in the sense of forming, the active quality Mondrian saw in his paintings. Strangely enough, Neo-plasticism (the term first appears in French as *Néo-Plasticisme* at this very moment), which at first glance is concerned with equilibrated relationships and classical purity, coincides with the destructive, negative side of modern society that finds a release in Dada.

143 Street life in Paris, c. 1920, still from a cinema film from the period. Strikingly, the ideas of fragmentation and mirror reflection are beginning to play a prominent role in the popular visual culture of cinema newsreels.

144 Piet Mondrian, *Trees Along the Gein: Rising Moon*, 1907, oil on canvas, 79 x 92.5 cm. Collection of the Gemeentemuseum Den Haag, gift of Albert van den Briel, 1956 (© Mondrian/Holtzman Trust c/o HCR International, Virginia, USA). In paintings like this one, Mondrian seeks to represent harmony and tranquillity. He gradually realises that the secret lies in how he combines composition, colour and form.

Lena Milius
(1889 Tilburg – The Hague 1968)

A highly educated, independent, business-minded bookkeeper who, when barely 25 years of age, walks and cycles with Van Doesburg, who sees her 'emerge shining and clear as a crystal vase in his hands'. Her bold decision to give up her sheltered life for the 'pioneer of modern painting' suggests that she guided Van Doesburg more than is often assumed. She mediates in all conflicts which Van Doesburg instigates, takes care of the administrative side of the journal and cannot abide the radical 'against everyone and everything' attitude of Dada. When Nelly appears on the scene she is happy to relinquish her place. She refuses to go along with Van Doesburg's proposal that they form an 'eternal triangle'. Her independence allows her to financially support Van Doesburg and Nelly. In March 1931 she travels to Davos not only to say goodbye to her recently deceased former lover, but to support Nelly, who had brought him such happiness.

1921 15 'I am no house painter. I take these things very seriously…'
The collaboration between Oud and Van Doesburg
on the housing blocks for Spangen II

Home City Exhibition **Street**

It's late autumn in 1921 and Lena Milius – still married – is standing with Annie Oud on the Potgieterstraat in the Spangen district of Rotterdam looking at the partly finished façade of the latest collaboration between their husbands. Van Doesburg has sent her to find out exactly what is going on. Oud responded positively to the colour designs he sent in October but since then has asked repeatedly for changes. First it was that he could no longer use yellow, then that black would cause a problem. Van Doesburg, writing from Weimar where he is currently living, puts his case in the strongest terms that his designs are not to be tampered with. He is not to be treated as a common house painter: 'Entweder so – oder nichts' (like this or not at all). Still, maybe the women can mediate and help reach a new agreement. Judging by the undercoat colours, which have all been put on, and a third of the shop front at the street corner which has been finished, Milius cannot see the problem. In fact she thinks it is even better than the drawings. But Oud turns up to tell her that the diagonal lines created by Van Doesburg's colour composition compete with the architecture. In fact, although he thinks that a solution might be found if the colours were applied in straight lines, he's decided in future just to use grey. Milius counters that the narrowness of the streets and the height of the buildings are not very conducive to a grand colour scheme anyway. She writes to tell Van Doesburg he is better off out of it.

It is not just about colour. These latest blocks at Spangen have changed Oud's mind about many things. Half-way through the planning process he has decided to completely reorient the floor plan of the apartments so that the living rooms all face an inner courtyard. Milius was right. The streets are narrow. The courtyards are wider, letting more light into properties from that direction. It is a practical decision but its consequences are numerous. The relationship of home to street changes. The direction from which the apartments are entered and the direction in which they look are opposed. Van Doesburg wants to link the interior with the exterior of the buildings with colour. He wants to break apart the traditional division of architectural space. Oud is trying something quite different, to further divide public and private space. In place of Van Doesburg's dynamic colours, he is content with a grey, featureless street because that expresses what to him the street is actually about. 'The street equals business. The inner sites living. Each strictly divided and opposed in character.' Van Doesburg thinks that Oud has become 'commercialised' but even his own choice of yellow has been motivated by the cars, postal trucks and underground trains he had seen in Berlin and Paris. They are each searching in a different way for a new form of urban art and architecture. Not only transforming the homes and the streets and the booming cities, but also, by these means, the hearts and minds of their inhabitants.

145 Potgieterstraat, Rotterdam, 1925, Collection of the Gemeentearchief Rotterdam.

146 Theo van Doesburg, *Colour design for the front elevation of Spangen block VIII*, Potgieterstraat, 1921, gouache on phototype print, 15.5 x 25.5 cm, Collection of the Fondation Custodia, Institut Néerlandais, Paris.

147 Theo van Doesburg, *Colour design for the rear elevation of Spangen block VIII*, Pieter Lagendijkstraat, 1921, pencil, indian ink and gouache on paper, 12 x 26 cm, Collection of the Fondation Custodia, Institut Néerlandais, Paris. Oud thought that the black rectangles would look like holes in the façade of his building.

148 Theo van Doesburg, *Colour design for the front elevation of Spangen block VIII*, Potgieterstraat, 1921, indian ink and gouache on paper, 29 x 32 cm, Collection of the Fondation Custodia, Institut Néerlandais, Paris. The horizontal and vertical organisation of the façade is transected by Van Doesburg's diagonal colour composition.

Piet Mondrian
(1872-1944)

149

'Several of my pieces hang and stand here. The painter points them out to me and pulls them out from behind others, where they face the wall. Unframed rectangles, divided into colourful squares, cut off at the edge, divided from grey areas by thick black outlines. The painter finds it difficult to explain the works; some are dear to him, on other occasions he seems fairly unfamiliar with them. He understands immediately that we are seeing them for the first time, are struck by them. It is of no concern to him, he acknowledges these children. By way of comparison he places others alongside them, painted at an earlier stage. They too resemble the tops of regular building blocks, but the whole thing is less calm, with weaker colours, and weaker contours. He has put this behind him now; in those pieces lies a tragedy that impedes him now.'

149 Piet Mondrian, *Tableau I*, 1921, oil on canvas, framed by a recessed wooden slat covered with oil paint, 103 x 100 cm. Gemeentemuseum Den Haag, Slijper bequest 1971 (© Mondrian/ Holtzman Trust c/o HCR International, Virginia, USA).

Source
From our correspondent [Henry van Loon], 'Bij Piet Mondriaan', *Nieuw Rotterdamsche Courant*, 23 March 1922, evening edition B1

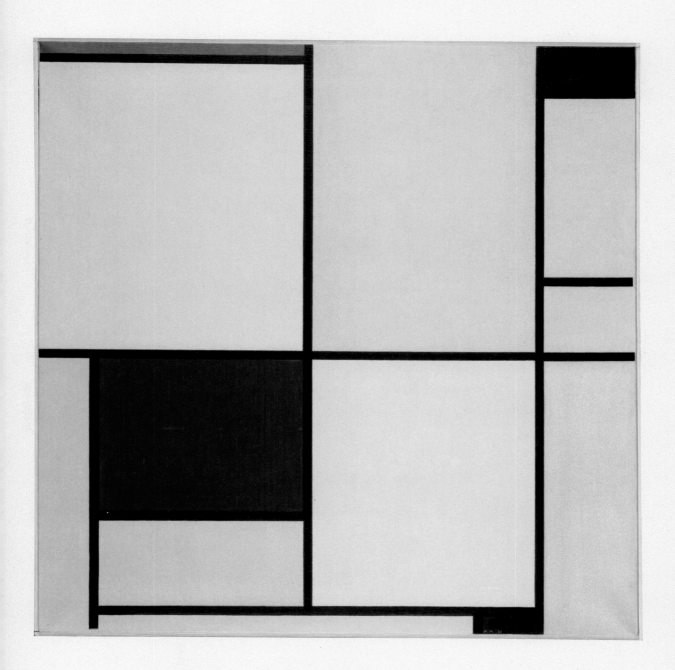

139

Aldo Camini

(1921 unknown – Milan, prior to 1921)

Born in early spring 1921 (after he has died in Milan), a wondrous mix of the best ideas of the Italian futurist movement combined with Nietzsche and Mondrian. Van Doesburg finds the manuscripts – or so he says – and publishes them under the title 'Caminoscopie', in a series of articles in *De Stijl,* because they have a clear and direct association with the views of the moderns. It is a raving, unrestrained concoction of semi-scientific arguments, conceits, torrents of abuse and razor-sharp incisive discourses about art and life, with no safe crossings or warnings at junctions and dangerous bends. At the end of every instalment, like Mondrian in his articles on 'The New Plastic in Painting', Van Doesburg adds reams of explanatory notes, allowing him yet another way to viciously rub extra salt into the wounds of supporters and opponents alike.

ALDO CAMINI

CAMINOSCOPIE

'N ANTIPHYLOSOFISCHE LEVENSBESCHOUWING ZON-
DER DRAAD OF SYSTEEM

BOEK II

I

De twee zekerheden: het leven als splitsings-
proces in mathematische orde. Evolutie als
afstootings-of objectiveersysteem. Hoe de woor-
den of teekens te vinden, die plastisch genoeg zijn, om
uitdrukking te geven aan een levensbeginsel dat zijn
ontstaan dankt aan de samenvatting van alle voor-
gaande. Tot lijken werden ons de beroemd-en berucht-
heden, vroegerer geslachten. Gretig bemesten wij de
nieuwe wereld daarmede.

Mogen de verschillende levensvoorwaarden ook al tot
de catagorie der noodzakelijkheden gerekend worden,
het systeem dat we bestaan noemen, hoe ook gedacht:
transcendentaal, geometraal of tastbaar blijft onverant-
woordelijk. Ik meen: de noodzakelijkheid van het leven
als geheel is niet aan te toonen.

Zelfs al mogen god en geometrie in ons bestaan be-
grepen zijn, geen enkele axioma kan het bestaan van
god rechtvaardigen; het leven vernietigt zich, ter-
wijl het zich opbouwt.

Het leven voltooit zich, door zich te vernietigen, De
zelfvernietiging van het leven is te verklaren uit zijn
absolute inconsequentie waarin — en + gelijke groot-
heden zijn. De oorzaak dezer zelfvernietiging bestaat
grootendeels in de bezigheid die wij denken noemen.
Voor zoover wij het leven denken bestaat het voor
ons (god bestaat in zoover ik hem denk enz.), terwijl
het zich niet objectiveerende subject, menschelijk onmo-
gelijk, ja liever geheel onbestaanbaar is . . .

Het objectiveersysteem is het eenigst wezenlijk-mensche-
lijke dat ons rest terwijl het naar binnen gekeerde
denken (afkomstig uit den drogen en harden bodem

The magazine *De Stijl* had been launched at an inauspicious moment. At the end of the First World War there are shortages of everything, including paper. To make it viable economically, the magazine is printed on a rough, cheap paper unsuitable for illustrations, which have to be printed separately and included as a supplement. The original cover design by Van Doesburg and Huszár exploits the crudity of block printing to give an initial visual identity to De Stijl based on uniformity, simplicity and abstraction. Van Doesburg is reliant on the publisher, X. Harms Tiepen in Delft, to raise funds by recruiting advertisers before the magazine can be printed at all. By the end of its first year of publication, he takes over the administration as well as the editorship of the magazine because of his dissatisfaction with the way it is being run. The end of the war does not improve the situation and in 1919 Harms Tiepen puts up the printing costs by a third.

In 1920 Van Doesburg sees an opportunity to free himself from the publisher and to redesign the magazine completely. He thinks the current format is unpractical and always leads to the magazine arriving creased in the post. He intends not to change the size but the format; instead of portrait, it will be landscape. As he explains to Oud, that will allow it not only to be folded in half to be put in an envelope but also to be carried in a pocket. He also discusses the new cover design at length with Mondrian. Van Doesburg wants to combine the letters *NB*, standing for Nieuwe Beelding, with *De Stijl*. Mondrian sends him a whole page of possible designs, suggesting a two-colour solution: 'Would it not be nicer to make the NB more eye-catching by making it black and De Stijl red?' In the end Van Doesburg does it the other way around, overlaying one on the other so that they are seen simultaneously.

The launch of the new-look journal coincides with Van Doesburg's decision to relocate from the Netherlands to Germany. He finds a new printer in Weimar where costs are lower. The cover of *De Stijl* starts carrying the names of cities where it has a base, initially Leiden, Antwerp, Paris and Rome but later Berlin, Warsaw, Vienna, New York and even Tokyo. Van Doesburg complains to Antony Kok that the redesign has meant the loss of some of the subscribers to *De Stijl* and writes an editorial to explain the reason for the change but fundamentally his approach to the distribution of the journal has changed. Van Doesburg poses in Weimar with the new cover on his hat. *De Stijl* is now to be seen on the street, in the shop window, on the magazine stand and not just on the table in the salon of the art lover.

150 Cover of the first issue of *De Stijl*, October 1917. The vignette, perhaps representing the intertwining of art and architecture, is combined with block-like, simple typography that straightens every curve.

151 Letter from Piet Mondrian to Theo van Doesburg, 5 August 1920, Netherlands Institute for Art History (RKD), Archive of Theo and Nelly van Doesburg, The Hague. The magazine *De Stijl* gets a makeover, with *NB* (*Nieuwe Beelding*, meaning 'Neo-plasticism') now leaping out at the viewer. Mondrian is happy with the new look. 'Yes, we'll carry on fighting as long as we can, Does!!' he writes.

152 Cover of the final issue of *De Stijl*, 1932, dedicated to Van Doesburg. Although published in the year following his death, the issue establishes a connection between the dates 1917-1931 and the journal, linking it forevermore to the life of its editor. Van 't Hoff writes inside that Van Doesburg and De Stijl are 'inseparable from each other'.

153 Postcard from Theo van Doesburg to Antony Kok, 12 September 1921, collection of the Netherlands Institute for Art History (RKD), Archive of Theo and Nelly van Doesburg, The Hague. The Bauhaus building 'gets bombed by n-dimensional style artillery'. *De Stijl* launches its campaign for international domination.

154 The Congress of Constructivists and Dadaists, Weimar, September 1922. Photograph from the collection of the Netherlands Institute for Art History (RKD), Archive of Theo and Nelly van Doesburg, The Hague. The new-look *De Stijl* takes pride of place on Van Doesburg's hat at the centre of the international avant-garde. Van Eesteren and the Van

Doesburgs launch the 'virgin microbe' Dada on the steps of the museum, together with Tristan Tzara, Jean Arp, Kurt Schwitters, László Moholy-Nagy and El Lissitzky, among others.

155 Theo van Doesburg's window display for the Librarie de Mésange, Strasbourg, 1927. Photograph from the collection of the Netherlands Institute for Art History (RKD), Archive of Theo and Nelly van Doesburg, The Hague.

Gerrit Rietveld

(1888 Utrecht – Utrecht 1964)

A young dreamer, he trains as a furniture maker in his father's work-
shop. Does it all for his own pleasure (he would later call this 'healthy
egocentricity'). Abandons the strictly Protestant creed of his youth,
which means that henceforth he no longer regards the material as
rotten. The spiritual is not the only thing that counts. In 1918 he
exchanges his father's dowel-hole joinery for joins that remain visible in
the final product. Helps Van Doesburg and J.J.P. Oud in their attempts
to give the traditional interior a new, spatial design, and goes on to
become an ingenious interior designer. In 1924 he reinvents architec-
ture when, in collaboration with Truus Schröder, he designs and builds
a house in Utrecht. Without confrontation with Van Doesburg, goes his
own way in 1928 and aligns himself with architects whose aim is a
strictly functional form of architecture. In 1951 he designs the De Stijl
exhibition at the Stedelijk Museum in Amsterdam, and does a great
deal to spread De Stijl to interiors all over the world.

1922 Bart van der Leck
(1876-1958)

156 'My dear Van der Leck, I received the consignment of lilies in good order, I was in Wapenveld when it arrived, but there was someone home [at the home of J.E. van der Meulen, founder of the Wibbina Stichting] to receive it. It has worked very well and I am highly delighted with the work. I find it very serious and refined, though it is a pity that those are precisely the things people have difficulty seeing, but we shall do our best to drill it in. I am waiting a little before showing it, because I spoke before my holiday so often of those other lilies and have fatigued people too much with it, though there are of course some who are unable to appreciate it at all.'

156 Bart van der Leck, *Composition with Lilies*, 1922, oil on canvas, 55 x 33.5 cm. Gemeentemuseum Den Haag, long-term loan from Wibbina Stichting 1950.

Source

Letter from H.P. Bremmer to Bart van der Leck, 10 January 1923, in Cees Hilhorst, *De correspondentie tussen Bart van der Leck en H.P. Bremmer*, Bussum (Thoth) 1999, p. 131

147

The purpose of the 'Prix de Rome' is obvious from its title. It enables its winner to spend time in Italy at the fount of classical culture. It is awarded yearly to brilliantly talented young painters, sculptors and
157 architects. In 1921 the winner for architecture is Cornelis van Eesteren (1897-1988). At the time he is living in Amsterdam, working by day in the office of G.F. Rutgers designing housing blocks for Berlage's *Plan Zuid* and studying in the evening at classes run by J.L.M. Lauweriks
158 (1864-1932), another architect working in the spirit of *gemeenschaps-kunst*. Van Eesteren has already produced his first piece of urban planning for his father, the director of a large building firm and alder-man of Alblasserdam, two schemes for the expansion of the town which are later partially realised. What is he going to learn in Rome about this brand-new field of architectural practice?

Deciding on a very different course of action, Van Eesteren sets off in February 1922 for a ten-month study tour of Germany. For his prize he needs to design a university building but his interest is mainly the city and how it is developing. His first stop is Berlin where he samples the atmosphere of Potsdamer Platz, one of the first junctions in the world
159 to have traffic lights. The German critic Adolf Behne (1885-1948) advises him to visit the Bauhaus in Weimar, hotbed of experimentalism and new thinking in architecture and design. Van Eesteren arrives there at the beginning of May but apart from a conversation with its director, Walter Gropius (1883-1969), about the importance of the machine in new design, he is otherwise unimpressed by what he finds. Nothing of what he encounters convinces him that it is any more advanced than the Netherlands. A similar opinion is held by Van Doesburg, who has been in Weimar for more than a year agitating against what he sees as an outmoded Romantic approach at the Bauhaus. Not only does Van Doesburg think differently from the Bauhaus masters, he looks different too. He writes to Oud about one of his outfits, an 'almost white American suit, with tailored waist, bright white tie with black French
160 collars, white gloves of fil d'ecosse and American cap. I've established this clothing as modern and taken it intentionally to the extreme of perfection. Modern clothing is above all *sport-clothing*: life is a sport and clothes must testify to the electric atmosphere of the great traffic centres.'

Van Doesburg runs a rival 'Stijl' course in his immaculately white-washed studio, which attracts and converts lots of Bauhäusler to the
161 cause of De Stijl. And it is in this studio that Van Eesteren's university design starts to take on a startlingly different form. Intended for a site close to the Amstelkanaal, Van Eesteren proposes a dramatic intervention in Berlage's expansion plan. Rather than imagining the university from street level as a monumental building, Van Eesteren conceives it from above as a multipart structure comprising three perimeter blocks and a central octagonal hall connected by cruciform

157 Cornelis van Eesteren, Prix de Rome design for a Royal Academy of Sciences, Literature and Fine Arts, 1921, collection of the NAi, EFL Stichting, Rotterdam.
158 J.L.M. Lauweriks, *Fire screen*, c. 1900, mahogany, wool and silk, 60 x 40 x 35 cm, collection of the Gemeentemuseum Den Haag.
159 Potsdamer Platz, Berlin, c. 1930. Ulstein Bild collection. Cars, buses and trams all compete for space at one of Europe's busiest junctions. The traffic-light tower was put up in 1924 to help regulate the chaos.
160 Theo van Doesburg in Weimar, 1921. Collection of the Netherlands Institute for Art History (RKD), Archive of Theo and Nelly van Doesburg, The Hague. Modern, American fashion combined with the European dandy's favourite accessory, the monocle.
161 Nelly and Theo van Doesburg with Harry Scheibe in Van Doesburg's studio, Am Schanzen-graben 8, Weimar, 1922. Collection of the Netherlands Institute for Art History (RKD), Archive of Theo and Nelly van Doesburg, The Hague.

162

arms at 45%. He thinks about it not as a single isolated object but a complex of buildings integrated with the whole urban ensemble, almost a city within a city. The panel overseeing the Prix de Rome is less convinced and his grant is discontinued. Van Eesteren is undaunted and in 1924 collaborates with Van Doesburg on a competition design for a shopping centre on the Laan van Meerdervoort in The Hague, to

163

be judged by Berlage among others. Collaged onto the design is a photo of a man in a sporty American suit walking briskly across the street; the modern man in the new traffic city? The design does not win but it throws down the gauntlet to the Amsterdam planners and shows that an alternative way of imagining and representing urban design is on the way.

162 Cornelis van Eesteren, *Design for a university in Plan Zuid*, Amsterdam, 1921, colour and graphite pencil on paper, 88.3 x 149.3 cm, NAi, EFL Stichting, Rotterdam. A building becomes a complex in the context of major urban development. The main entrance is no longer so easy to see from the street and the axis of the central structure is at odds with it.

163 Theo van Doesburg (colour) and Cornelis van Eesteren (architecture), *Perspective drawing of a design for a shopping arcade with café-restaurant*, 1924, indian ink, gouache and collage on paper, 53 x 51.5 cm, NAi, EFL Stichting, Rotterdam. Conceived for the development of the Laan van Meerdervoort, at the junction with Fahrenheitstraat, in The Hague. Pirouetting into space, the modern man conquers the landscape of the new city.

'Dumb, dumb, dumb, very dumb, very dumb, very dumb, dumb, dumber, dumbest.' Mr Heijting, chairman of the theatre section, gives his thanks in the only appropriate manner to the performers at the first Dada evening in the Netherlands which has taken place at the Haagsche Kunstkring in the Binnenhof on 10 January 1923. Everyone is getting in the Dada spirit although they were initially caught out by the German Dadaist, Kurt Schwitters (1887-1948), who, sitting in the audience at the beginning, began to bark and make other strange noises whenever Theo van Doesburg paused during his lecture 'What is Dada?'. This question gets no answer, apart from the reporter of the *Nieuwe Rotterdamsche Courant* who suggests that 'Everything was Dada, except the prices. They wanted 50 cents for a scrap of paper.'

Nelly van Doesburg (1899-1975) appears at the interval to sell copies of the lecture and other publications. She's on stage in the second half playing eccentric musical compositions such as a funeral march for a crocodile and a military march for an ant. The reporter from the *Telegraaf* thinks it sounds like a cat running back and forth over the keyboard.

Schwitters performs his poem 'Revolution in Revon' which tells of the pandemonium caused simply by 'a man standing there' [da steht ein Mann], a refrain he repeats over and over while behind him Vilmos Huszár demonstrates his mechanical dancing figure, a robotic shadow puppet shown on a large screen.

The bizarre nature of the event is reflected in the programme that the members of the audience have been given, a small poster where details of the acts are jumbled with slogans and adverts: **Dada has always existed**; **Dada is against the future**; **Against rheumatic toothaches and headaches 2-3 Revon tablets on the stomach**; **Subscribe to Mécano**. Like Eric Satie's 'Ragtime' from the ballet *Parade* that Nelly van Doesburg plays, the sounds and sights of the street have entered the world of fine art.

The uproarious success of the first night leads to a whole tour of the Netherlands, with subsequent performances through January and February in Haarlem, Amsterdam, Den Bosch, Utrecht, Rotterdam and Leiden. According to a report in the *Algemeen Handelsblad*, the poor people of the small town Bussum were expecting a performance at the Concordia Theatre on 9 February which was booked (without paying) by the Dadaists who enquired by phone in the morning 'whether or not ticket sales were going well, to which they were told that *already nine* seats had been booked. Around 8 o'clock approximately 30 inquisitive people were present but not one Dadaist appeared. The audience in Bussum attended the best possible Dada demonstration that can ever be imagined and were thankful and satisfied to have their pre-paid

164 Theo van Doesburg, *Programme and poster for the Little Dada soirée*, 1922, lithograph in red and black, 30.4 x 30.4 cm. Collection of the Gemeentemuseum Den Haag, acquired in 1965. Multiple versions of this poster are in circulation. Surprisingly, Nelly van Doesburg is not mentioned by name, even though as the pianist she has an important role.

165 Photograph of Kurt Schwitters taken in London, 1944, during a performance of the *Ursonate*. Collection of Spaarnestad Photo, Haarlem. They may know of his poems and collages, but they certainly do not know his face in the Netherlands in 1923. Since few photographs of Schwitters are in circulation at this time, he is able to hide in the audience and bark on Van Doesburg's cue.

166 Cover of Theo van Doesburg, *Wat is Dada???* (What is Dada???), De Stijl Publishers, The Hague, 1923. Collection of the Centraal Museum, Utrecht. Van Doesburg's self-defeating explanation of the inexplicable is available for purchase by members of the audience seeking further unenlightenment.

167 Nelly van Doesburg in a photograph accompanying an article about the glorious Dada soirée in the magazine *Het Leven*, 1923. The background around Nelly has been whited out. Collection of Spaarnestad Photo, Haarlem. Articles in news-papers and magazines are important forms of publicity for Dada, disseminating the artists' ideas to a broad public.

168 Vilmos Huszár, *Mechanical Dancing Figure*, 1922 (reconstruction by Andy Kowalski and Robert Pachowsky), aluminium, metal,

mica, wood, nylon, 103 x 50 x 35 cm (including base with control mechanism). Collection of the Gemeentemuseum Den Haag, acquired in 1985. The figure has movable joints. The eyes and the jaws can also move, creating the impression that the head is turning. Ten keys in the base connect to wires that control the movements; each key controls one part of the body. The figure is designed as a shadow puppet, so that when light is projected onto it, it creates a kind of moving painting.

169 Theo van Doesburg, *Mécano no. Jaune, Geel, Gelb, Yellow*, February 1922, printed matter, 32 x 52 cm. Collection of the Centraal Museum, Utrecht, on loan from the Archive of Theo and Nelly van Doesburg, 1999. *Mécano* comes about after Van Doesburg has assembled a 'fine collection' of Dada texts that he hopes will encourage 'international intellectual inter-change'. Each issue has a different primary colour. The final issue is white.

entrance fee returned.' This is perhaps a joking response to the near riots of the previous performances. In Utrecht, a fortnight before, the Gebouw K & W is filled with large crowds of students keen to make themselves heard. The police are on hand but don't know how to respond to the sudden appearance of an audience member on stage dragging a strange contraption partly made of a pig's skeleton, a bottle of Bols and the lid of a milkcan. The chaos that follows results in the Dadaists becoming part of the audience, who now 'do Dada' for themselves, 'an unparalleled Dadaist triumph', according to Schwitters. Two nights later in Rotterdam, the chief of police himself takes to the stage to quieten the uncontrollable audience down. He gets a huge round of applause and the howling goes on.

170

All this seems a far cry from the order and abstraction of the De Stijl aesthetic but Van Doesburg does not see it that way. In the middle of the tour he has organised a debate at the Delft Student Debating Club to defend the propositions of Neoplasticism. Schwitters publishes an article in the *Haagsche Post* describing the relationship between Dada's destructive and De Stijl's constructive nature. 'We are living at the end of an old and a beginning of a new time. The transition is Dada.' In Schwitters' new magazine *Merz* they come the closest yet to giving away that the Dutch Dadaist I.K. Bonset, the anagram of the Dutch 'ik ben sot' ('I am mad'), whose poems have been appearing in *De Stijl*

171

for the last couple of years, is in fact Van Doesburg himself. Not many people know this. Certainly not Mondrian. Not even Tristan Tzara, leader of the Dada group in Paris. Bonset is named as the literary editor of the journal *Mécano*, which Van Doesburg has been publishing from Weimar. In it he writes great satires on Dutch culture, defaming figures such as the philosopher Bolland, the painter Richard Roland Holst and Berlage but also includes in the final issue (which coinciding with the tour is dedicated to 'Holland's Bankruptcy through Dada') a manifesto on constructive poetry. Huszár's participation must also be understood in this way. His mechanical dancing figure goes back several years

172

to attempts to make 'moving painting'. His 1917 painting of skaters shows figures in a variety of poses quite similar to the jerky movements of the 'strange doll' commentators describe at the Dada shows in 1923. Theo van Doesburg thinks this is something completely new. Human form is transformed into abstract movement. Made out of metal with red and green mica inserts, the figure casts not just shadows but colours onto the screen and the controls, like stop tabs on an organ, allow Huszár to conduct their rhythmical transposition. Furthermore, as he explains in *Merz*, the idea is 'to incorporate the space around into the background'. In the Netherlands the audience has become the performance, life has become art, and vice versa.

170 Notice of the third meeting of the Delft Student Debating Club, where Kurt Schwitters and Theo van Doesburg defended eight theses on the nature of abstract modern art on Monday evening, 22 January 1923. Collection of the Netherlands Institute for Art History (RKD), Archive of Theo and Nelly van Doesburg, The Hague. Strikingly, Van Doesburg presents Dada as a transitional mechanism at work where one movement flows into another.

171 Page 44 of Kurt Schwitters's magazine *Merz*, no. 4 (1923), in which the editors hasten to explain that Theo van Doesburg never existed and that the name of the poet I.K. Bonset is a somewhat inaccurate anagram of 'Sodgrube'. Photograph, International Dada Archive, Special Collections, University of Iowa Libraries.

172 Vilmos Huszár, *Composition II (skaters)*, 1917, oil on fibre cement in a stepped, white-painted wooden frame, 79 x 85.3 cm. Collection of the Gemeentemuseum Den Haag, acquired in 1971. This reworking of the seventeenth-century skating scenes of Hendrick Avercamp in accordance with modern principles is Vilmos Huszár's initial response to seeing Bart van der Leck's *Mine Triptych* (see chapter 03). At the same time, it is a first attempt to give form to the ideal of 'moving painting' (*bewegende schilderkunst*) that guided almost all the painters in De Stijl.

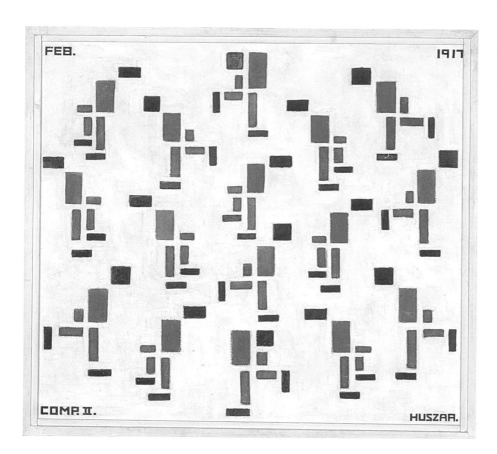

1923 Piet Zwart
(1885-1977)

173 'The most striking exhibit is by Piet Zwart. His structures of unplaned slats painted in elementary colours are particularly witty. The manner in which they hold the exhibited objects under the viewer's nose, as on a tray, is full of expression. But I do not agree with their purport; it appears to me that this is a conceited denial of what a piece of furniture should be and of what technical development over the centuries has achieved beyond the handiwork of the savage. This objection of mine applies equally to the design for a trade fair stand by the same artist.'

173 Piet Zwart
Maquette of a design for a trade fair stand, 1923,
realisation: Helmut Salden
wood, card, Perspex, paint,
25 x 69 x 39 cm,
Gemeentemuseum Den Haag,
acquired from Piet Zwart 1970,

Source
Anon., 'Haagsche Kunstkring',
Het Vaderland, 28 July 1923

1923 19 **A Far Flung Corner of a World City**
The businesslike but very Dutch solutions to the architecture
in the *Tusschendijken* district

Home **City** Exhibition Street

Johannes Pieter Mieras (1888-1956), director of the *Bond van Neder-landse Architecten* (Association of Dutch Architects) and secretary of the professional architects' magazine *Bouwkundig Weekblad*, has decided to go and look at architectural projects in Rotterdam. Photographs don't tell you enough. In fact, in his opinion 'only bad architecture lets itself be photographed well'. For years now people have been talking about the expansion of Amsterdam but what is happening in Rotterdam is, in his view, just as exciting. It is destined to become a world city and there is something about its peculiar development that makes the experience of modernisation there very special. While in Amsterdam, wherever you are in the city, you can think, 'Amsterdam's huge but in five minutes I can be with the cows in the meadow', the wonder of Rotterdam is that 'the cows are in front of you. The meadow is in front of you. But mind! This is the two-sided seed from which Rotterdam will grow as a world city. A viaduct cutting across the city and the cows in the meadow in the Land of Hoboken.'

174
175

He has been looking at the railway viaduct that cuts through the very centre of the city, unique in the Netherlands at the time, and he has gone past the open fields of Hoboken on his walk to reach the polders beyond where the largest new developments are taking place. He strolls through Spangen as far as the new Sparta football ground

176

and compares its housing blocks to the more famous Amsterdam developments. There's little flashiness here. None of the expressive angst of Michel de Klerk (1884-1923), say, but that suits Mieras. This Rotterdam architecture is 'good, natural, real' as opposed to the 'pathos, bravura and speedy decadence' of Amsterdam. Not long after-wards, in a memorial edition of *Wendingen* for de Klerk, who has died young from pneumonia, Mieras chooses to write exclusively on de Klerk's outstanding qualities as an artist. Many people, not just Mieras, see that the contribution of de Klerk to the direction of Amsterdam architecture lies in his artistry, in his sincere desire to bring beauty into the lives of everybody, no matter what their income. It is an expensive practice for social housing though. De Klerk even has individual bricks of special colours and sizes made for his projects. That kind of prof-ligacy is antithetical to Oud's view of architecture.

177
178

Turning back from Spangen, Mieras crosses the Mathenesser Weg to Tusschendijken where he visits the six large housing blocks Oud has just completed there. This is where Mieras finds the true heart of the Rotterdam spirit. Oud is businesslike in his approach. Mieras recalls a lecture the architect gave to the group *Opbouw* where he declared that 'an architecture based rationally on the modern circumstances of life will form an opposition to contemporary architecture in every respect. Without decaying into dry rationalism, it will be above all functional but in this functionality will immediately experience something higher'. This is not architecture that photographs very well, Mieras admits, but it is one totally appropriate for the new cityscape where each block

174 Postcard of the Hofpleinviaduct in Rotterdam, an elevated railway almost two kilometres long, towering high above the street. Opening in 1908, it is the country's first electric line, crossing the city of Rotterdam, connecting Hofpleinstation with Central Station in The Hague and even going on to the beach at Scheveningen. Photograph from the collection of the Gemeentearchief, Rotterdam.

175 Postcard of the Land van Hoboken in Rotterdam, the area bordered by Rochussenstraat, Nieuwe Binnenweg, Westersingel and Westzeedijk that remains farmland until the late 1920s, despite being in the heart of the city. Photograph from the collection of the Gemeente-archief, Rotterdam.

176 Het Schip designed by architect Michel de Klerk (1884-1923) for the housing association Eigen Haard between 1914 and 1921. Photo-graph, Museum Het Schip, Amsterdam.

177 J.J.P. Oud, *Perspective drawing of the courtyard for the housing blocks in Tusschendijken, Rotterdam*, 1920-24. Photograph from the collection of the NAi, Rotterdam, Oud archive. His friend W.C. Brouwers, with whom Oud worked together so successfully in the days of Villa Allegonda (see chapter 09), writes a letter to say that, despite every-one's good intentions, he feels Tusschendijken has turned out like rabbit hutches with a feeding trough.

178 View from Gysingstraat of housing blocks I to IV in the Tusschendijken district of Rotterdam soon after its completion in 1924. Photograph from the collection of the NAi, Oud archive, Rotterdam.

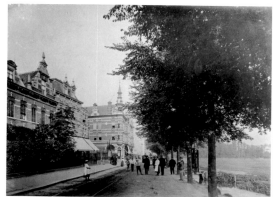

forms a unity and the consistency of each façade creates a total streetfrontage. Since the start of *De Stijl*, Oud has used the magazine as a platform for criticism of the Expressionist architecture of the Amsterdam School. The completion of the Tusschendijken project, with its resolute uniformity and severity, confirms the architectural rivalry between the two cities, one now associated with artistry, the other with business. Mieras thinks he has just seen the one that will win out and ends his article with a photograph of the highly photogenic and futuristic-looking site manager's hut that Oud has just constructed for himself on the site of his next project at Oud-Mathenesse.

179
180
181

179 J.J.P. Oud, *Colour design for the Oud-Mathenesse Manager's Hut*, Rotterdam, 1922-23. Collection of the NAi, Oud archive, Rotterdam. This small building shows that Oud's functionalism is guided by a very clear, poetic intuition.

180-181 The Oud-Mathenesse manager's hut in 1923, soon after completion, the first structure on the site where the district of Mathenesse was to be erected. Photograph from the collection of the NAi, Oud archive, Rotterdam. When the district had been completed, with its white houses that were the most simplified form possible of the typical Dutch house, the colourful hut remained in place. The contrast must have been extremely striking.

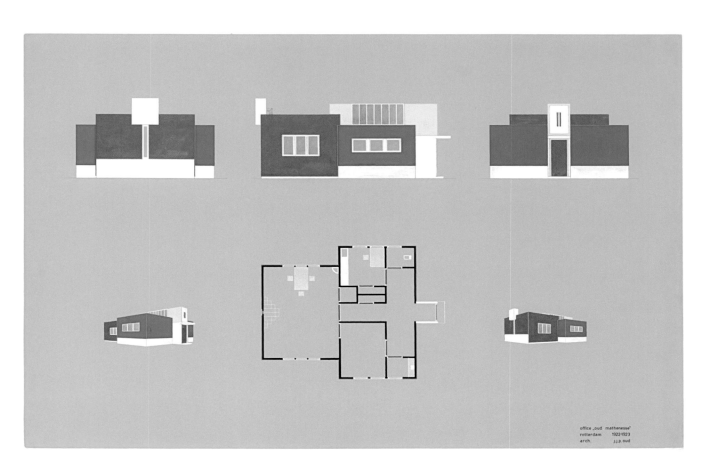

office „oud mathenesse"
rotterdam 1922-1923
arch. j.j.p.oud

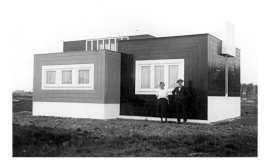

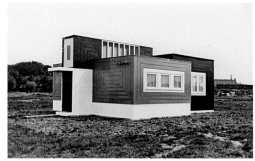

Cornelis
van Eesteren
(1897 Kinderdijk – 1988 Amsterdam)

Young and spirited, and difficult to keep on track, Van Doesburg
finds when they work together in Paris. It is not quite like that, how-
ever. Van Eesteren is from a family of builders and he has learnt the
architect's trade from the bottom up. He is therefore very practical.
But he is also in love with design, because it allows the 'spiritual utility'
of the material to manifest itself. Van Eesteren learnt a lot from the
Parisian experiments with Van Doesburg. They have taught him that
abstract, non-constructive aspects of a design can liberate the creative
process. In his later urban planning, logical thought, with an eye for
organisation and efficiency, go hand in hand with undogmatic and
imaginative solutions. He refers to himself as an architect-urbanist
concerned with design in a basic way, where experience, intuition and
knowledge play a decisive role. Creative power, free of the mistakes
of tradition, is paramount.

Ultimately, it all has to happen in a hurry. Even though Van Doesburg had begun his studies in plaster, wood and colour for an art centre somewhere just outside Paris in February 1921, for a commission from Léonce Rosenberg of *L'Effort Moderne*, the gallery where Picasso, Léger and other modern artists show their latest work. Rosenberg is interested in Mondrian's work and is impressed by De Stijl's idea of transforming life into art, what Van Doesburg calls 'the practical execution of the Stijl idea'. It might be that Van Doesburg had told him about the fabulous plans for a real museum of modern art that The Hague city council has asked Berlage to design. Or of Mrs Kröller-Müller's plans for her museum of modern art in Wassenaar, or on the Veluwe heathlands. And what the Dutch can do, the French can do too, of course, certainly if Van Doesburg helps.

But there is a difference. Rosenberg's commission never progresses beyond the imaginary. But the De Stijl people will produce all kinds of plans, not only for a museum. In January 1921 Van Doesburg attempts to rally all those working on the project. At the Haagsche Kunstkring he speaks to Wils, Rietveld and Van Eesteren. In his journal, Van Eesteren notes: 'Wils and I will handle the architecture, Rietveld furnishings and interior. Doesburg, Mondrian colour.' But Mondrian is unsure, believing the time is not yet right for the 'attempts at Stijl' to be applied to daily life. Jan Wils is too headstrong. Oud withdraws because imaginary plans are not practical. Gerrit Rietveld is willing to contribute ideas. Only the young architect Cornelis van Eesteren eventually participates in the close collaboration.

Van Doesburg's purpose is clear. In July 1922 – when there is already talk of an exhibition – he writes 'Our first show must be a bomb that falls in the midst of the immoral art brothels'. But it is not until May 1923 that they get together in Paris. First, arrangements are made with Rosenberg, who schedules the exhibition for October. In mid-June they begin working out the details of a much earlier plan of Van Eesteren's for a university hall. Van Doesburg has no idea of the dimensions – as will become clear later – but this does not stop him radically revising Van Eesteren's plans. He divides the floor and walls into rectangular areas of colour and the ceiling into diagonal black beams leaving space for areas of colour. This dissolves the space and turns the architecture on its head. The choice of materials has not yet been settled: glass or concrete, these are mere details. They prefer to focus on the real design project, and design three maquettes together: a *Hôtel particulier*, a *Maison particulière* and *Maison d'artiste*, based respectively on Rosenberg's imaginary commission, a free interpretation of a previous plan of Van Eesteren's for a house in Alblasserdam and an 'ideal little house' that Van Doesburg envisaged for himself and Nelly.

182 H.P. Berlage, *Model of the preliminary design for the Gemeentemuseum*, The Hague, 1919, plaster and wood, plastered, 25 parts (81 x 81 cm each). Collection of the Gemeentemuseum Den Haag, acquired in 1920. After Helene Kröller-Müller makes plans with Mies van der Rohe for a new museum of modern art in Wassenaar, its director, H.E. van Gelder, works with Berlage on a proposal for a major museum of contemporary art in The Hague, in the heart of Dutch society.

183 Mies van der Rohe, *Plan for a museum*, 1912. Collection of the Kröller-Müller Museum, Otterlo. Van der Rohe began making technical drawings for this project as a pupil of the architect Peter Behrens. After leaving Behrens's studio, he worked on the museum for a year, even making a full-size wood and canvas model. The way in which the wing and the colonnade are connected to the main building shows the influence of nineteenth-century architects such as Karl Friedrich Schinkel (1781-1840).

184 Carel Blotkamp, *Reconstruction of the wall on the window side of Mondrian's studio at Rue de Coulmiers 5, Paris, c. 1919/1920*, made in 1998, photograph of the original in the artist's possession. This reconstruction is the product of painstaking analysis of the description that Mondrian supplies in his *Trialogue*, a conversation published in *De Stijl* between a naturalist painter, a modern painter and a layperson.

185 Theo van Doesburg and Cornelis van Eesteren, *Colour design for a university hall in perspective, facing the stairwell*, 1923, pencil, gouache and collage on paper,

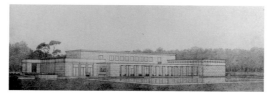

62 x 144 cm. Collection of the NAi, Rotterdam, Van Eesteren archive. Van Doesburg regards the 'development of the hall' as one of the most important components of the exhibition at the Paris art gallery *L'Effort Moderne*. He describes the hall in a letter as if he were standing inside it.

186-187 Gerrit Rietveld, *Model for a Hôtel particulier*, Gerrit Rietveld, based on a design by Theo van Doesburg and Cornelis van Eesteren (reconstruction by Gerrit Rietveld, 1951), wood, paint, c. 200 x 140 cm. Collection of the NAi, Rotterdam. In 1921, Van Doesburg begins work on a design for a large house for the gallery owner Léonce Rosenberg, 'a thing which has never been built, a *centre* for culture'.

188 Theo van Doesburg and Cornelis van Eesteren, *Model for a Maison particulière*, 1923 (reconstruction by Tjarda Mees, 1982), wood, silk-screen, Perspex, Plexiglas, 60.5 x 90 x 90 cm. Collection of the Gemeentemuseum Den Haag. Van Doesburg describes his collaboration with Van Eesteren in terms of *art collectif*, the new form of communal art. The age of destruction has ended, and the age of construction has begun.

189 Theo van Doesburg and Cornelis van Eesteren, *Model for a Maison d'artiste*, 1923 (reconstruction by Tjarda Mees, 1982), wood, silk-screen, Perspex, Plexiglas, 62 x 60 x 60 cm. Collection of the Gemeentemuseum Den Haag. Just before the opening of the exhibition at Rosenberg's gallery, Van Doesburg designs another 'ideal home, entirely in colour' in which he and Nelly plan to live, with a studio, a guest room, and a music room for Nelly.

190

When the conflict reaches boiling point there is a melding of the position of the architect and of the artist. Boundaries blur and architect and artist merge. The boundaries of function, structure and form are simultaneously exceeded. Painting and architecture guide each other through unknown territory. But fate also plays a hand. When the plans for the *Hôtel particulier* are not sent to Utrecht on time, Van Doesburg can no longer develop a colour scheme for the maquette when it arrives. So the maquette remains white. Absence of colour becomes the key feature of the architecture of Le Corbusier, Mallet-Stevens, Stam and many others.

191

In the *Maison particulière* Van Eesteren's dreams develop their own dynamic: 'house with skin to protect it from weather – air inlet and outlet – heating cooling – central hot air heating', he notes on a floor plan. When all load-bearing walls and heating stoves go, the house can breathe freely. The arrangement of rooms becomes informal. Gravity is abolished. Van Doesburg captures this in what he calls *Counter-constructions*, drawn and coloured analyses of load-bearing and dividing planes that he derives from Van Eesteren's drawings, dubbing them 'a new way of imagining architecture'. With lines of perspective that do not converge, it resembles a three-dimensional representation of the planes from the neoplastic paintings produced by Mondrian and himself. Nevertheless, the *Maison particulière* is not so much a spatial sculpture as a manifesto. Every part has its own independent presence, is elemental, but the relationships are never strictly defined, as a result of which all the elements remain isolated from each other.

192

193

194

Van Doesburg loses himself in the *Maison d'artiste*. The entrance and terrace merge, the music room rests on the back wall of the entrance without any further support; the planes formed by canopies and stair-wells transect each other. In structural terms, it is virtually impossible to realise. But Van Doesburg is unconcerned. After the opening, he even alters photographs to reinforce the idea that the structure is somehow floating freely in space. While an architect would think that the idea of structure has been sacrificed to the material, Van Doesburg in fact believed that the 'means of architecture' had been used here for the first time in a non-anatomical way, as he had envisaged in a 1922 article, that this was the first example of a totally new architecture, moving from 'the aesthetic to the material'.

After the exhibition opened, each went his own way. In 1924 an issue of *De Stijl* is delivered to Van Eesteren's home, with a manifesto from Van Doesburg, 'Towards a plastic architecture', with the explanatory note: 'Brief summary of architectural principles 1916-1923 developed in practice and theory by the Stijl group in Holland'. Van Eesteren writes a letter in which he irritably points out that the manifesto was the result of their collaboration. There is no *group*.

190 Van Doesburg and Van Eesteren at work on the model for the *Maison particulière*, photograph from the collection of the Netherlands Institute for Art History (RKD), Archive of Theo and Nelly van Doesburg. A journalist writes that the exhibition at Rosenberg's gallery exudes a *joie de vivre* that borders on recklessness but is 'satisfying to see in a country short on architectural initiative'.

191 Photograph from the Van Doesburg archive of one of the models for an early design by the architect Robert Mallet-Stevens. Collection of the Netherlands Institute for Art History (RKD), Archive of Theo and Nelly van Doesburg.

192 Cornelis van Eesteren and Theo van Doesburg, *Plan for the first floor of the Maison particulière*, 1923, indian ink and collage on paper on cardboard. Collection of the NAi, Rotterdam, Van Eesteren archive. Function, mass, surface, temporal and spatial experience, light, colour and materials make these designs open in character and tend to eliminate the distinction between inside and outside.

193 Piet Mondrian, *Composition with Large Red Plane, Yellow, Black, Grey and Blue*, 1921, oil on canvas, 59.5 x 59.5 cm. Collection of the Gemeentemuseum Den Haag, acquired in 1957 from Sal Slijper (© Mondrian/ Holtzman Trust c/o HCR International, Virginia, USA). While Mondrian wants his paintings to display 'timeless relationships', he searches also for emphatic contrasts and a lively rhythm.

194 Theo van Doesburg, *Counter-construction*, 1923, gouache on collotype, 57 x 57 cm. Collection of

the Museum of Modern Art, New York, Edgar J. Kaufmann Jr. Fund 1947. Although Van Doesburg spends his whole life searching for a means of transforming motion, time and space into visual art, the Counter-constructions that he makes in 1923 seem to come closest to this ideal.

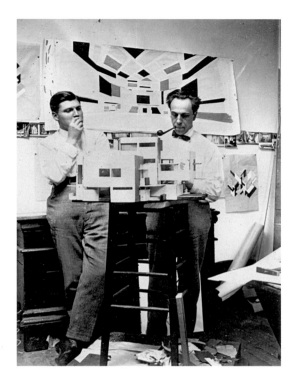

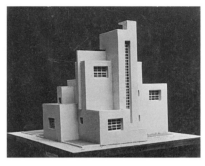

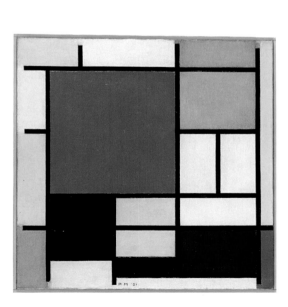

Truus Schröder

(1889 Deventer – Utrecht 1974)

Having trained at the Technische Hochschule in Hanover, she explores the idea of a career as an interior designer. Then she decides to conform to the expectations of her strict Catholic upbringing, and marries. In her marriage, she develops radical ideas about bringing up her children and claims – literally and figuratively – the space to make her dreams about how to live her own life come true. Finds like minds in the circles associated with De Stijl, and meets Rietveld. In the heated debate about the new architecture, she takes steps that result in a radical new way of living in the form of the Rietveld-Schröder House. She is irritated when, during a visit, J.J.P. Oud laughs at all the architectural solutions in the house. She does not realise that discomfort (brought on by unfamiliarity) can give one the urge to laugh just as much as ridicule. Until long after the war she continues to design unique and radical spatial solutions alongside Rietveld.

1924 21 **How do you want to live?**
 An emancipated woman's views on child rearing,
 and the new architecture of the Rietveld-Schröder House

 Home City Exhibition Street

195 'It was a dirty old wall and there were some weeds. So it was an aban-
doned corner where everyone who was caught short used the wall, you
know. It was a miserable little plot. And we said: yes, this is good, let's
just do it. And then we made a little space on that little plot, which was
rather good.' This is Gerrit Rietveld, the architect who in 1924 helped
Truus Schröder design her new house in Utrecht. Truus's husband,
the Utrecht lawyer Frits Schröder, has just died, but that is not the
immediate cause of her sorrow.

Truus feels she is failing her children and herself. She is not happy;
she wants something new; she wants to escape the passive, bourgeois
attitude to life that she feels oppresses her from all angles. Her sister
An is a liberated woman, working in Amsterdam as editor-in-chief of
196 the feminist magazine *De werkende vrouw* (The Working Woman). Truus
feels imprisoned in her Utrecht household, responsible for the strict
upbringing of three children. She withdraws more and more and her
views become radicalised. She prioritises the child's natural urge for
self-development, openness and honesty in personal relationships
and in society.

Frits did not understand. He pandered to his wife's need to isolate her-
self by asking Utrecht furniture maker Gerrit Rietveld (1888-1956) to
197 make a room for her. Rietveld produced a room with walls divided into
grey-toned rectangles. He also wants to furnish the room, but Truus
does not want that. The Schröder family's friends and acquaintances
frown at her, but Truus wants more. She welcomes Schwitters, Huszár
and Nelly and Theo van Doesburg to her home to stage a Dada evening
in January 1923. Her children enjoy the proceedings from their vantage
point at the top of the stairs.

When Frits dies ten months later, Truus presses ahead with her plans
to radically reshape her life, with Rietveld as her natural collaborator.
He draws designs for a house but Truus barely looks at them, and they
start again together. Living must be a conscious act. How does the
light fall? There must be balconies on all sides and large windows that
open wide. 'The next question was: how do you want to live? Well, I was
completely against living on the ground floor. […] So we began to work
on the upper floor, because you can't manage without bedrooms. A
room for the girls and a room for the boy. And where would we situate
them? All together of course; the children had missed so much.' Truus
proposes leaving out all the interior walls for the time being. This is
reminiscent of the happiest moments of her childhood, when she
played in the large attic of her parents' home. And so, a completely
198 asymmetrical house emerges – practical, based on how it will be used –
that appears to be composed of individual vertical screens and horizon-
199 tal planes and beams. On the upper floor there are ingenious dividing
200 walls, but other than that everything is communal, open, clear and

195 The blind wall at the end of
Prins Hendriklaan in Utrecht, photo-
graph from before 1924, a period
when the built-up area of the city
comes to a fairly abrupt halt here.
The parcel of land next to the blind
wall is reserved for a mansion
intended to brighten up the city gate
on this side of Utrecht. Photograph
from the Rietveld-Schröder archive,
Utrecht.

196 The cover of the March 1930
issue of *De werkende vrouw* (The
Working Woman), with an interview
with the artist Charley Toorop as the
lead article. This feminist magazine
is published by An Harrenstein and
has only a brief lifespan. Photograph
from the collection of the Inter-
national Institute of Social History,
Amsterdam.

197 This is the interior of the room
that Truus Schröder has Gerrit
Rietveld design for her in 1921,
because she wants a 'place of her
own'. Rietveld partitions the walls
with recesses and fixed furnishings
and lowers the windows. Photograph
from the Rietveld-Schröder archive,
Utrecht.

198 The Rietveld-Schröder House
immediately after its completion,
1925. Photograph from the Rietveld-
Schröder archive, Utrecht. At first,
it seems like a simple project: con-
struction is expected to take just
three months, and the contractor
agrees to a very low price. Perhaps
this is why it takes years to complete
the house, even though Truus
Schröder is already living there with
her children.

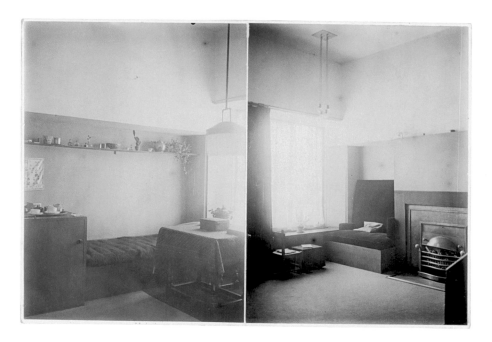

collective. The house is full of ingenious details and variety. The outward appearance follows the same arrangement. The street side has a modest façade – the main aim was not to stand out, for the sake of the neighbourhood – and on the garden side the appearance is that of a villa. And the view from the house itself – which looks out on the rural area immediately outside the city – is dominated by the countryside, the world of the Hague School. When J.J.P. Oud comes to look he laughs at every detail and invention. 'That vexed me greatly', Truus would later say, 'for I thought that was not the most important thing about this house, the little conveniences and the whimsical.' To her, the concrete expression of a conscious way of living was the main thing. Sleeping, bathing, cooking, playing, everything had to be considered. In this way, space is experienced visually and consciously every day.

A unique variation on this view of life takes shape around the same time in The Hague, where Gertrud Julie Arper (Weimar 1894 – Haarlem 1968) designs a piece of furniture for children that is built for her by her husband, the architect J.Th. van Winsen (1893-1939). This playful invention is made of stacked blocks and looks as though it was made by a child at play. Its appearance varies when viewed from different angles, and it shows surprising contrasts. Significantly, it receives a great deal of attention when on display in early 1928 at the exhibition *The Montessori Children's House* in Bussum. In both its form and its use of colour, it shows how well informed Arper is about the design principles of De Stijl. Arper studies with Henry van de Velde in Weimar until 1915. On Van de Velde's recommendation, she goes to the Netherlands to continue her education at the office of H.P. Berlage. From 1915 to 1925, she is also a freelance designer at the idealistic furniture factory LOV (*Labor Omnia Vincit*) in Oosterbeek. In the late 1930s, she becomes affiliated with De Kerkuil in Haarlem, an arts and crafts shop run by Jo van Regteren Altena (1876-1954).

201

202

199-200 Overall view of the upper floor of the Rietveld-Schröder House. On the left, the dividing screens are positioned to create a closed-off bedroom. On the right, the screens have been moved behind the stackable cupboard, removing the boundary between the red section of the floor and the rest of the interior. Photographs by Kim Zwarts, Rietveld-Schröder archive, Utrecht.

201 This view of the Rietveld-Schröder House just after its completion conveys a clear impression of the highly rural setting that provides the context for the house during its first decades. Photograph from the Utrecht Provincial Archives.

202 G.J. Arper, *Children's cupboard*, built by J.Th. van Winsen, c. 1928, wood, paint, linoleum, 74 x 58 x 52 cm. Collection of the Gemeentemuseum Den Haag. Photograph by Peter Jongejan.

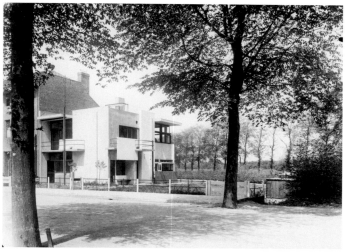

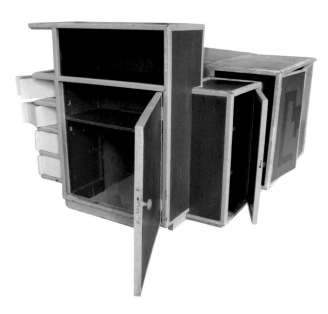

By the end of the 1910s Liberty is no longer modern, and Metz turns more to the tastes of the Amsterdam School and De Stijl. Metz director Joseph de Leeuw is a progressive entrepreneur who likes collaborating with modern artists. A clue as to Metz's new direction is the house De Leeuw commissions for his family in Laren, *D'Leewrik* (The Lark), based on a design by K.P.C. de Bazel. Willem Penaat is responsible for the interior. He will design a lot of furniture for Metz over the coming years. De Leeuw and his wife have artist friends in Laren and in Amsterdam, including Joseph Mendes da Costa, Samuel Jesserun de Mesquita, the Van de Werks and Bart van der Leck, who has lived in Blaricum since 1916. They also get to know Piet Mondrian in Laren, through their nanny Johanna Steyling, with whom Mondrian has a relationship. The De Leeuw children think Mr Mondrian a strange fellow, as evidenced by a rhyme they make up about him: 'Mr Mondrianus, with his bonce so bulbous, and the shell he'll put, onto his crooked nut' ('Meneer Mondrianus, met zijn bolle kanus, en zijn eierdoppie, op z'n scheve koppie').

In 1925 De Leeuw meets Sonia Delaunay in Paris, at the Exposition des Arts Décoratifs. She has her own gallery, *Atelier Simultané*, where she sells fabrics, accessories and clothes, most of them designed on the principles of Simultanism. De Leeuw brings some of her work to Metz, and on 20 November 1925 *De Telegraaf* shows a photograph of Delaunay scarves with the headline 'Today's Fashion': 'These modern silk scarves in a combination of brown, white and bright yellow were much admired at a recent Paris fashion show'. Delaunay will produce over 200 designs for Metz. After 1930, she will often collaborate with Hendrik de Leeuw, the son of Joseph de Leeuw. She will continue working for the firm until after the Second World War, with a series of exclusive specially commissioned designs. Joseph de Leeuw and Delaunay have a special bond. Indeed, De Leeuw, by then a widower, even asks Delaunay to marry him. Although Delaunay refuses, they remain close. They are often seen together in Paris, attending concerts by Louis Armstrong and Duke Ellington, and enjoying the company of Arp, Vantongerloo, Chagall, Kandinsky and Mondrian.

By now, 1920s fashion has overtaken the reform movement's desire for more freedom of movement. Short skirts and dresses for grown women, without a corset, with enough freedom to do modern dances like the Charleston: current fashion offers it all. Gabrielle 'Coco' Chanel is the figurehead of this youthful, sporty fashion. Chanel's clothes are highly wearable and practical, often made from supple jersey fabrics. At that time, fashion, applied arts and visual arts shared common interests. Chanel not only designs clothes with lines that match the geometric forms of art deco, she also designs fabrics with abstract, geometric motifs. Contemporaries like Sonia Delaunay and Madeleine Vionnet use the same geometric principles. This leads to highly modern

203 Sonia Delaunay, *Shawl*, c. 1925, crushed silk, silk fringe.
204 Shawls designed by Sonia Delaunay, in *De Telegraaf*, 20 November 1925.
205 Sonia Delaunay, Clothing designs and pattern design for automobile (Citroën B12), 1925.
206 Piet Zwart, *Dance costume design*, 1920, gouache on paper, 32.6 x 22.3 cm.
207 *Day dress*, c. 1925, crushed silk. Worn by Margaret Staal-Kropholler, architect.
208 R. Vriend-Reitsma, Suit with mosaic patchwork, Netherlands, 1923.

© Sonia Delaunay, L&M Services, The Hague.

203

204
205

206

207

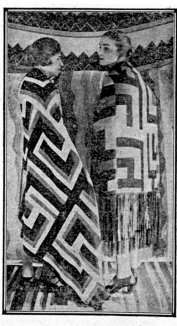

DE MODE VAN DEN DAG. — Op een der laatste Parijsche modeshows bewonderde men deze moderne zijden sjaals in een combinatie van bruin, wit en helgeel.

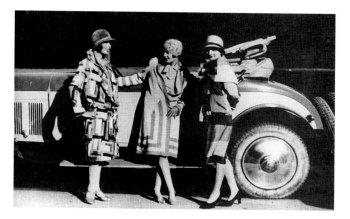

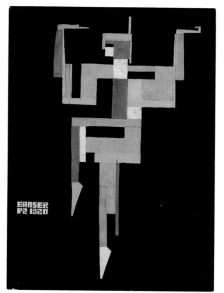

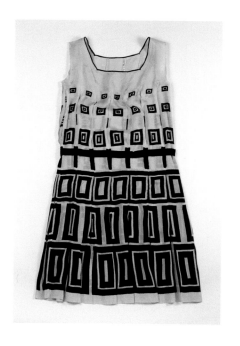

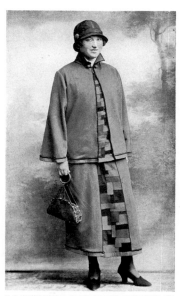

15. R. VRIEND REITSMA. MANTELPAK MET LAPJES MOZAÏK, 1923.

208
209
210
211

212

213
214

creations, dominated by abstract decoration. This influence can also be seen in the Netherlands, as in a 'suit with patchwork mosaic' from 1923, or the modernist dresses sold by Metz. Modern women cut their hair short and smoke cigarettes just like men, completing the ideal of the modern woman as a 'garçonne'. Nelly van Doesburg conforms to this fashion, with her angular short hairstyle and geometrically structured dress. She is photographed wearing it in 1924, in the Paris studio of husband Theo van Doesburg, along with Piet Mondrian and Hannah Höch. Nelly's straight dress is made of a supple fabric with a striking striped motif in contrasting colours. The geometric creations of Hélène d'Oettingen (= François Angiboult), in which Nelly is photographed in 1923, are even more progressive. Until January 1924 Nelly used to practise piano in a rehearsal room at the famous 'salon' of the artist at 229 Boulevard Raspail, Paris, as a note she wrote to Theo confirms: 'Little Does, if it rains, bring my raincoat! I'm studying all afternoon at Angiboult, 229 Raspail. Come there!!!'

209 Metz & Co, *Day dress*, c. 1927-28, silk, silk applique, label: 5720, K 55-1964. Worn by Else van Duyn.

210 Metz & Co, *Day dress (with jacket here)*, c. 1925, silk, encrusted with silk.

211 Metz & Co, *Day dress*, 1926, silk, velvet. Worn by Mrs C. Zwart-Cleyndert, Piet Zwart's second wife. She wore the dress on 3 July 1926 at a party in the home of the artist Chris de Moor, where she first met Piet Zwart.

212 Nelly van Doesburg, Piet Mondrian and Hannah Höch in Theo van Doesburg's studio in Clamart, 1924.

213 Nelly van Doesburg, dressed in a creation by Angiboult (Hélène d'Oettingen), Paris, c. 1923.

214 Theo van Doesburg with a shawl by Sonia Delaunay, c. 1928.

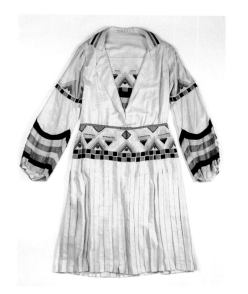

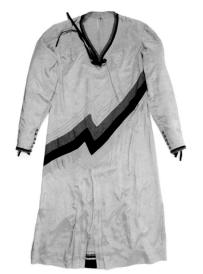

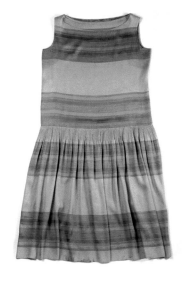

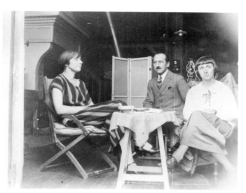

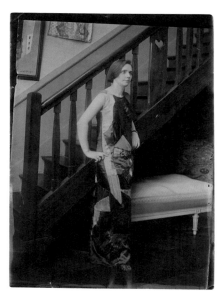

How the problems of 1925 turn De Stijl into a permanently disintegrating movement

Van Doesburg had always been a bit contrary. It will therefore come as no surprise to learn that in 1923-24 he starts developing a new form of art, which he eventually dubs *Elementarism* in around 1926. It is diametrically opposed to Piet Mondrian's theories. Take the diagonal. Mondrian had no objection to it in essence. Dynamism and rhythm played a great role in his own work and he had never been dogmatic. But when Van Doesburg relates the diagonal to a further progression in lightness, in spiritualisation, in breaking free of earthly fixity, Mondrian thinks he has overstepped the mark. The diagonal, in these terms, goes against everything that Neoplasticism and De Stijl stand for in his eyes: equilibrated relationships and classical purity. These could best be achieved in the laboratory conditions of the studio, slightly removed from the world. But Van Doesburg suddenly takes an entirely different path, leading in the opposite direction. In itself it is logical, the consequence of developments in his work that occurred around 1923.

Three influences play a role. First, the Rosenberg exhibition. The *Counter-constructions* from that exhibition owe all their floating, spatial elements to the diagonal. It suggests time; the compositions might change with time. That is why Van Doesburg soon starts to call them *Constructions de l'espace-temps* (Space-Time Constructions). Secondly, Van Doesburg's attitude to the *making* process changes: 'That painting by hand could be replaced by a more mechanical execution, don't you think?' he asks Antony Kok. 'Of course the process of composition will remain a matter of intuition and "handiwork". But the execution must really change. What do you think?' While Mondrian carefully ponders, shifting and changing, Van Doesburg boldly decides that, after devising the composition in a sketch, the rest follows on automatically. Thirdly, the international musical activities of Nelly van Doesburg revive Van Doesburg's interests in the relationship between music and visual art. The New Plastic in Painting must be further developed. Music includes some fantastic examples: Igor Stravinsky, George Antheil, Darius Milhaud and jazz musician Arthur Gibbs. He is particularly impressed by Antheil's music, reduced as it is to sound relationships produced by an unusual, divergent combination of instruments, which create fractious timbres. Rhythmic popular music and contemporary dance also have that contrariness, and point to the future.

Van Doesburg devises a theory of colour that borrows heavily from this music. He arranges colours in chromatic series, with dissonances and '(im)perfect contrasts'. Just how long these ideas had been maturing is revealed in a long letter written in 1922 to shoemaker Evert Rinsema of Drachten, in whom Van Doesburg finds an unexpected kindred spirit. In the letter, he explains the ideas out of which *Counter-composition XVI* of 1925 crystallised into mature form. The most striking thing about this painting are the yellow, blue and red planes juxtaposed in pairs, each of which displays minute colour differences. Bright yellow against

215

216

218

217

219
220

215 Piet Mondrian, *Tableau I* (Painting I), 1921, oil on canvas, 103 x 100 cm. Collection of the Gemeentemuseum Den Haag, Slijper bequest (© Mondrian/ Holtzman Trust c/o HCR International, Virginia, USA). As early as 1919, Mondrian writes that sound combinations, even *without* melody, can be profoundly moving, more so than music *with* a melody. This refers to the unprecedented new rhythmic phenomena that he has encountered in the jazz clubs of Paris, where American musicians are bringing the latest musical styles from the United States to Europe. In this music he recognises the same thing he is pursuing in his paintings. **216** Theo van Doesburg, *Counter-construction*, 1923, gouache on collotype, 57 x 57 cm. Collection of the Kröller-Müller Museum, Otterlo, on loan from the Van Doesburg archive, 1984. By experimenting with the illusion of weightless suspension in architecture, Van Doesburg brings the element of time into his art. Mondrian dismisses this as mere illusionism, but Van Doesburg becomes convinced that the foundations of Neoplasticism must be reconsidered, so that there is more room for contrast, dynamism and imbalance. **217** The American composer George Antheil and his wife in Paris in 1927. Antheil became well-known for constructing a machine with bells, a siren, and aircraft propellers that could be used as a musical instrument. **218** Theo van Doesburg, *Colour design for a stained-glass window for the stairwell in the Agricultural School*, 1922-23, pencil and gouache on paper, 100 x 33 cm. Collection of

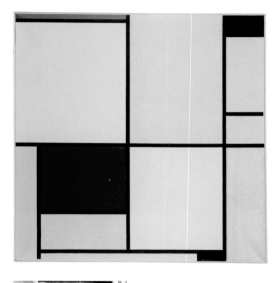

the NAi, Rotterdam, Van Doesburg archive. While in 1922 the half-finished colour fields are intended as mere instructions for the artisan who will select the glass, after 1924 the dynamic quality found in this design will take on an independent role in Van Doesburg's thinking, and the suggestion of movement and the passage of time will become central to his work.

219 Theo van Doesburg, *Counter-composition XVI in Dissonance*, 1925, oil on canvas, 100 x 180 cm, in a white-painted wooden protruding frame mounted on a broad, white-painted wooden surround. Collection of the Gemeentemuseum Den Haag, gift of Nelly van Doesburg 1934. The phrase 'in Dissonance' [*van dissonanten*] is not conventionally included in the title in later years but is found in the lists that Van Doesburg himself maintains. This phrase reflects Van Doesburg's desire to forge a connection with one of the most important aspects of modern music.

220 Theo van Doesburg, *Study for Counter-composition XVI*, 1925, pencil and gouache on paper, 5 x 9 cm, pasted on cardboard, 11.5 x 12 cm. Collection of the Kröller-Müller Museum, Otterlo, on loan from the Van Doesburg archive. Van Doesburg makes this sketch as part of a group of twenty-two studies with the potential to serve as models for finished paintings.

181

ochre. Harsh blue against ultramarine. Deep red against bright red. The planes are not all the same size, and this has an impact on the intensity of the colours. The colour pairs are combined with 'dissonances' in white, black and grey. As can be seen in a sketch, he based the composition – which is in fact quite old-fashioned – on a regular grid of five by nine squares. He drew all diagonals through the junctions in the grid, and then produced the composition by simply making some lines thicker. A recipe identical to that used by Piet Mondrian in his *Composition with Grey Lines* of 1918. Van Doesburg is so delighted with the result that he has several dancers perform in front of it; the painting is the 'music' for them. He also used it as the basis for his work on the Aubette entertainment complex in Strasbourg. *Counter-composition XVI* represents entertainment and modern amusement.

221
222
223
224

221 Series of photographs of the dancer Kamares (pseudonym of Willy van Aggelen, also known as Tai Aagen Moro) dancing in Piet Mondrian's studio in 1926. Photograph from the collection of the Theater Instituut Nederland, Amsterdam. In 1926, Mondrian concludes that the more strongly art is tied to form and illusion, the less it is capable of giving shape to a new world. Rhythm disrupts and liberates, slipping free of the bounds of time. Mondrian sees this taking place in both jazz and his own paintings.

222-224 Series of photographs of the dancer Kamares dancing in Theo van Doesburg's studio in 1925. Photograph from the collection of the Netherlands Institute for Art History (RKD), The Hague, Archive of Theo and Nelly van Doesburg. Around 1925, Mondrian and Nelly van Doesburg have lengthy discussions about the nature of rhythm. In essence, Nelly and Theo van Doesburg see rhythm as the marking of motion in time. In contrast, Mondrian sees rhythm as the structuring of duration.

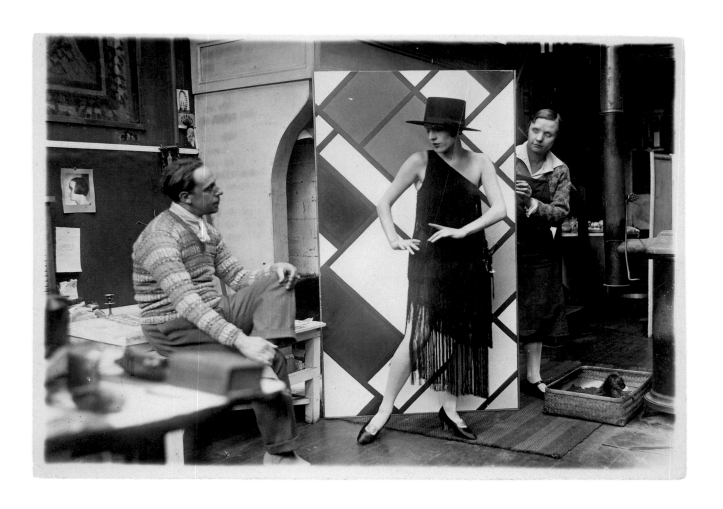

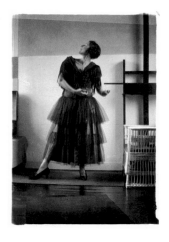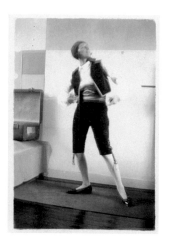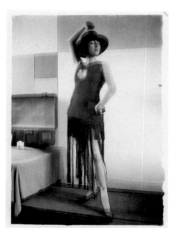

23　The applied arts swindle
The Exposition internationale des Arts décoratifs et industriels modernes, Paris, 1925

In November 1925 J.J.P. Oud receives a Gold and Silver Medal from the commission of the *Exposition internationale des Arts décoratifs et industriels modernes* (International Exhibition of Modern Decorative and Industrial Arts) for his contribution to the display of architecture and interior design in the Dutch pavilion. Whether he feels proud or slightly awkward about the award is difficult to say. He was asked to submit designs for his housing developments in Rotterdam and the holiday house, *De Vonk*, in Noordwijkerhout that he had worked on together with Theo van Doesburg in 1918 and which represented the early aspiration of De Stijl to promote collaboration between architects and artists. Although, from 1922, he is at odds with Van Doesburg, he has just completed his design for the Café-Restaurant De Unie in Rotterdam, in which advertising (including adverts in lights), form and colour have been treated as a single whole, and which in a certain sense is a textbook example of the ideas of De Stijl. When a local critic comments that 'the whole thing was rather falling apart', Oud agrees: destructive and temporary was exactly what he had in mind. Van Doesburg will certainly not be receiving an award after the protest he has put up against the Dutch contribution to the exhibition. He thinks the whole thing is a complete travesty. De Stijl alone should be selected to represent modern Dutch design and not the hotchpotch of individuals the Dutch commissioners have gone for. This is the most prestigious international exhibition since the 1915 World's Fair in California, which had little European representation due to wartime circumstances. France wants to reaffirm its cultural importance and regeneration after the First World War. It has also decided to exclude Germany from the exhibition, thus making it an 'international' rather than 'universal' event. That means none of the Bauhaus people will be there. Even more important, then, that De Stijl is shown to be leading the way.

In the late summer of 1924 Van Doesburg is confident that he will be in charge of the Dutch pavilion. He wants it to be a collective effort, a continuation of the Rosenberg exhibition, which has also been partly redisplayed in the meantime. He's going to put a giant city model in it that he has been developing. He's even writing to people that he has been given the job, even though *Bouwkundig Weekblad* has published full details of the commission; J.F. Staal will construct the pavilion with painters and sculptors such as Richard Roland Holst and Hildo Krop providing decoration. Hendrik Wijdeveld, editor of *De Stijl*'s arch-rival magazine *Wendingen*, will be curating the exhibition to take place within it. Van Doesburg believes that the interest and support of Jonkheer John Loudon, the Dutch ambassador in Paris, will swing things his way. However, the Dutch commissioner Jan de Bie Leuveling Tjeenk has to write to him in October to assure him that there will be absolutely no De Stijl entry to the exhibition. Van Doesburg's immediate response is to drum up support amongst his friends in the international avant-

225

226

227
228

225 J.J.P. Oud, *Drawing cabinet for Domela Nieuwenhuis's collection of prints*, 1925, pencil and ink on paper, 48 x 64 cm. Collection of the NAi, Rotterdam, Oud archive. This cabinet is intended for a large collection of prints kept at the Museum Boijmans van Beuningen. The design is executed by the Rotterdam furniture maker M. van Dort.

226 [Anonymous], *Model for Café-Restaurant De Unie in Rotterdam*, 1925 (reconstruction from the 1980s), wood and paint, 63 x 53 x 20 cm. Photograph from the collection of the Gemeente-museum Den Haag. The City of Rotterdam asks Oud to fill a narrow parcel of land between two fashion-able neoclassical buildings. Many feel that this is no place for a café, but 'if a café does not belong on a large, busy traffic artery, where does it belong?' Oud asks.

227 Johannes Steltman (1891-1961), *Three-part tea service*, 1925, silver, enamel, and stone, executed by Firma Steltman, The Hague. Collection of the Gemeentemuseum Den Haag, acquired in 1980. In 1925, this service is part of the Dutch contribution to the Exposition internationale des Arts décoratifs et industriels modernes in Paris, where it is awarded a bronze medal.

228 A selection of the French ceramics purchased by the Gemeentemuseum during a visit by its director, H.E. van Gelder, to the Exposition internationale des Arts décoratifs et industriels modernes in Paris. Photograph from the collection of the Gemeentemuseum Den Haag.

185

garde to launch a protest on behalf of constructivism calling for 'the applied arts swindle in all areas of production to be destroyed'.

We do not know how closely Van Doesburg looks when he goes into the Dutch pavilion, where he might unwittingly encounter his own designs for *De Vonk*, and also work by Wils and Zwart. Passing over it all quickly in disgust, he calls it 'a farmhouse that belongs rather in Wassenaar than in the heart of Paris'. Van Doesburg is a frequent visitor to the exhibition site, often going in the evening to enjoy the coloured fountains and fireworks over the river. He has also found a De Stijl contribution he thoroughly approves of in the Austrian pavilion, produced by a new De Stijl recruit, the theatre designer Frederick Kiesler (1890-1965). The day after the exhibition opens, Kiesler finds Van Doesburg and Mondrian standing in front of his huge 'City in Space' model. Van Doesburg greets him, 'You did what we all ever hoped to do. You've done it.'

229

230

231

232

229 J.F. Staal, Sketch for the Dutch pavilion at the Exposition internationale des Arts décoratifs et industriels modernes in Paris, 1924, pencil and colour pencil on paper, 32 x 100 cm. Collection of the NAi, Rotterdam, Staal archive.
230 Porte d'Orsay, the entrance to the site of the Exposition inter-nationale des Arts décoratifs et industriels modernes in Paris, designed by L.H. Boileau. Reproduction from the guide to the fair, collection of the Gemeentemuseum Den Haag.
231 The illuminated Pont Alexandre III leading over the Seine to the site of the fair, with artificial waterfalls to catch the light, a performance by the light artist Vedovelli. Reproduc-tion from the *Rapport Général*, collection of the Gemeentemuseum Den Haag.
232 Frederick Kiesler, *City in Space*, 1925, Exposition internationale des Arts décoratifs et industriels modernes, Paris.

229
230
231 232

187

233 Theo and Nelly van Doesburg are settled now in Paris with a fantastic studio in the district of Clamart with a large garden. It's only a half an hour by suburban train to the centre of the city. That's good as Nelly needs to earn a bit of money playing the piano in cinemas and dancing. But it's not at all good for Theo's allergies. He suffers terribly from hay fever and asthma. They have to get to the coast for some cleaner air when summer comes. The dusty environment of the studio is not helpful either. Surely modern life is not supposed to be so filthy? These respiratory problems are eventually going to lead to his death and, in a text published posthumously, he calls for the artist's workplace to be like 'a glass bell or a hollow crystal. […] The palette must be of glass, the brush square and hard, without a trace of dust and as immaculate as a surgical instrument.' Where might such a studio be found? At an altitude of 3,000 metres, according to Van Doesburg, where 'the cold kills the microbes'.

Building upwards is crucial to modern life. This is what Le Corbusier is proposing in his provocative articles in the magazine *L'Esprit Nouveau* where he calls for the demolition and rebuilding of the centres of all major cities. As Van Doesburg describes when reviewing Le Corbusier's plan for an ideal contemporary city in January 1925, the architect sees himself as a physician trying to heal the sick body of the city. His recommendation is for drastic action; it will be surgery rather than medicine to alleviate the most urgent condition of the city, the clogging of its road network – its cardiac system, as he puts it – with traffic. Le Corbusier's counter-intuitive idea is that the city will be able to breathe again if the centre becomes even more concentrated than it is at the moment. The solution is vertical: huge glass skyscrapers accessed 234 by a central airport. The suburbs need to be swept away and kept as green space and act as a lung for the city. Van Doesburg is only partly convinced and thinks he has a better proposal. Together with the Dadaist impresario Tristan Tzara, he has designed a viaduct city that will demonstrate all the new traffic possibilities. People are no longer travelling just at street level; there's the metro, and elevated trains and aeroplanes as well. He wants to make an enormous model of it to show at the *Exposition internationale des Arts décoratifs et industriels modernes* in Paris in the summer of 1925. Maybe he has got wind of Le Corbusier's intention to exhibit his *Plan Voisin* there, which shows 235 the entire historical centre of Paris erased and replaced by skyscrapers.

As it happens, it is only in 1929 that Van Doesburg gets the chance to put his plans on paper. They look quite different from Le Corbusier, 236 buildings that are merely ten rather than sixty storeys high. And they 237 are not concentrated in the centre; they spread out in all directions. 238 The entire structure of house, street and neighbourhood has been replaced by an endlessly repeatable system. It's all based on flow of traffic and services which can go in any direction, not impeded by plan

233 Van Doesburg in the garden of the studio in Clamart, just outside Paris, 1925-26. Photo from the collection of the Netherlands Institute for Art History (RKD), The Hague, Archive of Theo and Nelly van Doesburg. 'We also have a large garden right next to the studio,' Nelly writes to Antony Kok, 'and we can already tell that spring is on the way! It's just lovely here!'
234 Le Corbusier, *Plan Voisin for Paris*, 1925, pencil and indian ink on paper, 58 x 80 cm. Fondation Le Corbusier, Paris. In 1922, Le Corbusier sets to work on this plan for the total redevelopment of the centre of Paris. In the 1925 version of the plan, he claims that his centrally organised world can accommodate three million residents.
235 Le Corbusier, *Plan Voisin for Paris*, 1925, pencil and indian ink on paper, 58 x 80 cm. Fondation Le Corbusier, Paris. Aircraft can land in large squares that are directly linked to automotive and pedestrian routes.

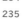

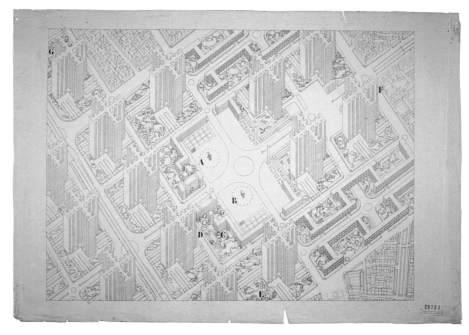

or structure. The buildings themselves are turned inside out so that service pipes and lifts are all on the exterior. The interior is left unspecified, perhaps clean and white and sterile as he so desired. While the plan looks inhuman, it expresses two key ideas that emerge from the Dutch experience. One is that decentralisation is key to modern urban development and, as a consequence, greater and greater height will not solve the problem. Le Corbusier's proposal is simply a garden city on a grand scale, in Van Doesburg's view, an old-fashioned approach. In his last public lecture, Van Doesburg goes even further against the Corbusian model and speaks out specifically against trying to cure the problem of cities by planning from scratch. The radical treatment of his nose he receives in 1928 to cure his hay fever did not work either.

236 Theo van Doesburg, *Study for* Cité de Circulation*, district with tower blocks, viewed from above*, 1929, pencil and indian ink on tracing paper, 63 x 63 cm. Collection of the NAi, Rotterdam, Van Doesburg archive.

237 Theo van Doesburg, *Study for* Cité de Circulation*, seven tower blocks, side view*, 1929, pencil and indian ink on tracing paper, 22.5 x 102 cm. Collection of the NAi, Rotterdam, Van Doesburg archive.

238 Theo van Doesburg, *Study for* Cité de Circulation*, eleven-storey tower block, side view*, 1929, pencil and indian ink on tracing paper, 39.5 x 66.5 cm. Collection of the NAi, Rotterdam, Van Doesburg archive.

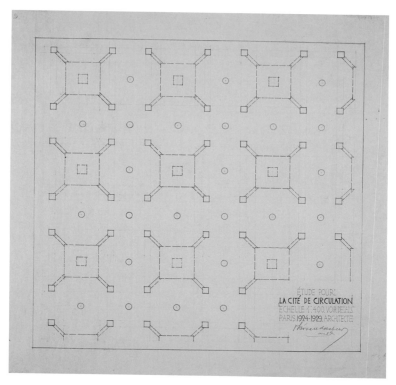

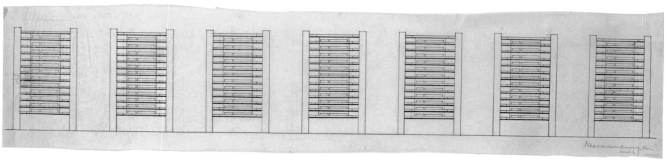

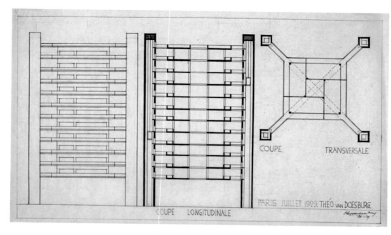

191

Vicomte Charles de Noailles loves art, and also flowers. He has bought a painting by Piet Mondrian at an exhibition in Paris in 1925, and has **239** hung it above a bed designed by Dutch architect Sybold van Ravesteyn. Charles had married Marie-Laure in 1923. For their wedding gift, his mother gives them a piece of land on which to build a 'little house'. Mies van der Rohe is too busy and Le Corbusier is being difficult. **240** Charles chooses the young architect Robert Mallet-Stevens. He has little experience as an architect, but showed – with great success – the core of Rosenberg exhibition again in Paris in 1925.

Charles is a society figure. If the Parthenon belongs to the Ancient Greeks, and Chartres to the Gothic, he says, the Palais Stoclet in Brussels belongs to the modern age. His uncle lives in this city palace **241** designed by Viennese architect Josef Hoffmann. A choice selection of the very best international designers and artists was brought in to realise this elitist fusion of art and architecture which in the Netherlands was referred to as *gemeenschapskunst*. Initially, the plan for the Vicomte is for a house with six bedrooms, but it ends up with sixteen, **242** plus an indoor pool, a squash court, a gym and a Cubist garden.

244 Eileen Gray and Pierre Chareau are asked to design the furniture.
243 Theo van Doesburg is commissioned to create a 'Salle des Fleurs', where Marie-Laure can arrange flowers every day. He is not involved any further in the execution of the plans. His design for the room is strongly influenced by the *Counter-compositions* of 1925: diagonal triangular planes cleave the space. Black and grey dominate, with accents in red for the ceiling, and yellow and blue at the tops of the walls. All separated by white. It is a logical follow-up to the destructive colour solutions used in Bart de Ligt's room in Katwijk six years earlier. There, too, five separate planes of colour contribute to the whole. Now everything has been cut into triangles and diagonals, continuity and discontinuity jostling for supremacy. It is a painting in three dimensions, which can only be viewed in time, while turning. The final result bears little resemblance to the design. In the drawing, Van Doesburg uses the latest form of projection. It must be viewed in such a way that the composition converges on the ceiling, seen from *outside*, and therefore in mirror image. The walls 'hang' from it: the side closest to the point of convergence is situated along the top of the space, along the ceiling, also seen from *outside*. Mallet-Stevens and the Noailles interpret the drawing incorrectly and accidentally execute it in reverse: the ceiling is rendered as a mirror-image; the walls are swapped round. Van Doesburg is blithely unaware of the fact. The Vicomte is unaware of the fact. He sends Van Doesburg a letter of thanks on 25 December.

239 Photograph of the guest room in the home of Vicomte Charles de Noailles, Hyères. Above the bed designed by Sybold van Ravesteyn is Piet Mondrian's *Tableau No. II avec noir et gris* (Painting No. II with Black and Grey), oil on canvas, 50 x 50 cm, now in the collection of the Kunstmuseum Bern, Switzerland. De Noailles purchases the painting at an exhibition in Paris in 1925. It is the only painting that Mondrian sells to a Frenchman in all the years that he lives in France. Photograph from the collection of the Netherlands Institute for Art History (RKD), The Hague, Archive of Theo and Nelly van Doesburg.

240 Photograph of the houses designed by the architect Robert Mallet-Stevens for Rue Mallet-Stevens in Paris in 1927. Photograph from the collection of the Netherlands Institute for Art History (RKD), The Hague, Archive of Theo and Nelly van Doesburg. Mallet-Stevens is impressed with the exhibition that Van Doesburg and Van Eesteren mount for the Galerie de L'Effort Moderne in 1924. 'Paris is not a city that can suddenly be taken by storm!' gallery owner Léonce Rosenberg warns them, but Van Doesburg believes that Rue Mallet-Stevens proves otherwise.

241 Photograph by the architect Josef Hoffmann of the Palais Stoclet in Brussels, an opulent mansion built between 1905 and 1911 and the leading example of the type of collaboration between a building's architect, painter and designer that comes to be known as *Jugendstil*.

242 The Cubist garden at the villa of the Vicomte de Noailles in the southern French town of Hyères, just after its completion by the architect

and landscape designer Gabriel Guévrékian (1890-1970) in 1928. Photograph by Thérèse Bonney.

243 Theo van Doesburg, *Colour design for the* Salle des Fleurs *(Flower room)*, 1924-25, pencil, ink and gouache on tracing paper, 55 x 61.5 cm. Collection of the Van Abbemuseum, Eindhoven, gift of Nelly van Doesburg, 1970. Because the architect and client misinterpret the drawing, the wall painting is not executed in the way that Van Doesburg had intended.

244 A chair designed by Pierre Chareau for the villa of the Vicomte de Noailles in Hyères, photographed in the villa in 2010. Photograph from the collection of the Villa Noailles, Hyères.

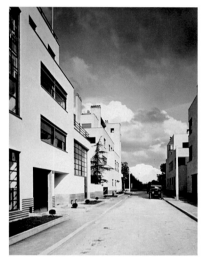

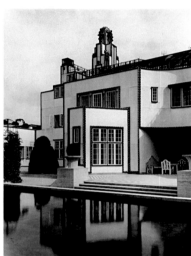

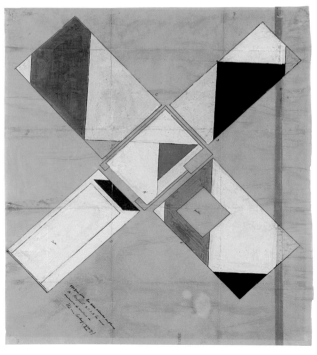

César Domela

(1900 Amsterdam – 1992 Paris)

Son of the anarchist and socialist leader Ferdinand Domela
Nieuwenhuis, he becomes an artist in order to wrestle free of his
father's overbearing ego. Lives on Monte Vérita near Ascona for a
few years, with artists who dance at sunrise, in search of spiritual
expansion and artistic development. He also travels to Berlin, where
he broadens his horizons and immerses himself in a world in which
actuality equals rigid stylisation, geometry and total abstraction. In
1925, in Paris, he quickly becomes familiar with the already diverging
artistic standpoints of Van Doesburg and Mondrian. In 1927 he
produces graphic designs and photomontages back in Berlin. He
again relates this experience to Neoplasticism by producing tense
geometric reliefs in various materials, on a quest to translate the
geometry of De Stijl into a spatial form. He also uses unconventional
materials that allow him to develop his own language independent
of De Stijl.

1924　　**César Domela**
　　　　　 (1900 -1992)

245 César Domela, *Composition néo-plastique 5a* (Neoplastic Composition 5a), 1924, oil on canvas, 58 x 58 cm.
Collection of the Triton Foundation.

Source
Til Brugman, 'Kunst en karakter' ('Art and Character'), *Kroniek van Kunst en Cultuur*, vol. 14, no. 5 (1953), pp. 114-115

245　'For Domela, there was no flash of lightning, no St Paul experience. It was the natural course of a process of spiritual growth, a gradual unfolding of thought and feeling. His current *tableaux-objets* are under-girded and in a sense prefigured by his earliest expressions. In terms of both form and content, the core of his work is already present there. […] There is joy in this work and it calls on us to rejoice. Its balance makes us want to search for balance in our own structures.'

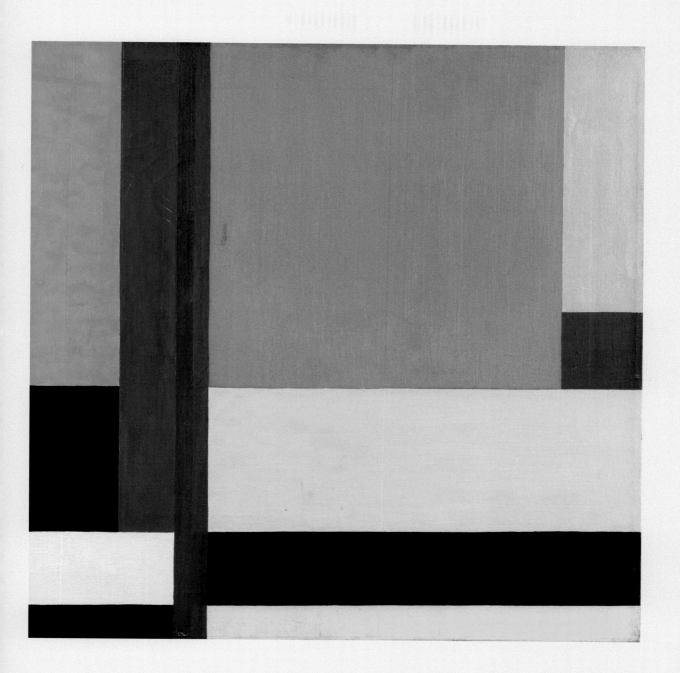

1927 26 'Not as sectarian as (the late!) "De Stijl".'
César Domela, Arthur Lehning, Piet Mondrian and *i10*

Home City Exhibition Street

The word has gone out that a new journal is in preparation. Its editor, Arthur (Müller) Lehning (1899-2000) is an anarchist writer and through the radical circles in which he moves he knows Bart de Ligt and Charley Toorop (1891-1955), the daughter of Jan Toorop, a great realist painter and intellectually engaged in every cultural debate in the Netherlands. He also knows César Domela (1900-1992), the young artist son of Ferdinand Domela Nieuwenhuis. Having left the Netherlands in 1921 to study in Berlin and then Vienna, in 1926 Lehning is living briefly in Paris and his friends recommend that he visit Piet Mondrian in his Montparnasse studio. Lehning meets Mondrian there frequently, or sometimes for a drink in the Café du Dôme, where they discuss the idea to launch a journal covering art, literature and politics. Mondrian puts him in touch with a number of former contributors to *De Stijl*, such as Vantongerloo and Oud. Despite the concerns Oud has about Lehning's political affiliations, he agrees to become editor for architecture. Rietveld is also going to join in, although he has some sympathy for Van Doesburg who is being deliberately kept out of discussions. Oud suggests that the journal be called *EEN* (ONE) which Lehning really dislikes. Mondrian is looking forward to it having broad content and being 'not as sectarian as (the late!) "De Stijl"'. But finding a name everyone can agree on is the first challenge. Lehning visits the Bauhaus in Dessau to recruit László Moholy-Nagy as his film and photography editor and tells him about the problem with Oud. In his opinion politics should definitely be included in the journal but he doesn't intend to represent any particular political direction, let alone the Third International, as Oud fears. Joking, he says that when all of those who are going to participate agree ideologically, he will be at the Tenth International. Moholy jumps up and shouts, 'I've got it! Let's call the journal *i10*'.

When Lehning returns to live in the Netherlands in the summer of 1926, preparations for the launch of *i10* begin in earnest. Domela is also back in Amsterdam and Lehning has him redesign his apartment on Karel du Jardinstraat in a manner one could call De Stijl, if it wasn't for the fact that he might be putting that particular journal out of business. Domela, who has only recently joined De Stijl, and has spent many enjoyable evenings with Theo and Nelly in Clamart, also designs the front cover of the new journal which Moholy-Nagy integrates with his overall graphic design. By the time of *i10*'s first issue in January 1927, Lehning has Van Eesteren and Huszár listed as contributors as well, and will soon be adding Bart van der Leck. Mondrian takes the opportunity of the journal's combination of art and politics to publish an article he has been planning for a while about Neoplasticism in society. It appears under the title 'Home – Street – City' (De Woning – De Straat – De Stad) and describes how people's lives will change entirely, starting from the transformation of the basic unit of dwelling and working outwards to the cityscape as a whole. What he calls the

246 Arthur Lehning and Charley Toorop at the top of the stairs, in the doorway to Leidsegracht 48 in Amsterdam, summer 1928. Photograph by John Fernhout, collection of the Netherlands Institute for Art History (RKD), Charley Toorop archive.

247 César Domela, *Composition néo-plastique no. 5 O*, 1926, oil on canvas, 103.5 x 82.8 cm. Kunstgalerij Albricht, Netherlands. As he works on this painting, Domela's admiration for both Mondrian and Van Doesburg pulls him in two different directions at once.

248 Arthur Lehning's study on Karel du Jardinstraat in Amsterdam, 1926, reproduced from the magazine *Vouloir*, 25 (1927). Lehning is working on a study of the Russian anarchist Bakunin and beginning to inventory the library of the socialist Ferdinand Domela Nieuwenhuis. He is also developing plans for a new periodical.

249 László Moholy-Nagy in his studio at the Bauhaus in Weimar, 1925. Photograph from the Bauhaus archive, Berlin. Moholy hopes that his paintings will change society. In Constructivism, he finds a utopian vision that can help him achieve this goal. His compositions become less static; he begins to work with aluminium and Perspex and to experiment with spray paint.

250 The cover of the first issue of *i10*, published in January 1927. The aim of the periodical is to report on the signs visible throughout Europe of a general cultural renewal, and to investigate the nature of the emerging culture. Lehning involves Europe's leading intellectuals in this effort. Collection of the Gemeentemuseum Den Haag.

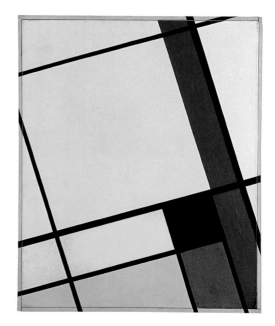

'refuge' of the home cannot and will not be any longer strictly separated from the world outside. In his view, the new, open society that has been born is mirrored in the 'denaturalisation' of the home, stripped of its 'rustic' appearance and decked out in smooth surfaces of 'pure' colour. The home will no longer be a closed 'box' but a construction of planes and colours continuous with the street and the metropolis beyond it. As an example, he illustrates his article with a photograph of his own studio, the space that impressed Lehning so much on his first visit, and explains how the idea of 'home, sweet home' must disappear. Despite the fact that *i10* seems far more directed at social reality, Van Doesburg derides it as 'vegetarian-spiritualist' and carries on with the planning of a tenth anniversary edition of *De Stijl* with contributions from all of its original members.

251

251 Piet Mondrian's studio on Rue du Départ, Paris, April 1926, photographed by Paul Delbo, Rue Vavin, Paris. Collection of the Netherlands Institute for Art History (RKD), The Hague, Mondrian archive. Among all these strangely positioned household objects (most of them from a pawn shop), mirrors, brightly coloured sheets of cardboard and real paintings, it is next to impossible for visitors to find their bearings in this world, which is nevertheless clear and organised.

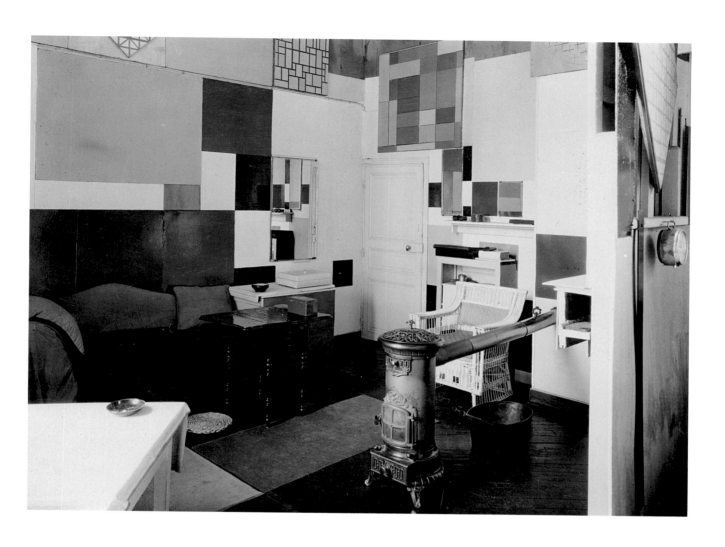

Friedrich Vordemberge-Gildewart
(1897-1962)

252 'Mr Van Eesteren regarded Vordemberge-Gildewart as one of the Stijl group, to which Mondrian and Van Doesburg also belonged. He has furthered the development of abstract art in a unique way. The task of absolute painting is the pure plastic expression of colour relationships, as that of architecture is the pure plastic expression of volume relationships. Absolute painting creates its own forms (according to Kandinsky) and, for those sensitive to the visual, this abstract painting opens a new world of sensation. One should not think on viewing this exhibition of decorative ornamentation; these paintings also emerge from creative concentration.'

252 Friedrich Vordemberge-Gildewart, *Komposition Nr. 31*, 1927, oil on canvas, in a wooden frame painted in an aluminium colour, 100 x 130 cm. Gemeentemuseum Den Haag, acquired 1966.

Source
C. van Eesteren, quoted in 'Opening tentoonstelling Vordemberge-Gildewart. Het beelden als het eigenlijke van de kunst', *Het Vaderland*, 4 December 1938, morning edition B

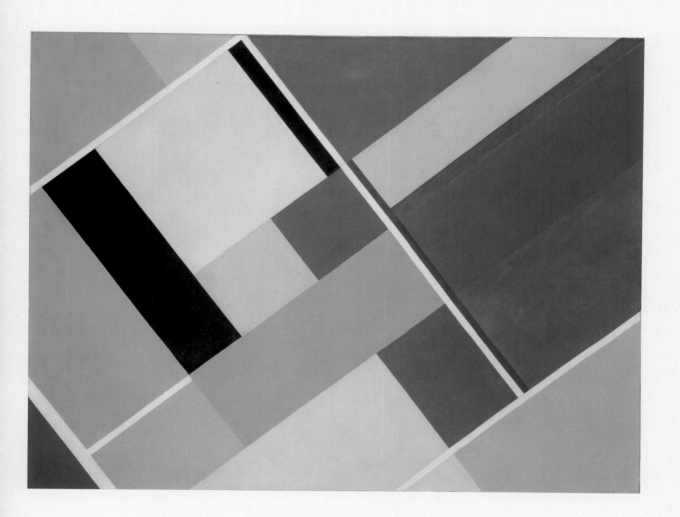

Vilmos Huszár is getting impatient. It is months since he agreed with
Oud to contribute to *i10*. He wants to write about his latest work in
advertising and he has sent Oud images of the billboard posters he has
been making for Miss Blanche cigarettes but they have yet to appear
in the journal. Fortunately, he has a visit from Domela who offers to
introduce him to Arthur Lehning directly and the two of them head off
the next day to Amsterdam to confront the editor in person. Huszár is
worried that by the time the images appear in the journal, they will
already look out of date. He might also be conscious that what he is
doing is highly original and wants to get it into print as soon as possible.
His idea is that advertising can be fine art. Even more so, this is the
answer to the question of public art that has so obsessed Dutch artists
since the end of the last century. 'Whoever believes in "Art for the
People", has no better means of achieving his aim than advertising art',
he explains.

The Vittoria Egyptian Cigarette Company has employed Huszár for
over a year now to design their Miss Blanche cigarette packaging
and advertising. The image he provides is of a confident and strikingly
modern young woman whose bright red coat and blue glove are
reduced to basic flat shapes set against an intense yellow background.
The text is in English to give the appearance that Miss Blanche is
American and she has some of the look of the Gibson Girl brand
manufactured by the German company Manoli. The reality is that
the cigarettes are being made on the Admiraliteitskade in Rotterdam.
In 1926 a national poster campaign is launched. The pier at
Scheveningen is full of boards covered with Miss Blanche adverts.
Some of them simply have the name of the product and a few coloured
rectangles. Elsewhere in The Hague, Huszár produces one-off wall
paintings, such as on the side of the tenement building 'Concordia'
on Scheepmakersstraat, not a very prestigious location but one that
can be seen clearly from the adjacent canals.

The authorities in Amsterdam are less keen on Huszár's designs
though and have banned them from buildings, stating that they may
only appear on hoarding panels. As Huszár writes in *i10*, 'One has to
deal with various authorities, such as city officials, and they want every-
thing carried out with too much "taste" (most modern artists are anti-
aesthetic, in the sense of tasteful) without having any *objective* insight;
they consider advertising as decoration and pay no attention to its
function.' Piet Zwart, who since their public debate in 1919 has often
worked together with and become friends with Huszár, is baffled
why someone would approve of a perspectival picture of a packet
of cigarettes on a building but object to Huszár's flat designs which
work with rather than against the buildings on which they are placed.
He contrasts a Miss Blanche poster with one for aspirin to make his
point. Is it just that the officials have a problem with abstraction?

253 Advertisement for Miss
Blanche cigarettes by Vilmos Huszár.
Photo-graph from the collection of
the Gemeentemuseum Den Haag.
Clean, minimalistic design clearly
communicates the message and
reflects the spirit of the new age.
254 Jan Toorop, *Poster for the Delft
salad oil factory NOF*, 1895, executed
by S. Lankhout & Co., The Hague,
lithograph, 87 x 66.5 cm. Collection
of the Gemeentemuseum Den Haag.
For a long time, many artists
continue to see poster art as an
extension of printmaking.
255 Postcard of the pier in
Scheveningen, 1926, showing the
signs for the national Miss Blanche
poster campaign. Collection of the
Gemeentearchief Den Haag.
256 Photograph of the pier in
Scheveningen, 1926, showing the
signs for the national Miss Blanche
poster campaign. Collection of the
Gemeentearchief Den Haag.
257 Vilmos Huszár, *Poster for
Miss Blanche cigarettes*, 1926,
litho, 70 x 59.7 cm. Collection of
the Stedelijk Museum Amsterdam.
Huszár derives his colours, which
tend towards the sharpest, most
intense possible contrasts, from the
visual idiom he developed ten years
earlier with his artistic collaborators.

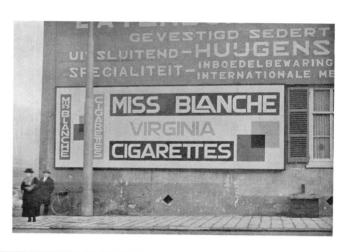

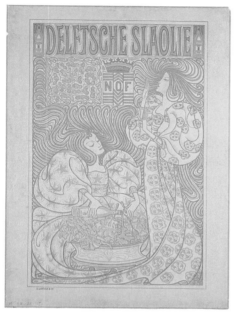

Scheveningen. Wandelhoofd Wilhelmina

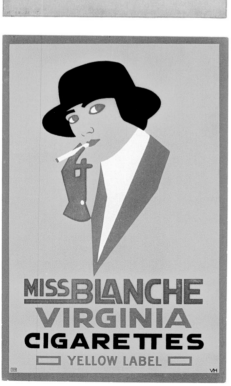

205

Does there need to be a picture, no matter how poor quality it might be? Huszár's claim that advertising can be fine art is certainly based on putting an end to so much 'kitsch'. He sees no difference between making adverts and monumental art. The De Stijl principle of bringing together art and architecture is here writ large across the streets of the city, albeit for commercial ends.

258 Photograph of the enormous wall painting produced by Vilmos Huszár on the side wall of Concordia, a tenement building on Scheep-makersstraat. The fact that the press has photographed the painting shows that it is news; Huszár's work has aroused public interest. Collection of the Gemeentearchief Den Haag.

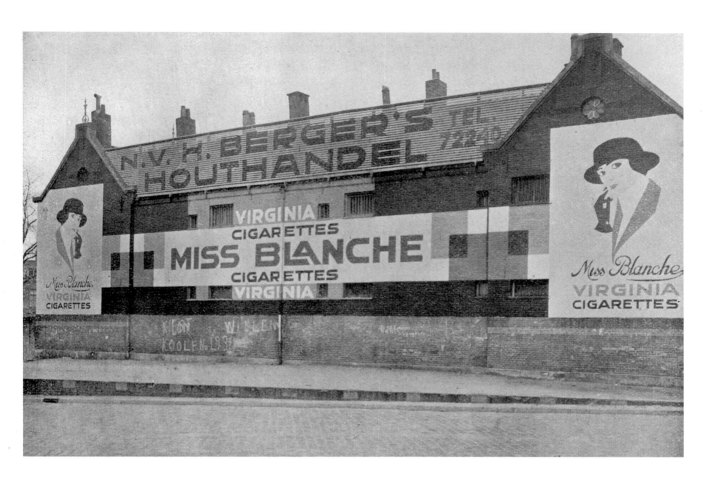

259 Van Eesteren is giving his slide lecture, 'One Hour of Town Planning', in the Martin Gropius Bau in Berlin. It has developed from the course on urban design he has been teaching since 1927 at the Staatliche Bauhochschule in Weimar. He tried the lecture out for the first time in Rotterdam last year when speaking to the *Opbouw* (Construction) group of architects and then gave it again in Stuttgart at the time of the Werkbund exhibition there.

A journalist writes that it consists of 'pithy, brief comments on a long series of photographs, plans and statistics, a movie that filled the whole evening'. Certainly Van Eesteren prefers to make his argument visually rather than through words; he has pictures of all kinds of cities in various stages of growth, from the earliest settlements and medieval towns to the skyscrapers of New York and contemporary traffic problems.

Again and again he contrasts 'organic order' of earlier times with 'modern chaos'. Attempts to redesign the city have merely covered over the muddle, he argues. Photographs taken from tall buildings, such as the Eiffel Tower, reveal the ramshackle division of building plots behind the elegant façades facing the boulevards. What is required is a 'scientific' rather than an 'artistic' approach to the issue.
260 Diagrams showing volume and direction of traffic demonstrate how
261 congestion is created. People are moving away from city centres at
262 the same time that business is being concentrated there.

For this particular audience, he includes a special section on the changes to the centre of Berlin from medieval to modern times, culminating with his own plan for its most famous street, Unter den
263 Linden. The task is to balance preservation of historical monuments, such as the Brandenburg Gate, with the need for new office space, high-rise structures and motor-vehicle access.

Van Eesteren also has a few slides of Amsterdam, showing such things as the development of its canal structure and the recent explosion in its population, which has trebled in the last fifty years. He shows Berlage's expansion plan with the comment 'how chaotically the city renovates itself'. When he publishes a short summary of his lecture in *i10* (originally titled 'Five Minutes of Town Planning') he again criticises the Amsterdam expansion, which he mocks as 'stage set city planning'. According to Van Eesteren, people today want the truth 'even if it is ugly', an obvious attack on the 'aesthetic committee' which has overseen all construction in the capital during the last years.

His critique comes at an auspicious moment as political change in the Amsterdam council leads to a radical shake-up in the Office of Public Works and the creation of a Department for City Planning and

259 Cornelis van Eesteren presents his analysis of Amsterdam at the fourth CIAM conference in July 1933, on the packet boat *Patris II* that transports the conference-goers from Marseilles to Athens and back.
260 W. Hegemann, 'Comparative Analysis of Traffic in London, New York, Paris, Berlin, Chicago, Philadelphia and Boston', from *Der Städtebau: nach den Ergebnissen der allgemeinen Städtebauausstellung in Berlin*, 1910. Here, quantitative analysis becomes a key tool in establishing a cohesive urban-planning discipline.
261 London, 1930.
262 Berlin, 1931.
263 Cornelis van Eesteren, Design competition entry for the reorganisation of Unter den Linden in Berlin, 1925. Photograph from the collection of the NAi, Van Eesteren archive. The question for the competition is: 'How should Berlin's most important street develop over the 20th century?' Rather than settling for half-measures, Van Eesteren proposes to demolish almost everything and start over. His entry wins first prize.

259 260
261 263
262

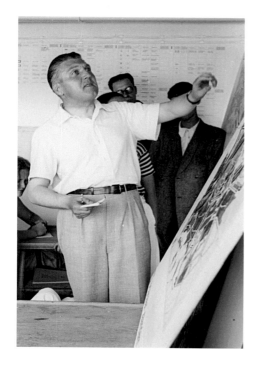

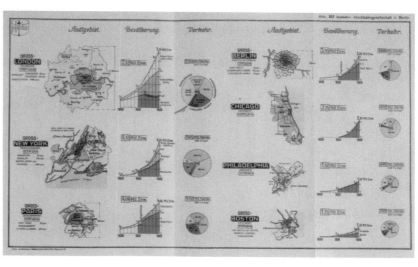

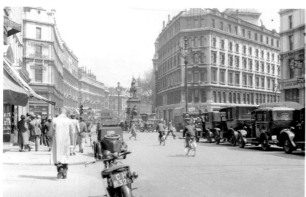

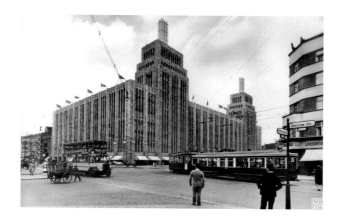

Expansion in which Van Eesteren will begin employment in May 1929. His first job is to design the Western expansion of Amsterdam and he begins with a new road plan, putting transport rather than buildings at the heart of the scheme. He presents the proposal in a lecture to the architects' group *de 8* in March 1932 very much in the form of his earlier slide presentation, although this time the 'movie' is made up not of images of Berlin, New York or Paris but all the intersections, junctions and highways of the outskirts of Amsterdam.

264

265

264 Amsterdam sample map II, December 1931, on which the Department for City Planning and Expansion has indicated different types of road links, in preparation for a final diagram of traffic improvements in the city centre. Photograph from the collection of the NAi, Rotterdam, Van Eesteren archive.
265 Amsterdam sample map III, March 1932, which reflects definitive agreements about regional transport infrastructure between the Amsterdam Housing Department, the Department for City Planning and Expansion and the Dutch CIAM group. Photograph from the collection of the NAi, Rotterdam, Van Eesteren archive.

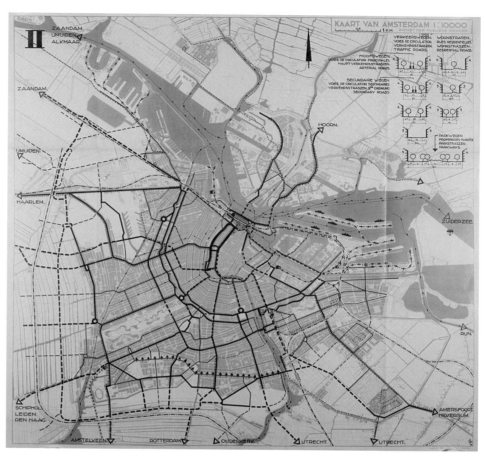

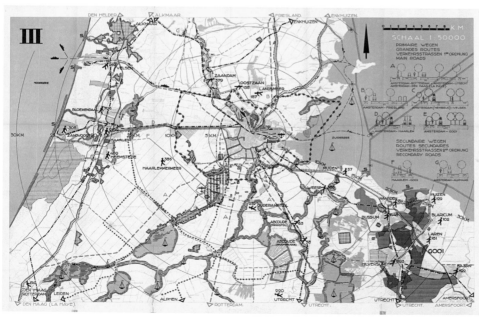

Nelly van Doesburg

(1899 The Hague – Meudon 1975)

Runs away from home on New Year's Eve 1920 when her 'strict
Catholic' parents condemn her relationship with Theo van Doesburg.
She is keen to find her own way. Plays contemporary piano at the
Dada evenings, and also builds up a career performing modern
piano music, giving concerts in cultural centres throughout Europe.
She also appears in variety theatre in Paris to support herself and
Van Doesburg. She advises Van Doesburg on all his activities, deals
with his correspondence, makes contacts and organises exhibitions.
After Van Doesburg's death Nelly devotes herself to keeping his
memory alive. Her activities quickly result in the first brilliantly
managed marketing campaigns in the visual arts. With exhibitions,
books, interviews and strategic sales of paintings, she knows how to
convert her role of 'co-conspirator' to that of key witness to a coherent
movement that would change modern art forever.

In February 1928 the grand reopening of the Aubette takes place. It is
an enormous eighteenth-century building in the centre of Strasbourg
which was once a barracks but was used more recently as a café and
concert hall. After being badly damaged by fire during the Franco-
Prussian war in 1870, it has been largely derelict but has now been
brought back to life through the entrepreneurship of the brothers Paul
and André Horn. Together they run an architectural firm and are also
extremely keen collectors of contemporary art. The new Aubette build-
ing, which incorporates cafés, bars, restaurants, cinema and dance
halls, is both an exciting entertainment complex and a work of art in its
own right, as they have commissioned Jean Arp, Sophie Taueber-Arp
and Theo van Doesburg to design the interiors; Arp's basement café
features his strange biomorphic shapes, Taueber-Arp's tea room and
foyer bar are much more geometric and abstract, using colours and
shapes inspired by the wall paintings of Pompeii, while among Van
Doesburg's contributions, his cinema dance hall stands out for its
striking use of diagonal forms which break open the rigid box of the
room.

266
267
268
269

270
271

Taueber-Arp was supposed to be in charge of the project but Van
Doesburg has taken the lead with many things. This is his first chance
to work on a large public building project in years, after all the dis-
appointments of his collaborations with Oud and Wils. He wants to
give the building, made up of so many different spaces, an overall
identity. His idea is that it should be a building which visitors move
through continually rather than just staying in one part. He even thinks
that you should be able to continue to watch a film in the cinema
dance hall while walking around and going to fetch a drink from the
bar. In order to assist the public in orientation he has devised a sign
system which accords each of the sixteen different spaces of the build-
ing an individual symbol. A large panel will greet visitors as they enter
the building indicating where to find the place they are looking for,
much like a department store. The lettering Van Doesburg uses is a
variation on the typography he designed in 1919 which uses only
capital letters of a square shape.

272

The Horn brothers have acquired the Aubette on lease from the
municipality and one of the conditions is that the exterior cannot be
altered. It is a protected historical monument. Van Doesburg runs into
trouble with his plans to run neon signs along the entire length of the
façade which looks onto the Place Kléber. He does manage to install a
smaller set of signs though, using the same stark and rigid typography,
which lists a number of the attractions to be found inside such as a
cabaret, tea room, patisserie and billiards. When the neon is lit up
at night, one can almost overlook the pompous, classical exterior
which conceals the jazzy, geometric, colourful inside. However, Van
Doesburg's insistence on a 'severe' appearance for the signs reflects

273
274

266 Jean Arp, *Sériegraphie d'après
une maquette pour l'Aubette
(Lithograph after a design for the
Aubette complex)*, 1965, lithograph,
26 x 52.8 cm. Collection of the
Musées de Strasbourg. The litho-
graph shows the left side of the wall
painting with which Arp decorated
the *caveau-dancing* (dance hall in
the cellar).

267 The *caveau-dancing* in the
basement of the Aubette complex in
1928. Photograph from the collec-
tion of the Netherlands Institute
for Art History (RKD), The Hague,
Archive of Theo and Nelly van
Doesburg. The ceilings are painted
dark blue and the walls grey,
probably to create an oceanic or
nocturnal atmosphere, in stark
contrast to the enormous, golden-
yellow 'toadstool trees' on the walls.

268 *Salon de thé-Pâtisserie 'Five
O'Clock'* at the Aubette complex,
1928, with decorations by Sophie
Taueber-Arp. Collection of the
Musées de Strasbourg. As early as
1920, Sophie Taueber-Arp is making
watercolours with loosely stacked,
four-sided, brightly coloured forms.

269 Sophie Taueber-Arp, Design
for the *Aubette-bar*, 1927, pencil and
gouache on paper, 22 x 72.5 cm.
Collection of the Musées de
Strasbourg. This version uses silver
and gold leaf and leads the viewer
'into the plastic form', rhythmically
organised by colour and non-colour.

270 Interior of the *ciné-dancing* in
the Aubette complex, 1928. Photo-
graph from the collection of the
Netherlands Institute for Art History
(RKD), The Hague, Archive of Theo
and Nelly van Doesburg. The large,
diagonal areas of colour are highly
disorienting. The effect is quite over-
whelming.

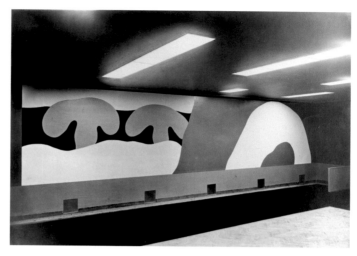

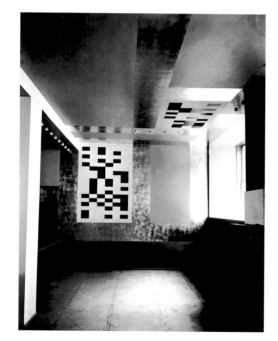

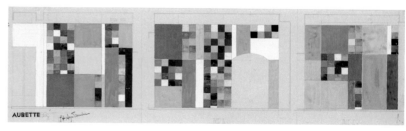

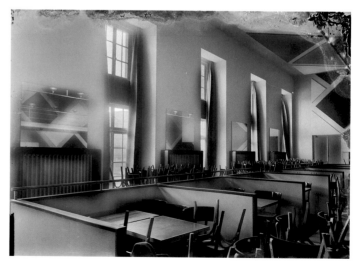

215

his attitude to the use of the building as a whole. While Arp and Taueber-Arp leave Strasbourg almost immediately after the opening, he stays on to work on André Horn's apartment and is witness to the cool reaction to what he has euphorically just termed 'the beginning of a new era in art!' The waiters have started to put artificial flowers and coloured lights around the place to make it cosier. 'The public is not ready to leave its "brown" world and stubbornly rejects the new "white" world', he writes despondently to a German architectural critic.

271 Interior of the *ciné-dancing* in the Aubette complex, 1927. Photograph from the collection of the Netherlands Institute for Art History (RKD), The Hague, Van Doesburg archive. Here Van Doesburg poses in front of the decorative project he has just completed, the largest one that he will ever carry out. Seated casually on one of the dividing walls, he looks every inch the proud artist.

272 Theo van Doesburg, *Draft design for the* table d'indication *(signpost) for the Aubette complex*, 1927, pencil and gouache on tracing paper, 92 x 27 cm. Collection of the Centre Georges Pompidou, Musée national d'Art moderne, gift of the State of the Netherlands. Van Doesburg designs this signpost to be displayed on the wall to the left of the entrance. Each room is to be marked with the corresponding number. The plan is never carried out.

273 Theo van Doesburg, Sophie Taueber-Arp and Jean Arp in Place Kléber in front of the Aubette complex in Strasbourg, spring 1927. Collection of the Netherlands Institute for Art History (RKD), The Hague, Archive of Theo and Nelly van Doesburg.

274 Neon lettering on the façade of the Aubette complex by night, 1928. Collection of the Netherlands Institute for Art History (RKD), The Hague, Archive of Theo and Nelly van Doesburg. 'At first, I wanted the entire façade to be dominated by neon advertising, but the city authorities refused permission.' Van Doesburg is forced to limit himself to the edge of the long terrace roof that extends over the entire length of the façade.

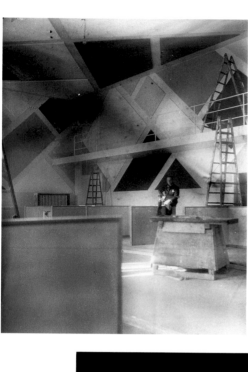

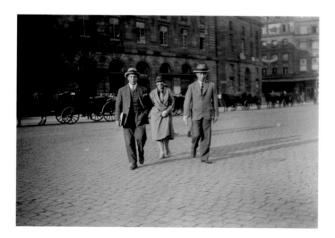

217

Bart van der Leck
(1876-1958)

275 'The truth, the psychological truth, is always altered to fit man's relationship to the universe. – As the truth is altered, so art is altered, and the difference between modern truth and what went before is as great as the difference between the form of modern art and what went before. The modern form, i.e. the form that is consistent with the modern view of the eternal, is exclusively for modern man and, having evolved from old creeds and beliefs, cannot satisfy those who have not arrived at a modern way of life. But a true modern, who manages to make contact, will welcome the new form as the embodiment of his own perception of the truth.'

275 Bart van der Leck, *Woodcutters*, 1922, oil on canvas, in a wooden frame covered with oil paint, 140 x 165 cm. Gemeentemuseum Den Haag, long-term loan from Wibbina Stichting 1947.

Source
Bart van der Leck, *Tentoonstelling van werken door B. van der Leck*, Utrecht (Vereeniging Voor de Kunst) 1919, n.p.

219

In honour of their hostess, Madame Hélène de Mandrot, the conference-goers organise a fancy-dress party at La Sarraz castle near Lausanne on the evening of 28 June 1928. All 28 artists and critics – all men – are dressed in amusing costumes, or at least as amusing as possible with the means at their disposal. After three days of debate, it is time for some fun.

276

What was the reason for the conference? Was it the competition for the new League of Nations building in Geneva? Le Corbusier was the preferred candidate of the international jury chaired by Berlage. But the influential French conservative architect Charles Lemaresquier had managed to torpedo the entry. At La Sarraz, Le Corbusier was seeking a platform for his vendetta, which tied in nicely with the militant battle for a 'modern architecture in keeping with the times' in Germany. Down with conservatism! The 'Nieuwe Bouwen' requires a radical clear-out. Functionalist-inclined architects like Mart Stam and Hans Schmidt establish a journal in Switzerland, *ABC Beiträge zum Bauen* (ABC. Contributions to Building), in which they air their 'Activist-Architectural-Collectivist' ideas.

277
278

279

The Dutch are represented by Stam and Rietveld. The international vanguard relies on that which the designer of the Rietveld-Schröder House and others have set in motion. Van Doesburg is not invited. Van Eesteren is unable to attend and Oud is suffering from stress. This is a pity, because they in particular were the ones who remained loyal to the views of De Stijl after they broke with Van Doesburg. The year before, Oud had noticed how Berlage rejected him, while he himself believed that he had further developed Berlage's lessons.

280

The debates at the *Congrès préparatoire international d'Architecture moderne* grow heated on the day of the costume party. A small group of architects are considering 'General Economics', another group are looking at 'Urbanism'. Berlage gives the latter group a lecture entitled 'The State and Conflict in Modern Architecture' in which he demonstrates how the issue is being tackled in the Netherlands. The contrasts that radical architects create do not exist there. Everything is consistent with modern life. The French and German architects, in particular, get into fierce arguments. The German version of the final declaration that is being prepared at the time of the party on the evening of the 28th presents a completely different view of urbanisation than that propounded by the French. The difference of opinion can be traced back to the role of the architect. For Le Corbusier, the architect is a technician, working alongside industry to consign the old urban planning traditions to the dung heap of history. The German version tends more to consider how the architect can be used in the production process alongside the artist – as in De Stijl. Berlage keeps out of the debate. All the excitement among the young architects is not to

281

276 Le Corbusier (centre) with the architecture critic Sigfried Giedion and the architect Gabriel Guévrékian at a costume ball following a three-day conference in June 1928. Tensions have been running high, so it is an excellent time for a party. Photograph from the collection of the Fondation Le Corbusier, Paris.
277 Le Corbusier, Entry for the design competition for the Palace of the League of Nations in Geneva, 1927, collotype on paper, 84 x 59.2 cm. Collection of the Fondation Le Corbusier, Paris. The odd site, wedged in between Lake Geneva and the mountains just behind it, seems poorly suited to a monumental vision. Le Corbusier opts for a delicate concrete structure on poles.
278 Le Corbusier, Entry for the design competition for the Palace of the League of Nations in Geneva, 1927, pencil and collage on paper, 37.6 x 50.7 cm. Collection of the Fondation Le Corbusier, Paris.
279 Cover of the first issue of the second volume of *ABC Beiträge zum Bauen*, the periodical published by Hannes Meyer. Collection of the NAi, Rotterdam. This periodical will become a major platform for what will soon be labelled functionalism.
280 Group photograph of the participants in CIAM's founding conference, June 1928. The second from the left in the top row, against the wall, is Mart Stam; the third from the left in front is Gerrit Rietveld. H.P. Berlage is missing from this picture. Photograph from the collection of the Eidgenössische Technische Hochschule Zürich – gta Archiv – Departement Architektur Institut für Geschichte und Theorie der Architektur.

276
277 279
278 280

Beiträge zum Bauen Serie 2 No. 1
Adm. Augustinergasse 5 ÷ Basel

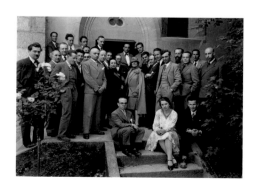

his liking. To him, it smacks too much of syndicalism and the extolling of individual heroics. High-rise building. The functional city. They contain nothing of the 'organisation of purposes' he propounds, based on the endless Dutch search for solutions until consensus is reached with the help of all parties – called in Dutch 'polderen'. But he does sign the declaration. A group photo is then taken, to show posterity that everything ended well.

282

281 H.P. Berlage, Aerial view of *Plan Zuid* from above the Berlage-brug, 1915, pencil and colour pencil on paper, 135 x 153 cm. Collection of the Gemeentearchief Amsterdam, Topografische Atlas. At the conference in La Sarraz in 1928, Berlage argues that no other city in the world shows such perfect harmony between architecture, the city plan and government policy as Amsterdam.

282 Group photo of the reception following the conference in La Sarraz, June 1928. Photograph from the collection of the Eidgenössische Technische Hochschule Zürich – gta Archiv – Departement Architektur Institut für Geschichte und Theorie der Architektur. Just to the left of the hostess in the middle is H.P. Berlage, wearing a serious expression. On the right we find Mart Stam (inexplicably wearing a Chinese lantern on his head) next to Gerrit Rietveld.

AMSTERDAM ZUID GEZIEN VAN BOVEN DE ZUIDERBRUG

Mart Stam

(1899 Purmerend – Zurich 1986)

Teetotaller who wants to 'create a new world' as a furniture maker. His neighbour in the village, J.J.P. Oud, knows how to channel his ambitions, and, as an architect, Stam designs in the De Stijl mode, developing radical functionalist ideas: 'A nut is angular – we know why'. But it is a puzzle to Stam why functional objects (stations, conference centres, transformer substations etc.) have to become theatrical monuments. Comes into contact with Van Doesburg via Lissitzky, in 1922. The association does not last long, as Stam refuses to go along with the editor of *De Stijl*. In Zurich, he establishes the journal *ABC Beiträge zum Bauen*. This brings him into contact with the leading architects in Europe. He is invited to contribute to the Weissenhofsiedlung in Stuttgart, a project in which the most prominent architects are asked to construct dwellings of modest expense, and develops the idea of a tubular steel chair with no back legs. Helps design the Van Nelle factory in Rotterdam, and is involved in establishing the CIAM in 1926. Travels to Russia to help build Stalin's dreams. When the political situation gets too hot for him there in 1934, he returns to the Netherlands, where he continues to dream of merging art with society.

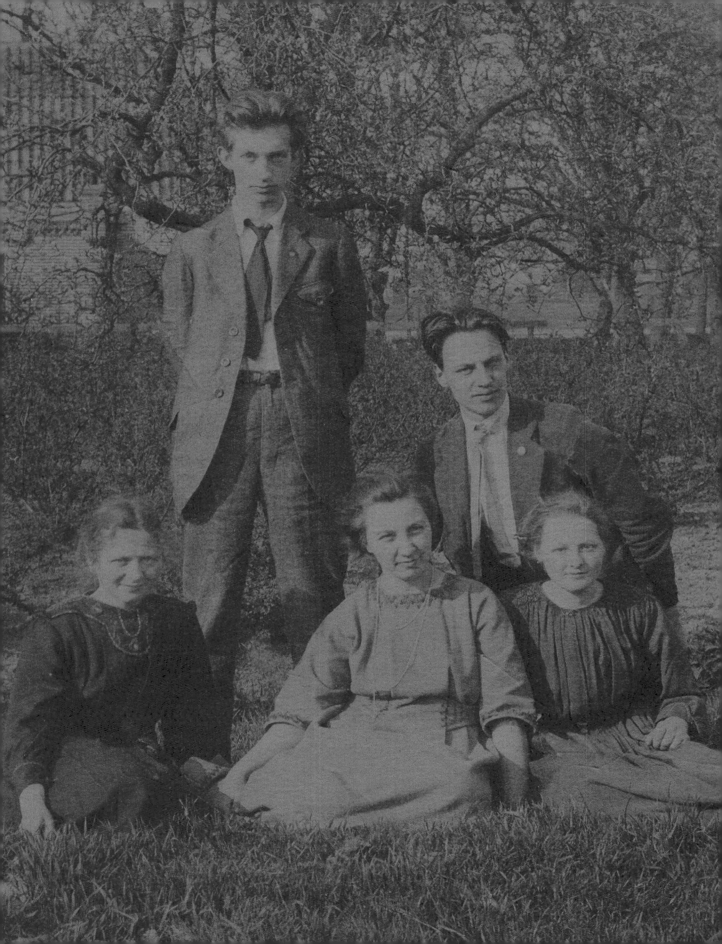

1937 **Georges Vantongerloo**
 (1886-1965)

283 'Art has no dimension; by nature it is like time and space. To determine space, one is obliged to take a point of reference; and in relation to a volume, situated in space, one is able to determine the relation of another volume. This done, one can also determine time. Volumes, in relation to one another, imply the notion of space, and the distances separating volumes from one another imply the notion of time. For the notion of *art*, we can determine only an aesthetic feeling. We obtain the notion of art through a so-called work of art. A work of art is one of the numerous solutions of what we represent as art. A work of art never contains all possible solutions. Aesthetic is our name for the form a solution has taken. And we call the feeling we receive from this form, *art*.'

283 Georges Vantongerloo, *Intervalles* (Intervals), 1937, oil paint on Triplex, mounted on a white-painted, receding wooden frame, 53.3 x 88.8 cm. Collection of the Triton Foundation.

Source
Georges Vantongerloo, 'Reflections VI (Paris 1930)', *Problems of Contemporary Art. Georges Vantongerloo, Paintings, Sculptures, Reflections*, New York (Wittenborn, Schultz, Inc) 1948, pp. 38-39

227

The train is en route to Stuttgart, sometime in November 1926. In the dimly lit carriage, two men are engaged in a lively discussion. Mart Stam has just been to the Bauhaus in Dessau. They had invited him for a job in the architecture department they are about to open, but it came to nothing.

He is full of enthusiasm for a chair he and El Lissitzky had seen at Gerrit Rietveld's in Utrecht. It was in fact a chair made of steel gas pipes and woven leather bands secured by rivets. The pipe structure was held together using right-angled and T-joints – such a fabulous modern innovation. An entirely new design, based on modern materials and techniques.

The other man in the carriage is Marcel Breuer, who runs the Bauhaus furniture workshop. He is very interested; he has been experimenting for some time now with making furniture from bent steel tubes. It is robust and modern, and with a few clever adjustments it could be just as suitable for mass production as the roundwood furniture with which Thonet dominates the market.

Stam actually wants to produce a chair with no back legs, by connecting ten steel pipes of equal length using nine right-angled joints. The benefit of such a structure lies in its simplicity, but also in the fact that a chair of this design is slightly springy and that would be something for his newly pregnant wife. Breuer has just developed an occasional table which, if turned on its side, would actually be such a chair without back legs. Having arrived in Stuttgart, during dinner at the Hotel Manquart, Stam sketches a design for the chair for his dinner companions. He has it all worked out. The chair is as good as made.

The tubes would have to be thicker, though. Stam is as yet unaware of this fact: the prototype will collapse under him. So the tube will have to bend, no joints. Or a solid piece of steel will have to be fixed in the bend.

Two years later, in fact, an exhibition is staged on 'Der Stuhl' – again in Stuttgart. The future belongs to tubular furniture, and to Mondrian's art. Both Breuer and Stam have submitted a chair without back legs. It is not long before they are taken to court. It appears that Breuer had already transferred the patent for his chair to the firm Standard-Möbel on 30 July 1928. The same company also bought the rights to use Mart Stam's design on 18 June 1929. Breuer also has a contract with Thonet in Vienna, which continues to develop the design until it is marketed in 1929, when they take over Standard-Möbel. In the meantime, the owner of Standard-Möbel has set up a new firm, Desta (Deutsche Stahlmöbel), however, which exploits Stam's rights. The two firms, Thonet and Desta, both claim copyright. After a court battle lasting years, Desta wins the case. The main argument is that Stam's

284

285

286

287

288

289

290

284 Mart Stam with the smartly dressed Russian artist El Lissitzky (1890-1941), on a visit to Gerrit Rietveld and Truus Schröder in their new house in 1926. Photograph from the collection of the Rietveld-Schröder archive, Utrecht. 'He is not a credentialed architect but a furniture-maker,' Lissitzky later writes, 'and he cannot simply dash off a technical drawing. He works with rough models, feeling things with his hands, and so his square is not abstract.'
285 Gerrit Rietveld, *Armchair*, 1926, steel, leather and wood, 118.5 x 72 x 84 cm. Collection of the Gemeentemuseum Den Haag, on long-term loan to the Centraal Museum, Utrecht. Rietveld makes this chair for A.M. Hartog, a family doctor in Maarssen. It is the first, experimental piece of tubular furniture designed by Rietveld.
286 Marcel Breuer, *Chrome-plated tubular chair*, 1926-28, chrome-plated iron, wood and wicker, 83 x 45 x 45 cm. Collection of the Gemeentemuseum Den Haag. For Breuer, who has been experimenting with metal furniture since 1925, function is only half the story when it comes to household objects. The other half relates to our urge to lead our lives as clearly and directly as possible, and the role of beauty in that effort should not be under-estimated.
287 Theo van Doesburg, *Working drawing of a stool for Café-Brasserie and Café-Restaurant* L'Aubette *in Strasbourg*, pencil, indian ink and yellow gouache on tracing paper, 27 x 67 cm. Collection of the NAi, Rotterdam, Van Doesburg archive. The wood-bending technique mentioned by Van Doesburg in his

working drawing makes this chair sound very similar to the most popular chair of all time, Thonet's *No. 14 Chair*.

288 Mart Stam, *Prototype of the first piece of tubular furniture*, 1927 (reconstruction), dimensions unknown. Although Stam is known as an 'Anti-Art-Super-Functionalist', it is amusing to speculate as to how this open Communist sympathiser, who felt most at home on the far left of the socialist movement, might have come up with the idea of designing a tubular chair.

289 Mart Stam, *Cantilever chair*, model 263, produced by Gebrüder Thonet AG, 1932, metal and wood, 47 x 37 x 39 cm. Collection of the Gemeentemuseum Den Haag.

290 With Mart Stam's help, it proves possible to bring together nineteen abstract works by Mondrian for 'Der Stuhl', an exhibition of one hundred ultramodern chairs in Frankfurt. The paintings and chairs are displayed side by side, in a celebration of the triumph of modernity. Photograph reproduced from the April 1929 issue of *Das Neue Frankfurt*.

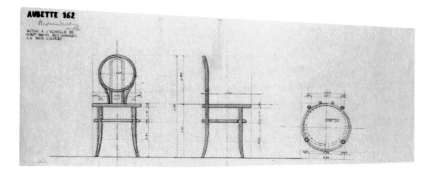

AUBETTE 162

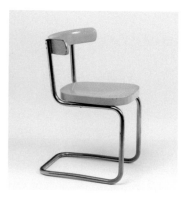

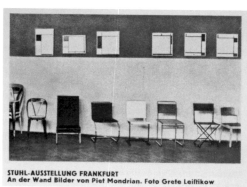

STUHL-AUSSTELLUNG FRANKFURT
An der Wand Bilder von Piet Mondrian. Foto Grete Leiftikow

chair is not a technical innovation, but an independent artistic design. Breuer's chair may be better in technical terms, but his was not an independent creation, not a work of art. Working for humanity is a fine thing, but a copyright turns out to be more useful than a patent. For his part Rietveld uses the developments in bent-metal furniture construction to produce a commercial version of his Red/Blue Chair sold by the Amsterdam shop Metz. Laughing at Stam and Breuer from the sidelines, he also creates his 'structural joke', another chair without back legs, the Zig-Zag Chair, made from just four inch-thick planks of Bruynzeel board. Metz also puts the chair into production and sells it alongside Rietveld's self-assembly 'crate furniture' at a far more affordable price than those of Breuer and Stam.

291

291 Gerrit Rietveld, *Zig-Zag Chair for the Jesse Family*, 1944, wood, multiplex and paint, 113 x 60.5 x 60.5 cm. Collection of the NAi, Rotterdam, on long-term loan to the Centraal Museum, Utrecht. Rietveld makes this high chair for the child of a good friend. Despite its impersonal design, the Zig-Zag Chair for adults was intended as a 'constructive joke', according to Rietveld. In a play on words, he calls it *een schotje in de ruimte*, which means both 'a shot in the dark' (that is, a wild guess) and 'a small partition in space'. Yet this Zig-Zag Chair for the Jesse family is at the other end of the design spectrum, with its finely carved wood and detail work.

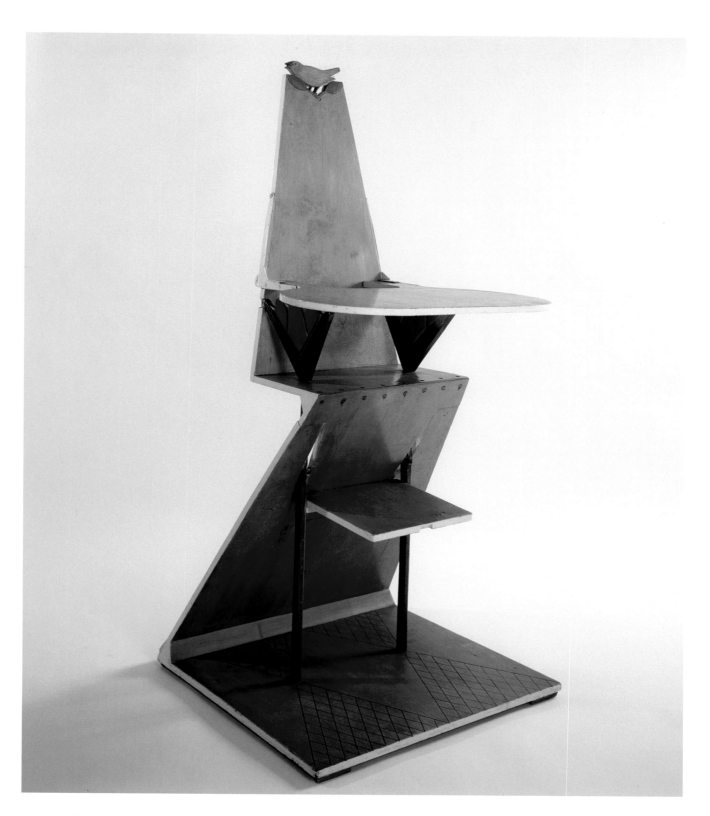

1930 César Domela
(1900-1992)

292

'If the structure of the work is more important than the material of which it consists, one can in principle work with any material. Though this might appear questionable at first glance, the various materials I use are ultimately chosen for their subtle shades, their specific degree of roughness or smoothness. In their structure, my *tableaux-objets* must be a precise and perfect expression of the inner reality they evoke.'

292 César Domela, *Relief néo-plastique No. 10*, 1930, copper, bronze, oil on Perspex and wood, 85 x 85 cm. Gemeentemuseum Den Haag, acquired from the artist, 1960.

Source
César Domela, 'Einige Hinweise und Überlegungen zur modernen Kunst. Vortrag des Künstlers vom 30. Oktober 1954 im Museo de Arte Moderna, Rio de Janeiro', *César Domela. Werke 1922-1972*, Kunstverein für die Rheinlande und Westfalen (Düsseldorf) 1972, n.p.

233

'I trust you are well? I'm very curious to see your little houses – I'm becoming more and more interested in small houses. I was working for a lady in Bergen. She was very taken with the design – but suddenly I was so fed up with the whole thing – all that meticulously planned living and sitting – this is how you eat, this is exactly how the food is brought in, that's where you sit to look outside – that's where you sit when there are visitors, this one sits here and that one sits there and you turn that chair around and then you sit there.' A disgruntled Rietveld is writing to Oud in 1927 about the tiresome business of designing houses for the fussy middle classes, so concerned to have everything prim and proper. The real challenge lies in building for the working classes and here Oud is a real path-breaker. He is planning a housing development behind Groene Hilledijk in Rotterdam for the poorest people, who continue to move from outlying villages to the city to seek work in the fast-expanding docks.

While he is thinking about the most economical way to develop the site, Oud receives an invitation from the German architect Ludwig Mies van der Rohe (1886-1969) who is organising an exhibition in Stuttgart on behalf of the Deutscher Werkbund about new building methods and ways of living. Oud is one of the few architects from outside of Germany to take part, along with fellow Dutchman Mart Stam, Le Corbusier (1887-1965) from France and the Austrian Josef Frank (1885-1967) and his treatment of the commission varies dramatically from others. Rather than the apartment block and single detached house that he was originally asked for, Oud designs a small row of five houses of a single type. His aim is to demonstrate how cost-effectively a house can be built and how efficiently it can be used.

During their correspondence Mies van der Rohe sends Oud a copy of Erna Meyer's book *Der neue Haushalt* (The New Household) which puts the greatest emphasis on the placement of the kitchen as the basis of rational domestic organisation for the benefit of the housewife. Oud integrates Meyer's ideas into his designs in which the kitchen not the sitting room becomes the hub of the house, positioned so that the back of the house, where deliveries and services occur, and the front, where the family interacts, can both be overlooked and supervised from there. Oud designs a complete set of furniture for one of the houses including a fitted kitchen along the guidelines Meyer has suggested. Her approval is registered in an article she publishes in *i10* where she praises Oud for his commitment to 'the collaboration between housewife and architect'.

Back in Rotterdam, Oud completes his housing development, now known as the Kiefhoek. He proudly presents these houses as the equivalent to Henry Ford's 'Model T' car; standardised building tech-niques had permitted construction costs to be kept to only 2400

293 Gerrit Rietveld, *Zig-Zag Chair*, 1933, Norway spruce, 79 x 40 x 36 cm. Collection of the Centraal Museum, Utrecht. Four broad boards screwed together – this chair is no more than that. Writing about Rietveld in 1935, Mart Stam remarks, 'He knows that the old working method cannot take him any further; he knows there is a need for new materials and a different, simpler method of assembly.'

294 Brochure for the exhibition *Die Wohnung*, organised by the Deutscher Werkbund, about the development of the Weissenhof housing estate in Stuttgart. Photo-graph from the collection of the NAi, Oud archive. Though the original plan was very different, this exhibition ultimately takes the form of a suburban housing estate, with dwellings that reflect a variety of cutting-edge approaches to contemporary living.

295 A photograph of five recently completed terraced houses, Oud's contribution to the exhibition, September 1927. Photograph from the collection of the NAi, Oud archive. Oud, who is accustomed to grappling with scarcity and impossible tasks in Rotterdam, has an opportunity in Stuttgart to spread his wings and experiment with new materials and techniques for efficient small homes.

296 Title page of *Der neue Haushalt* (The New Household) by Erna Meyer. Oud finds his own vague ideas about 'everyday life' presented more concretely in this bestselling book, as the basis for a new kind of architecture. Collection of the NAi, Rotterdam.

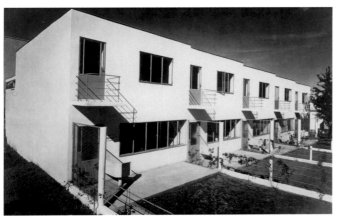

297 The district of Kiefhoek in Rotterdam, which Oud designed between 1925 and 1930. Photograph from the collection of the NAi, Rotterdam, Oud archive. In 1928, Rietveld writes excitedly that he is curious how Oud will 'come up with a solution for those small dwellings. If they are well-furnished, I think small dwellings can make life much simpler.'

298 The brochure *Die Wohnung für das Existenzminimum* (Dwelling for Minimal Existence), published in connection with the second CIAM meeting in 1930, in which contributions by Dutch architects associated with De Stijl are held up as models. Photograph from the collection of the NAi, Rotterdam.

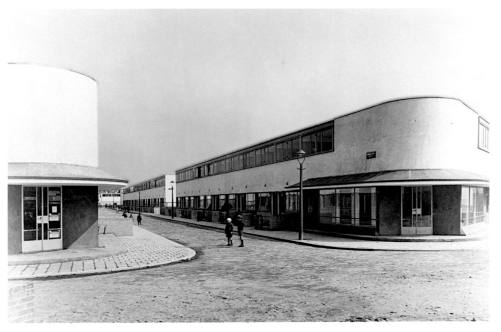

guilders per house, less than half of what an average house would
have cost at the time. Publicising the project in the British magazine
The Studio, Oud advertises it as 'The £213 House', 'a solution to the
re-housing problem for rock-bottom incomes'. These are 'Dwelling
Fords' with absolutely nothing wasted in terms of space or materials
intended for families with as many as six children, none of whom would
have been able to afford a car, although they now have the luxury of a
brick shed in which to keep a bicycle. The only compromise to social
politeness over function is Oud's inclusion of a small entrance hall for
the gas, water and electricity meters, so that 'intrusion of Municipal
officials into living rooms is avoided'. Just before the project is com-
pleted in 1930, both the Kiefhoek plan and a design for row housing
by Rietveld are discussed at the second CIAM meeting under the
heading of 'Dwelling for Minimal Existence' (Die Wohnung für das
Existenzminimum). Small houses for Dutch workers take the lead
internationally.

298

299 J.J.P. Oud, *Dining Room
Furniture for the Weissenhof Estate*,
1927 (reconstruction by Écart
International, Paris, 1979),
metal, Bakelite, wood and paint,
75 x 90 x 140 cm (table) and
90.7 x 42.3 x 45 cm (chair).
Collection of the Gemeentemuseum
Den Haag.

1930 **Jean-Albert Gorin**
(1899-1981)

300 'I was so utterly bowled over by the great intensity of the beauty revealed to me by Neoplasticism that after returning to my provincial home I immediately wrote to Mondrian to share the profound emotions his work had stirred up and ask for additional technical information, and this led to a correspondence.'

300 Jean-Albert Gorin, *Composition néo-plastique à lignes en creux N 29*, 1930, oil on panel, framed by a strip of wood covered in oil paint, 66,7 x 66,7 x 2,5 cm. Gemeentemuseum Den Haag, acquired from the artist 1981.

Source
Yve-Alain Bois, 'Lettres à Jean Gorin: Mondrian, Vantongerloo, Torres-Garcia, Bill, etc....', *Macula*, no. 2 (1977), p. 128.

239

301

The photograph is taken by Charles Karsten, architect, when he comes to pick up the painting *Composition with Yellow Lines* in August 1933. With fifteen others – mainly architects and artists – they had all contributed money to buy Mondrian a suitable gift for his sixtieth birthday, they had written to him. 'A pure world (your work) has shown us and thus have we become aware of it.' Mondrian had gathered quite a following. Not only in the Netherlands, but also elsewhere. In Germany, Switzerland and the United States artists, designers and architects were fascinated by his message. The artist is standing to the right of his easel. He has his hand on his hip, slightly stiff, but also challenging, perhaps even wilful. He looks straight into the lens. He wears a smart suit, polished shoes, his hair neatly combed. Here stands a man who is done, who has completed his work, and is proud of the result.

For some time now, Mondrian has been toying with the idea of collecting several of his last articles and publishing them in a book. 'L'art nouveau – la vie nouvelle: la culture des rapports pures' ('Art and Life. The New Plastic – The New Life (The Development of Pure Relationships)') should be about Neoplasticism's impact on society. Mondrian no longer saw Neoplasticism as a painting style or a movement, but as a social phenomenon that was becoming visible all around. He described the development of the new art amidst the 'natural tyranny' of forms, styles and conventions. The new life would be purified, just as the Puritans had envisaged, but in such a way that 'the spirit would be above the tyranny of limiting forms', as exemplified in art. As painting broke the restrictive form, so must humanity free itself of the narrow, the crushing associations with church and fatherland. 'How much more beautiful the world would be if the battle of the states, the sects and even of the sexes were to make way for harmonious equilibrium!' The growth of steadily purer relationships would create freer individuals.

302

And so life would become truly equilibrated, a completely new system would emerge in which each individual interest that existed at the expense of others would disappear. Painting is an example. In an age of movement and action, in which we are distracted by all kinds of needs – real or imaginary – it was up to art to reveal a true beauty in the rhythm of equilibrated contrasts, in the face of the 'emptiness' of

303

forms. Jazz and modern dance are also good examples of how it would be, because they are concerned only with rhythm, rather than with melody or storyline. Only material or spiritual independence was impeding progress. There were many risks (militarism, capitalism, unbridled technology, rash science, and also family, country, the appeal of friendship and love ('leaning on each other' as Mondrian called it), which in the higher ideal become selfless love, sincere friendship, true goodness etc.). Mondrian would continue with this project for many

304

years. In New York, after 1942, he changed the title to 'L'art révélateur', the art that would reveal supernatural truths.

301 Piet Mondrian in his studio on Rue du Départ, Paris, August 1933. Photograph from the collection of the NAi, Rotterdam, Charles Karsten archive. Karsten takes this photograph when the painting *Composition with Yellow Lines* is presented to a Dutch museum. In it, Mondrian confronts Dutch viewers with his two most extreme artistic positions thus far: one painting with a minimum of contrasts and differences (in colour) and another with a maximum of contrasts and differences (in line).
302 Place de l'Étoile, Paris, circa 1930. In a manuscript entitled *L'art nouveau – la vie nouvelle* (New Art – New Life), Mondrian notes that 'in many areas of contemporary life we already observe that people are striving towards greater and greater punctuality and accuracy, compelled by necessity. We need look no further than the traffic in our major cities. Place de l'Étoile in Paris conveys a better image of the new life than many a theoretical discourse on the subject.' Photo The Print Collector/Heritage Images.
303 Orsi (1889-1947), *La Revue Nègre, Théâtre de l'Étoile*, 1925, lithograph, executed by Publicité Phogor 92, Rue d'Amsterdam, 158 x 120 cm, collection of the Gemeentemuseum Den Haag. Josephine Baker's debut performance in Europe is an unparalleled event, even for the dancer herself, as she will later recount: 'Driven by dark forces I didn't recognize, I improvised, crazed by the music, the overheated theatre filled to the bursting point, the scorching eye of the spotlights. Even my teeth and eyes burned with fever.' That night, she becomes a legend.

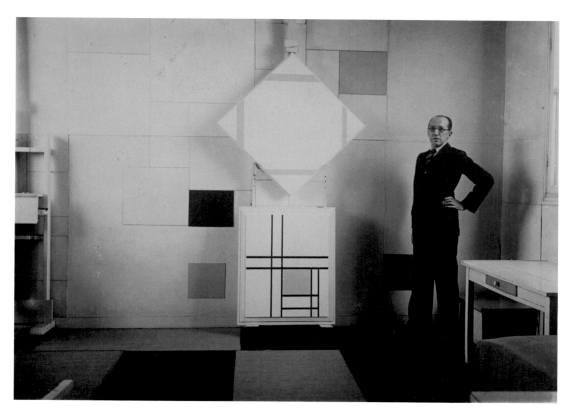

305 From day to day he transformed his Paris studio into a space in which mirrors and the use of planes and colour ensured above all that any perception of literal space dissolved and made way for a more figurative 'mental space'. The space reflects the way in which one can look at the paintings. The studio on Rue du Départ did not therefore necessarily reflect the combination of art and architecture, as has been suggested. Much more important is the fact that Mondrian's studio made it clear that the decorative – provided it was done with care and well supervised – was no longer an application within architecture, but could totally transform a space. The main precondition was, however, that the private space (which a studio ultimately is) be presented as a public space. In the transition from private to public, everything, personal possessions, paintings, the absence of the artist as Creator takes on sacred significance. It was as if the studio constitutes the living proof that you can live in a painting.

304 Titlepage for the manuscript of 'L'art nouveau – La vie nouvelle', with corrected title.

305 Piet Mondrian's studio on Rue du Départ, Paris, April 1926, photographed by Paul Delbo, Rue Vavin, Paris. Collection of the Netherlands Institute for Art History (RKD), The Hague, Mondrian archive. After Mondrian moves to another studio in 1936 (because the complex on Rue du Départ was slated for demolition), the coloured pieces of cardboard and the white and grey planes remain visible for months, high above the ground, fluttering in the wind, against the blind wall that forms the boundary with the adjacent complex. It pains Mondrian to see his sanctuary desecrated, laid bare to the inexpert eyes of strangers.

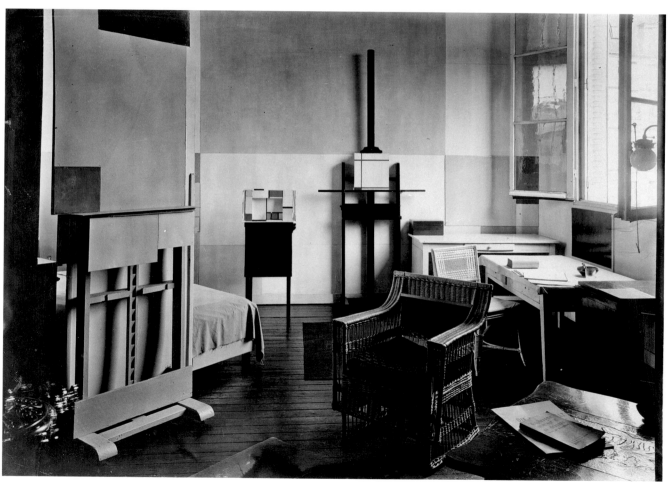

1932 Marlow Moss
(1890-1958)

[306]
'"A disciple of Mondrian", the viewer will say. Marlow Moss would be the last to deny it. She fully acknowledged Mondrian as her "master". Her first encounter with his work (in 1927) was a decisive moment for her, the springboard that prompted her to take a leap into space. I say "space" deliberately, for "space, movement, light" had for years been her obsession. Her slogan – "I am no painter, I don't see form. I only see space, movement and light" – says it all. From the outset, her goal (at first unconscious, later highly conscious) was to define a form for this trinity. […] Light was the source of all vital energy, the shaper of the visible, the triumph of life over death, of construction over destruction: 'the flame of life'.

306 Marlow Moss, *Composition in White, Black, Red and Grey*, 1932, oil on canvas, with a protective edge painted white, 54 x 45 cm. Gemeentemuseum Den Haag, acquired in 1972 from a private collector.

Source
Netty Nijhoff, 'Marlow Moss (Richmond, Surrey, 29 May 1890 – Penzance, Cornwall, 23 Aug 1958)', *Marlow Moss*, Amsterdam (Stedelijk Museum) 1962, n.p.

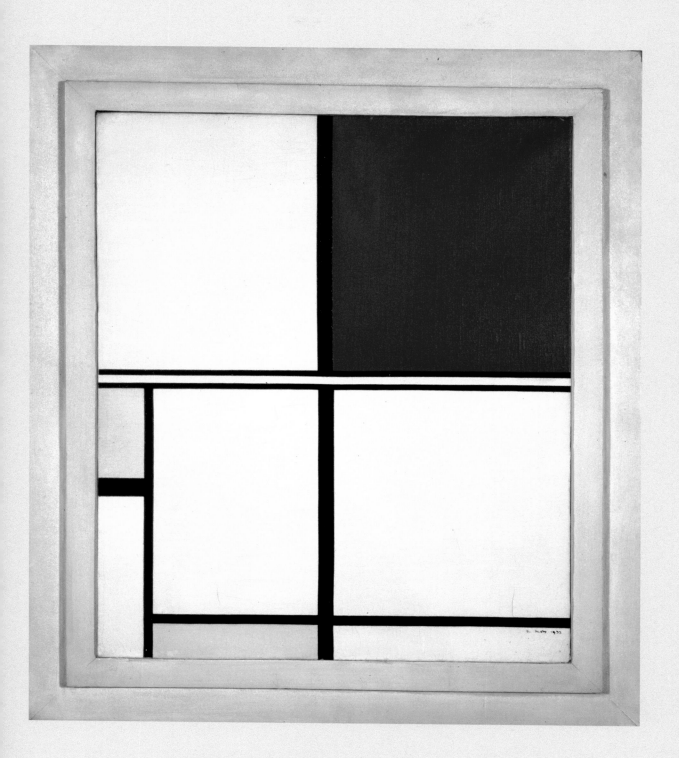

245

Fashion is change. In the 1930s geometric designs disappear to be replaced by fashionable floral gowns. But the influence of De Stijl can be seen more and more in interiors and in household textiles. Joseph de Leeuw, director of Metz, continues to look for innovation and to collaborate with avant-gardists. Sonia Delaunay is still one of the company's favourite fabric designers, both for clothes and for soft furnishings. In 1929, De Leeuw approaches Gerrit Rietveld and Bart van der Leck to work on interiors for the firm. Uniquely, De Leeuw manages to ensure that their work is shown in Paris at the first *Union des Artistes modernes* exhibition staged at the Pavillon de Marsan. Rietveld's tubular furniture and Van der Leck's rugs feature in the exhibition. Metz provides the only foreign submissions, as well as being the only shop to participate. This results in an agency in Paris for Van der Leck's rugs. When, in 1933, an extra floor is added to the building on Leidsestraat in Amsterdam, De Leeuw invites Gerrit Rietveld to design it. In June 1934 a sales exhibition of Sonia Delaunay fabrics is held in the cupola he designs.

De Leeuw also asks Bart van der Leck to develop a colour scheme which will harmonise with the colours of the fabrics. Van der Leck and De Leeuw take the project very seriously: 'In producing this range of colours the painter intended that the colours of the fabrics used for curtains, upholstery, cushions etc. should present a good image, both in juxtaposition and as a whole'. Besides Van der Leck's rugs, Metz also puts designs by Vantongerloo and Huszár into production. Van der Leck's two rugs are based on one of his paintings from 1918, and bear a slight resemblance to the rugs Piet Zwart designed in the 1920s. The design drawings for these rugs are structured like two-dimensional paintings. A similar design was used for an evening bag designed by Zwart and made by his second wife, C. Zwart-Cleyndert.

The influence of De Stijl permeates many households. Like Metz, N.V. Linnenfabrieken E.J.F. van Dissel & Zonen puts modern designers into production. In the 1930s they enter into a collaboration with Kitty van der Mijll Dekker (1908-2004), commissioning her to design modern, functional household linen. Van der Mijll Dekker had already trained in weaving at the Bauhaus (1929-1932) as part of her interior design studies. Between 1938 and 1960 she produced around 40 designs for Van Dissel. Many of her creations adhere to De Stijl principles in terms of colour, form language and functionality. One example is her glass cloths from 1935/1936, woven from fine linen. They have an ingenious pattern of lines in red and blue on a white background woven into them. The glass cloths shown here are marked with the initials dMH, in reference to Mr S.J.R. de Monchy (1893-1969) and his Swedish wife V.H.M. Herzog, for whom they were made. Both were doctors and had met in Vienna, where they were training with famous psychoanalyst Sigmund Freud. The couple settle in Rotterdam

307
308
309
310
311
312
313
314
315

316

317

318

319

320

in 1939, moving into a house at Schiedamsesingel 273. They engage architect J.J.P. Oud for the interior. The glass cloths show that the principles of De Stijl were applied right down to the smallest details.

315 Sonia Delaunay, *Textile pattern design for Metz & Co, no. 1177*, 1933-34, gouache on paper, 21 x 22.7 cm, private collection.

316 Piet Zwart, *Carpet design*, 1920, gouache on paper, 23.8 x 24 cm.

317 Designs by Bart van der Leck (carpet), C. Survage and Alvar Aalto (chair) in the Metz & Co. catalogue.

318 Piet Zwart, *Evening bag*, c. 1928-29, wool, hand-woven by Cornelia Zwart-Cleyndert.

319 Kitty van der Mijll Dekker for Firma Van Dissel & Zonen, *Tablecloth with napkins*, c. 1935-40, linen.

320 Kitty van der Mijll Dekker, *Glass cloths*, c. 1935-36, linen woven with a striped pattern, monogrammed dMH, a reference to Mr and Mrs De Monchy-Herzog.

reversible rugs

(beide zijden gelijk)
1. ontwerp B. van der Leck
 60 x 120 cm. ƒ 6.95
2. ontwerp Ch. Survage
 60 x 120 cm. „ 6.95
 140 x 170 cm. „ 21.50
3. kleedjes in effen kleuren,
 60 x 120 cm. „ 6.25
 90 x 160 cm. „ 13.25
 120 x 185 cm. „ 19.75

armstoel, uitgevoerd in blank ber-
kenhout, ontwerp Alvar Aalto ƒ 18.50

24

315 316 317
318
319 320

249

1933 **Piet Mondriaan**
 (1872-1944)

321 'It is in this way that we should understand the great, classical art of
 the past: as work created in the harmonious light of the full moon.
 Those works cannot have been created in the full light of day. If such
 work can still be produced today, at daybreak, it is out of nighttime
 reflection, and because the idea of full daylight is not yet clear. Yet, as
 artificial light steadily conquers the night, so shall the man of daylight
 ultimately vanquish the night. […] Let us live our lives in the full light
 of day, so that we can create [art].'

321 Piet Mondrian,
Composition with Yellow Lines, 1933,
oil on canvas, 80.2 x 79.9 cm.
Gemeentemuseum Den Haag,
acquired with financial support
from friends of the artist, 1933
(© Mondrian/Holtzman Trust c/o
HCR International, Virginia, USA).

Source
Piet Mondrian, 'L'art réaliste et l'art
superréaliste', in Paul Citroen (ed.),
Palet, Amsterdam (De Spieghel)
1931, p. 80

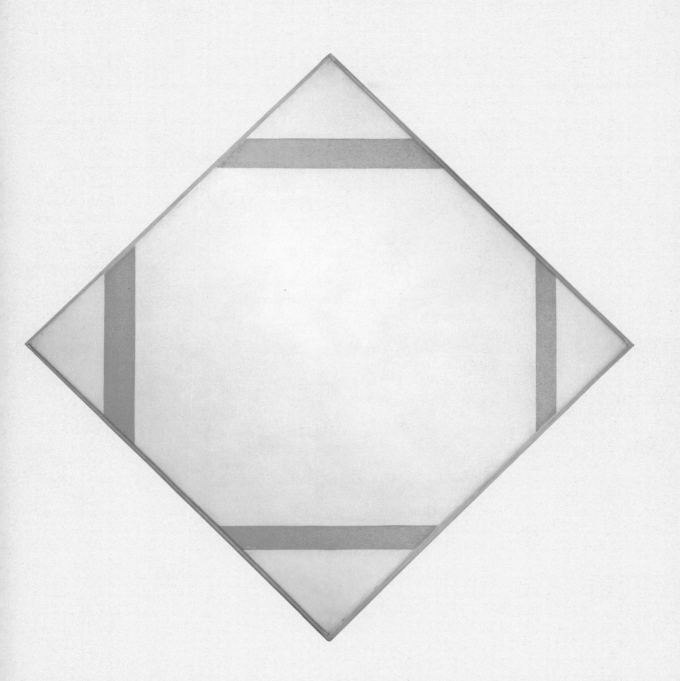

1935 34 'A daily joy'
The Bruynzeel kitchen and the 'standardisation'
of women's work **Home** City Exhibition Street

**34 'A daily joy'
The Bruynzeel kitchen and the 'standardisation'
of women's work**

'An inadequately or inefficiently designed kitchen costs time, labour, money [and is] a daily irritation. A Bruynzeel kitchen is always complete and efficient, saves time, labour and money and [is] a daily joy.' And so it was, in 1935, that Bruynzeel launched the kitchen of the future. Back in 1921 designer Piet Zwart had called during a lecture for 'standardisation'. It was the magic word that took the Netherlands into the new age. Everything must be tuned and standardised, and deviations banished. If, according to Zwart, a piece of furniture were to serve 'the interests of the community', it would urgently need to be 'standardised'. 'Do not think', Zwart warns, 'that by standardisation I mean the designation of some standard type [...]. An entirely new system of distribution of materials in standardised ratios will form the crux of this problem. A skilled engineer will have to be brought in.'

And so women in their 'complex cottage industry' are subjected to numerous studies in the 1920s and '30s. The design of the traditional kitchen is not well thought-out. Bruynzeel observes in 1936 that a kitchen must be designed in such a way that the woman 'can do her work without having to make any unnecessary effort'.

Piet Zwart has already become concerned with the 'standardisation' of women's work. As early as 1911 he had tinkered with some equipment in a school kitchen, in search of efficient arrangements. His wife has subsequently written booklets with practical cooking tips. When Zwart gets the commission from Bruynzeel in 1937, he knows the problems inside out. At first he is to concern himself with the kitchen cabinets, which it should be possible to join together. But Zwart gradually takes every conceivable detail in hand. Efficiency, hygiene and convenience lead him to create simple handles, ventilation grilles, recessed plinths, ingenious catches and hinges, spoon holders, slide-out chopping boards, special worktops and sinks.

The Bruynzeel kitchen is launched in 1938 and soon becomes a household name. The price is not to be sniffed at, only affordable for the middle classes, but it does turn cooking into a pleasurable experience. The standardisation of women's work ties in well with the typical features of De Stijl: each part elemental, coherent as a whole. That does not go for the sea-green colour of the kitchen but in that case there is also a parallel of the elementary and synthetic. When Cees Bruynzeel's staff ask what colour the wood should be painted on the first prototype model, the director thinks immediately of the sea-green summer dress he had bought his wife when they met in the summer of 1918. Bruynzeel still remembers that dress and that summer. He must have bought it just as Mondrian was first hanging his recently completed *Composition with Grey Lines*, the First World War was drawing to a close and a new world was being born.

322 Piet Zwart, *Blotting paper with monthly calendar for Bruynzeel*, 1939, three-colour printing, 22.5 x 9.5 cm. Collection of the Gemeentemuseum Den Haag. Bruynzeel produces vast amounts of this blotting paper from the 1930s onward, as presents for its growing base of customers and business associates and as monthly gifts for its own employees.
323 Piet Zwart, *Presentation Drawing of the Bruynzeel kitchen*, 1937, pencil and brush in colour on paper, 24.8 x 32.6 cm. Collection of the Gemeentemuseum Den Haag. 'Even before the war, the Bruynzeel kitchen was an institution in the Netherlands,' Zwart writes in 1968. It was an expensive proposition, he adds, 'but for the middle class, it was the only real option'.
324 Pots, pans, dishes, a pressure cooker and a spoon rack in a Bruynzeel kitchen cupboard, 1938, 24.2 x 18 cm. Photograph from the collection of the Gemeentemuseum Den Haag.
325 Piet Zwart, *Bruynzeel kitchen*, 1938, wood, glass, metal and chrome, 160 x 55 x 387 cm. Collection of the Gemeentemuseum Den Haag. The kitchen consists of four upper cupboards, a rack for pots and pans, drawers for groceries, a broom closet, four lower cupboards, an additional cupboard with a set of drawers, a breadboard and a sink. The manufacturer advises buyers to purchase a leading brand of steel furniture for use in the kitchen.

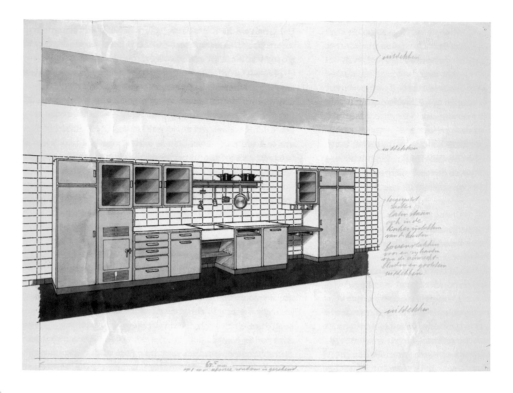

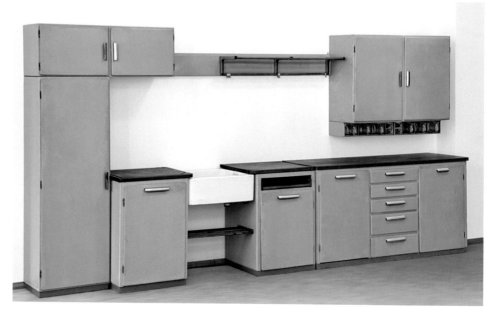

253

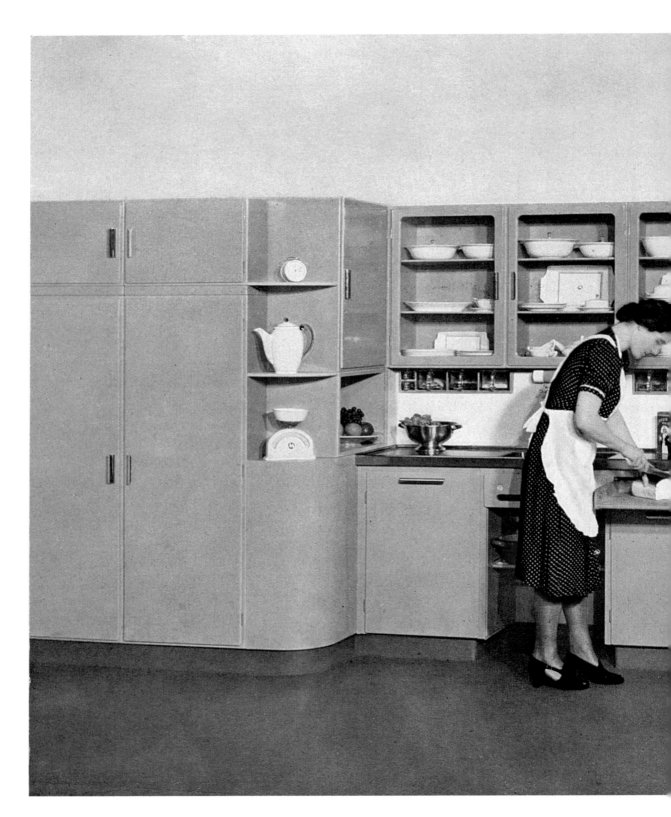

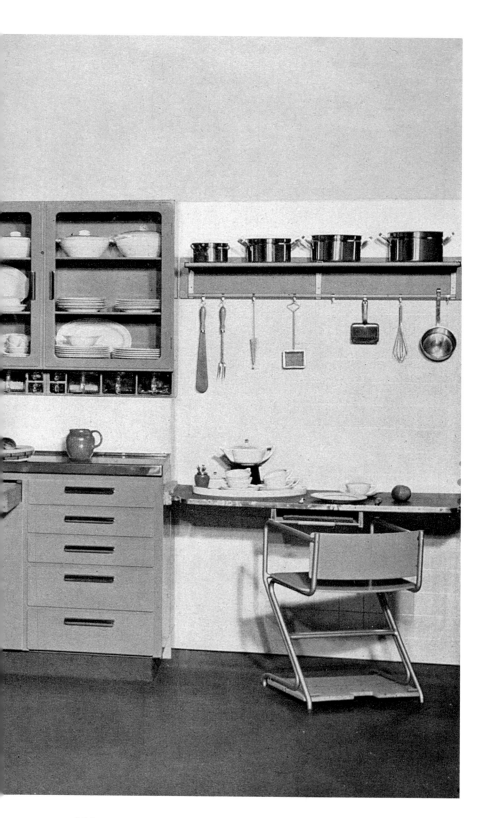

326 Presentation photograph of the Bruynzeel kitchen from a 1939 brochure. Photograph from the collection of the Gemeentemuseum Den Haag.

327 On the eve of the Second World War, the World's Fair is opened in New York with the slogan 'Building the World of Tomorrow'. The highlight of the exhibition is Norman Bel Geddes' extraordinary 'Futurama', a one-acre-sized model of an American city as it might look in the year 1960, complete with moving cars. The visitors to the exhibit, some 28,000 per day, view it from above while carried around on moving seats, as if on a simulated flight. They go on to tour the rest of the exhibition site sporting a badge which reads 'I have seen the future'.

328 The Dutch pavilion is hardly futuristic. In fact, according to Gijsbert Friedhoff, writing for *Bouwkundig Weekblad*, the Netherlands has managed to make a huge backwards step since the previous few World's Fairs. The problem has begun with the commission of the pavilion itself, awarded after a competition to D.F. Slothouwer (1884-1946), an architect of wide-ranging talents and writer of many books on architectural history. His historical tastes have led him to design the pavilion with a peculiar mixture of classical and industrial elements topped by a tower based on Stockholm town hall. The architects' group *De 8 en Opbouw* are not impressed and think the competition unfair. Willem Sandberg, curator of modern art at the Stedelijk Museum, has organised a boycott by artists. It is just a year since he helped Nelly van Doesburg organise an exhibition in Amsterdam of abstract art, so it seems that De Stijl will once again fail to be represented at a World's Fair.

329
330 However, in the Dutch pavilion, which includes a full-size church organ and a windmill sponsored by KLM, tucked away in a vitrine representing artistic achievements from past to present, is a miniature
331 De Stijl gallery built by Vilmos Huszár. Unlike 'Futurama', Huszár's model takes the more traditional form of a doll's house where the viewer can peek in from eye level and not have to fly above. It sits on top of two lower storeys representing rooms at the Mauritshuis and Pulchri Studio in The Hague. Tiny reproductions of paintings by Mondrian, Van Doesburg, Van der Leck and Huszár himself are included, along with a sculpture by Vantongerloo. Friedhoff's description of the vitrine further identifies a model of the entrance to the Beurs van Berlage just behind it and, on the right-hand side, a city planning scheme inspired by J.J.P. Oud integrated into a set design for Gijsbrecht van Amstel.

Although a highly imaginative and anachronistic construction, we can clearly see how De Stijl is understood here in two key contexts: on the one hand it stands for the supreme achievement of Dutch art in the modern period, the equivalent of Rembrandt for the 17th century and The Hague School for the 19th, while on the other it is connected to the reform tradition of *gemeenschapskunst*, represented by the crossovers between architecture, planning and theatre, and by Berlage's bid to

327 At the 1939 World's Fair in New York, the public is informed about 'Futurama', the transport system of the future, sponsored by General Motors and designed by Norman Bel Geddes (1893-1935), in which fully automated highways provide transport through endless suburbs with the help of the latest technologies. Photograph from the *Bouwkundig Weekblad*, September 1939, collection of the NAi, Rotterdam.

328 D.F. Slothouwer, The Dutch Pavilion at the 1939 World's Fair. While cultural exchange is a central theme for many participating countries, the Dutch Pavilion is filled mainly with Dutch products. Photograph from the *Bouwkundig Weekblad*, September 1939, collection of the NAi, Rotterdam.

329 One of the attractions at the Dutch Pavilion is a windmill at the stand for the national airline KLM. The designer of this part of the exhibition is Henri Pieck, who decided after meeting Mondrian in 1922 that he wanted to serve society with his art. It will later come to light that he did not merely have left-wing sympathies, but was in fact a spy for the Russians in the 1930s. Photograph from the *Bouwkundig Weekblad*, September 1939, collection of the NAi, Rotterdam.

330 H.W. Flentrop from Zaandam, a well-known organ builder in the Netherlands, is offered the chance to exhibit a full-size organ at the World's Fair. The exhibition was an unquestionable success: after 1940, the United States market for Flentrop organs expanded enormously. Photograph from the *Bouwkundig Weekblad*, September 1939, collection of the NAi, Rotterdam.

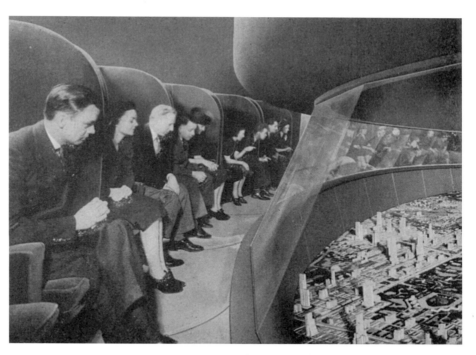

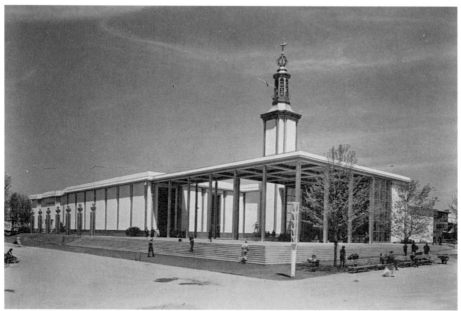

FIG. 3. STAND VAN DE K.L.M. ONTWERP H. C. PIECK

ORGEL DOOR H. W. FLENTROP TE ZAANDAM IN DE CULTUREELE AFDEELING, DAARBOVEN

unite all the arts in a single building. Whether or not Huszár's contribution met with Sandberg's blessing is unclear but, at an exhibition dedicated to what is yet to come, De Stijl is firmly integrated with the recent history of the Netherlands.

331 A display case showing masterpieces of Dutch art in miniature, designed by Prof. H. Rosse, professor of decorative arts in Delft. An urban plan inspired by the work of J.J.P. Oud is displayed amid scenery developed by the theatrical designer Van Dalsum. On the left, the entrance to the Beurs van Berlage tops the stack of exhibitions. Photograph from the *Bouwkundig Weekblad*, September 1939, collection of the NAi, Rotterdam.

„KUNST" STAND. ONTWORPEN DOOR PROF. H. ROSSE. VAN BOVEN LINKS NAAR BENEDEN GAAND:

De bouwkunst aangeduid door den ingang van de Beurs van Berlage omgeven door glasdecoratie geïnspireerd op v. Tijens Flat-gebouw te Rotterdam. Modern interieur van Huszar. Interieur Pulchri Studio. Interieur Mauritshuis. (alles in miniatuur formaat!) In het midden van boven naar beneden: handen van Mengelberg, v. Hoogstraten en Flipse. Glas in lood van A. N. de Lint. Literatuur met koppen van dichters. Rechts van boven naar beneden: Stedebouwkunst geïnspireerd op een plan van arch. J. J. P. Oud in een Theaterdecor voor de Gijsbrecht van v. Dalsum, daaronder een theaterdecor voor de Lucifer van Rooyaards naar ontwerp van Roland Holst, daaronder figuurtjes van Kloris en Roosje door Rie Cramer.

332 'We can see him draw ever closer to the abstract, until in 1917
and 1918 he reaches the point of pure geometric representation.
Compositions of colour blocks and lines on white fields in which,
it is fair to say, the origin of the picture is no longer identifiable. Then
he returns his focus to reality, so that the pictorial content of his work
becomes more visible. But we can let go of that image. Whether one
sees a cat in it or not is irrelevant, after all, to deciding whether this
is a work of art.'

332 Bart van der Leck, *Jewel*,
c. 1949, glazed pottery, 4.6 x 4.6 cm.
Collection of the Gemeentemuseum
Den Haag, bequest, 2011.

Source
H.P. Bremmer, 'B. van der Leck,
De kat (1914)', *Beeldende kunst*,
vol. 15 (1928), no. 7, pp. 53-55.

01 Rudi Oxenaar, *Bart van der Leck tot 1920. Een primitief van de nieuwe tijd*, The Hague 1976;
Carel Blotkamp (et al.), *De Stijl: The Formative Years, 1917-1922*, Cambridge MA & London (MIT) 1986;
Michael White, *De Stijl and Dutch Modernism*, Manchester/New York (Manchester University Press) 2003

02 Lien Heyting, *De wereld in een dorp: schilders, schrijvers en wereldverbeteraars in Laren en Blaricum 1880-1920*, Amsterdam (Meulenhoff) 1994;
Lien Heyting, 'Laren en Blaricum en Bart van der Leck' in Toos van Kooten (ed.), *Bart van der Leck*, Otterlo (Kröller-Müller Museum) 1994, pp. 132-142;
Sal Slijper Archive, The Hague (RKD);
Maaike Middelkoop-Domselaer, 'Herinneringen aan Piet Mondriaan', *Maatstaf*, vol. 7, no. 5 (August 1959), pp. 269-293

03 Carel Blotkamp (et al.), *De Stijl: The Formative Years, 1917-1922*, Cambridge MA & London (MIT) 1986;
Sjarel Ex and Els Hoek, *Vilmos Huszár, schilder en ontwerper 1884-1960*, Utrecht (Reflex) 1985;
Winnie van der Horst, *Het Rijke Leven van Helene Kröller-Müller*, Ede (Mevr. W. van der Horst) 1998;
Eva Rovers, *De eeuwigheid verzameld. Helene Kröller-Müller (1869-1939)*, Amsterdam (Bert Bakker) 2010

04 Alied Ottevanger ed., *'De Stijl overal absolute leiding.' De briefwisseling tussen Theo van Doesburg en Antony Kok*, Bussum (Thoth), 2008, pp. 205-208;
Evert van Straaten, *Theo van Doesburg. Painter and Architect*, The Hague (SDU) 1988;

Jahrbuch des Deutschen Werkbundes, Munich (Bruckmann), 1915;
Allan Doig, *Theo van Doesburg: Painting into architecture, theory into practice*, Cambridge (Cambridge University Press), 1986;
Carel Blotkamp (et al.), *De Stijl: The Formative Years, 1917-1922*, Cambridge MA & London (MIT) 1986

05 Carel Blotkamp, 'Tryptieken in Stijl', *Mondriaan in detail*, Utrecht/Antwerp (Veen – Reflex), 1987, pp. 102-123;
Theo van Doesburg, 'Der Kampf um den neuen Stil', *Neue Schweizer Rundschau*, vol. 22, no. 5 (May 1929), pp. 373-77;
Leo Jansen, Hans Luijten, Nienke Bakker, *Vincent van Gogh – De brieven*, Amsterdam (Amsterdam University Press) 2009, letter 597 to Theo van Gogh, from Arles, written on Friday 13 April 1888;
Michael White, *De Stijl and Dutch Modernism*, Manchester (Manchester University Press) 2003

06 Exchange of letters between Van Doesburg and Vantongerloo, Vantongerloo Archive, Zumikon; personal communication with Wolf Jordan, grandson of Frans Vantongerloo, May 2010;
Carel Blotkamp (et al.), *De Stijl: The Formative Years, 1917-1922*, Cambridge MA & London (MIT) 1986;
Michael White, *De Stijl and Dutch Modernism*, Manchester/New York (Manchester University Press) 2003;
Christoph Brockhaus and Hans Janssen, *Voor een nieuwe wereld, Georges Vantongerloo 1886-1965*, The Hague (Gemeentemuseum) 2010

07 Sjarel Ex and Els Hoek, *Vilmos Huszár, schilder en ontwerper 1884-1960*, Utrecht (Reflex) 1985;
Dolf Broekhuizen (ed.), *Robert van 't Hoff: Architect of a New Society*, Rotterdam (NAi) 2010;
Carel Blotkamp (et al.), *De Stijl: The Formative Years, 1917-1922*, Cambridge MA & London (MIT) 1986

08 Correspondence between Vantongerloo and Van Doesburg, Vantongerloo archives Zumikon;
Els Hoek, 'Piet Mondriaan' in Carel Blotkamp (ed.), *De vervolgjaren van De Stijl*, Utrecht 1996, pp. 115-152;
Entr'acte 1
Yvonne Brentjens, *Piet Zwart (1885-1977). Vormingenieur*, The Hague (Gemeentemuseum), pp. 35-47;
Truus Kuivenhoven, *Je brood verdienen met je penseeltje? 1913-1920 textielontwerpen van Piet Zwart*, University of Leiden Master's dissertation, 2005;
Ietse Meij, 'Mode en beeldende kunst', *Modus, over mensen, mode en het leven*, Issue 0, December 1990, pp. 112-123;
Ietse Meij, 'Mode en reform', *Den Haag rond 1900. Een bloeiend kunstleven*, The Hague & Blaricum (Gemeentemuseum) 1998 (II), pp. 40-54; C. Proos-Berlage, *Sierkunst en Vrouwenkleding*, Rotterdam 1927;
Petra Timmer, *Metz & Co. De creatieve jaren*, Rotterdam 1995, p. 23: quote from Constance Wibaut, fashion journalist and illustrator, referring to the Liberty fashions worn by her grandmother and her circle in Amsterdam;
Carin Schnitger, Inge Goldhorn, *Reformkleding in Nederland*, Utrecht (Centraal Museum) 1984;

Hanneke van Zuthem, *Kunste-naarskleding. Piet Zwart en andere kunstenaars als kledingontwerper, 1900-1930,* University of Leiden dissertation, 1981; Piet Zwart, 'Mode en Kunstnijver-heid', *De Cicerone,* vol. 1, no. 1 (1918), pp. 32-33

09 Evert van Straaten, *Theo van Doesburg. Painter and Architect,* The Hague (SDU) 1988; Carel Blotkamp (et al.), *De Stijl: The Formative Years, 1917-1922,* Cambridge MA & London (MIT) 1986; Els Hoek (ed.), *Theo van Doesburg. Oeuvre catalogus,* Bussum (Thoth) 2000; Peter van Dungen, 'Introduction' in Bart de Ligt, *The Conquest of Violence,* London (Pluto Press) 1989; Carel Blotkamp, 'Mondrian: Bits and Pieces', lecture held at the Centre Pompidou, Paris (9 February 2011); Letter from Piet Mondrian to Theo van Doesburg (especially that of 11 October 1919) and letters from Van Doesburg to Antony Kok (especially that of 9 December 1919), Archive of Theo and Nelly van Doesburg, RKD, The Hague

10 Sjarel Ex and Els Hoek, *Vilmos Huszár, schilder en ontwerper 1884-1960,* Utrecht (Reflex) 1985; Yvonne Brentjens, *Piet Zwart 1885-1977, Vormingenieur,* The Hague (Gemeentemuseum) 2008; H.P. van den Aardweg (ed.), *Persoonlijkheden in het koninkrijk der Nederlanden,* Amsterdam (Van Holkema & Warendorf) 1938

11 Herman van Bergeijck, *Jan Wils: De Stijl en verder,* Rotterdam (i10 Uitgeverij) 2007, p. 46 et seq.; K. Schippers, *Holland Dada,* Amsterdam (Querido) 1970, pp. 47-8 et seq.

12 Ed Taverne, Cor Wagenaar and Martien de Vletter, *Poetic Functionalist. J.J.P. Oud 1890-1963. The Complete Works,* Rotterdam (NAi) 2001; Wim Beeren ed., *Het Nieuwe Bouwen in Rotterdam 1920-1960,* Delft (Delft University Press) 1982; J.J.P. Oud, 'Gemeentelijke Volks-woningen, Polder "Spangen", Rotterdam', *Bouwkundig Weekblad,* vol. 41, no. 37 (11 September 1920), pp. 219-222

13 Correspondence between Van Doesburg and Vantongerloo, Vantongerloo Archive, Zumikon; Correspondence between Mondrian and Van Doesburg, Archive of Theo and Nelly van Doesburg, RKD, The Hague

14 Carel Blotkamp, August Hans den Boef, *Piet Mondriaan. Twee verhalen,* Amsterdam (Meulenhoff) 1987; Letter from Theo van Doesburg to J.J.P. Oud, 23 February 1921, Fondation Custodia, Paris

15 Ed Taverne, Cor Wagenaar and Martien de Vletter, *Poetic Functionalist. J.J.P. Oud 1890-1963. The Complete Works,* Rotterdam (NAi) 2001; Els Hoek (ed.), *Theo van Doesburg. Oeuvre catalogus,* Bussum (Thoth) 2000; Donald Grinberg, *Housing in the Netherlands 1900-1940,* Delft (Delft University Press) 1982; J.J.P. Oud, 'Gemeentelijke woning-bouw in "Spangen" en "Tusschen-dijken"', *Rotterdamsch Jaar-boekje,* 1924, pp. XLIX-LV

16 Els Hoek, *Theo van Doesburg. Oeuvre Catalogus, Bussum* (Thoth), 2000; Alied Ottevanger ed., *'De Stijl overal absolute leiding.' De briefwisseling tussen Theo van Doesburg en Antony Kok,* Bussum (Thoth), 2008;

Evert van Straaten, *Theo van Doesburg, 1883-1931,* The Hague (Staatsuitgeverij) 1983; Administratie [Theo van Doesburg], 'De Nieuwe Typografische Indeeling van "De Stijl",' *De Stijl,* vol. 4, no. 2 (February 1921), pp. 17-18.

17 Carel Blotkamp (ed.), *De vervolgjaren van De Stijl 1922-1932,* Amsterdam & Antwerp (L.J. Veen) 1996; Evert van Straaten, *Theo van Doesburg. Painter and Architect,* The Hague (SDU) 1988

18 K. Schippers, *Holland Dada,* Amsterdam (Querido) 1974; Hubert van den Berg, 'A Victorious Campaign for Dadaism?: Dada in the Dutch Daily Press 1923' in Harriet Watts ed., *Dada and the Press,* Farmington Mills MI (G.K. Hall) 2004, pp. 441-488; Sjarel Ex and Els Hoek, *Vilmos Huszár: schilder en ontwerper, 1884-1960,* Utrecht (Reflex), 1985

19 J.P. Mieras, 'Een Uithoekje van een Wereldstad', *Bouwkundig Weekblad,* vol. 44, nos. 33-6 (1923), pp. 361-364, 368-372, 375-378 and 381-386; J.J.P. Oud, 'Over de toekomstige bouwkunst en hare mogelijkheden', *Bouwkundig Weekblad,* vol. 42, no. 24 (1921), pp. 147-160; J.P. Mieras, 'Reisschetsen door Architect M. de Klerk', *Wendingen,* vol. 6, no. 2 (February 1924), pp. 3-5

20 Manfred Bock, 'Cornelis van Eesteren', in: Carel Blotkamp (ed.), *De vervolgjaren van De Stijl,* Utrecht (L.J. Veen) Amsterdam/Antwerp 1996, pp. 251-276; Evert van Straaten, *Theo van Doesburg. Painter and Architect,* The Hague (SDU) 1988

21 Ida van Zijl, Bertus Mulder, *Het Rietveld Schröderhuis,* Utrecht (Uitgeverij Matrijs) 2009, passim.;

Marijke Küper and Ida van Zijl, *Gerrit Rietveld, Het volledige werk, 1888-1964*, Utrecht 1993, pp. 84, 97-102

Entr'acte 2

Ietse Meij, *Mode 1920-1930. Kleding voor dynamische vrouwen*, Gemeentemuseum Den Haag pamphlet, 1995;
Madelief Hohé and Georgette Koning, *Voici Paris! Haute Couture*, Zwolle (Waanders) 2010;
'De Mode van den Dag', *De Telegraaf,* 20 November 1925, with thanks to Matteo de Leeuw-Monti;
C. Proos-Berlage, *Sierkunst en vrouwenkleeding*, Rotterdam (Brusse) 1927;
Wies van Moorsel, *Nelly van Doesburg 1899-1975. 'De doorsnee is mij niet genoeg'*, Nijmegen (SUN) 2000;
Petra Timmer, *Metz & Co. De creatieve jaren*, Rotterdam (010) 1995

22 Alied Ottevanger, *'De Stijl overal absolute leiding'. De briefwisseling tussen Theo van Doesburg en Antony Kok*, Bussum (Thoth) 2008, letters 156, 157, 160, 165, 166, 172;
Letter from Van Doesburg to Evert Rinsema, 20 August 1922, quoted in Evert van Straaten, 'Theo van Doesburg', in Carel Blotkamp (ed.), *De vervolgjaren van De Stijl 1922-32*, Amsterdam/Antwerp (Veen), pp. 48-49

23 Oud Archive, Rotterdam (NAi);
Archive of Theo and Nelly van Doesburg, RKD, The Hague;
Theo van Doesburg, *On European Architecture: The Complete Essays from Bouwbedrijf 1924-1931*, Basel, Berlin, Boston (Birkhäuser, 1990);
Michael White, 'Spiritual Hygienists: Van Doesburg, Teige and the Concept of Progress', *Umění*, vol. 48, nos. 1-2, pp. 63-5;

Theo van Doesburg and Karel Teige, 'Aufruf', *Pasmo* nos. 7-8 (1924), p. 1; (1995), pp. 63-5;
Peter Wiebel ed., *Frederick Kiesler: Architekt 1890-1965*, Vienna (Hochschule für Angewandte Kunst) 1975

24 Theo van Doesburg, 'Elementarisme', *De Stijl*, dernier numéro, 1932, p. 16;
'Élémentarisme (les elements de la nouvelle peinture)', *Abstraction-Création*, no. 1, 1932, p. 39;
Evert van Straaten, *Theo van Doesburg. Painter and Architect*, The Hague (SDU) 1988;
Alied Ottevanger (ed.), *'De Stijl overal absolute leiding.' De briefwisseling tussen Theo van Doesburg en Antony Kok*, Bussum (Thoth), 2008;
Theo van Doesburg, *On European Architecture: The Complete Essays from Bouwbedrijf 1924-1931*, Basel, Berlin, Boston (Birkhäuser) 1990

25 Mary Blume, 'Celebrating a Stylish Modern Architect', *The New York Times*, July 8, 2005;
Evert van Straaten, 'Kleurconstructie voor een bloemenkamertje (1924-25)' in *Theo van Doesburg, schilder en architect*, The Hague (SDU) 1988, p. 177;
G. Monnier, 'La Salle des Fleurs' in Serge Lemoine, *Theo van Doesburg*, Paris (Philippe Sers Editeur) 1990, pp. 140-145

26 Yve-Alain Bois, *Arthur Lehning en Mondriaan: Hun vriendschap en correspondentie*, Amsterdam (Van Gennep) 1984;
Toke van Helmond (ed.), in: *i10: sporen van de avant-garde*, Heerlen (Abp) 1994;
Kees van Wijk, *Internationale Revue i10*, Utrecht (Reflex) 1980;

Carel Blotkamp (ed.), *De vervolgjaren van De Stijl 1922-32*, Amsterdam/Antwerp (Veen) 1996

27 Vilmos Huszár, 'De Reclame als Beeldende Kunst', *i10*, vol. 1, no. 5 (May 1927), pp. 161-3;
Vilmos Huszár, 'De Reclame als Beeldende Kunst' *Bouwkundig Weekblad*, vol. 50, no. 20 (1929), pp. 155-160;
Piet Zwart, 'Goed Begrijpen Overheidsbemoeiing?', *Bouwkundig Weekblad*, vol. 48, no. 32 (6 August 1927), pp. 286-88;
Sjarel Ex and Els Hoek, *Vilmos Huszár, schilder en ontwerper 1884-1960*, Utrecht (Reflex) 1985

28 C. van Eesteren, *Het Idee van de functionele stad/The idea of the functional city*, Rotterdam (NAi) 1997;
Vincent van Rossem, *Het Algemeen Uitbreidingsplan van Amsterdam*, Rotterdam (NAi) 1993

29 Mariet Willinge, Emmanuel Guigon and Hans van der Werf (eds.), *L'Aubette ou la couleur dans l'architecture*, Strasbourg (Musees de la ville de Strasbourg) 2008;
Theo van Doesburg, 'Notices sur l'Aubette à Strasbourg', *De Stijl* , nos. 87-89 (1928), pp. 2-18;
Theo van Doesburg, *On European Architecture: The Complete Essays from Bouwbedrijf 1924-1931*, Basel, Berlin, Boston (Birkhäuser) 1990;
Hugo Weber, 'Commentaire du catalogue de l'œuvre de Sophie Taueber-Arp' in Jean-Louis Faure & Claude Rossignol (eds.), *Sophie Taueber-Arp*, Strasbourg (Musée d'Art Moderne) 1977, p. 16

30 Auke van der Woud, *CIAM Housing Town Planning*, Delft (Delft University Press) 1983;

Giorgio Ciucci, 'The Invention of the Modern Movement', *Oppositions*, no. 24 (Spring 1981), pp. 68-91

31 Jack Otsen, 'De Purmerendse Jaren van Mart Stam', www.onvoltooidverleden.nl, issue 19, June 2010; Otakar Máčel, 'Avant-garde Design and the Law: Litigation over the Cantilever Chair', *Journal of Design History*, 3 (1990) 2-3, pp. 125-143; Angela Thomas, *Mit subversivem Glanz. Max Bill und seine Zeit*, Zürich (Scheidegger & Spiess) 2009, pp. 109-110; Marijke Küper and Ida van Zijl, *Gerrit Th. Rietveld, 1888-1964: Het volledige werk*, Utrecht (Centraal Museum) 1992

32 J.J.P. Oud, 'The £213 House. A Solution to the Re-housing Problem for Rock-bottom Incomes in Rotterdam', *The Studio*, vol. 101 (1931), pp. 175-9; Ed Taverne, Cor Wagenaar and Martien de Vletter, *Poetic Functionalist. J.J.P. Oud 1890-1963. The Complete Works*, Rotterdam (NAi) 2001; Sjoerd Cusveller (ed.), *De Kiefhoek, een woonwijk in Rotterdam*, Laren (V+K Publishing) 1990; Erna Meijer, 'Wohungsbau und Hausführung', *i10*, vol. 1, no. 5 (1927)

33 (from our correspondent) [W.F.A. Roëll], 'Bij Piet Mondriaan. Zijn nieuwe levensleer', *Het Vaderland*, 12 March 1932, evening edition C2; Nancy Troy, *The De Stijl Environment*, Cambridge/London (MIT) 1983, passim; Michael White, *De Stijl and Dutch Modernism*, Manchester 2003, p. 121 et seq.

Entr'acte 3

With thanks to Erna Onstenk and Mr and Mrs De Monchy-Westerhuis, Inge Jolein Schoone and Annemarie den Dekker, Amsterdam Museum; 'Textiel voor tafel en keuken. Huishoudtextiel' in *Textuur*, Nederlands Textielmuseum Tilburg, June 1984; 'Een bijzondere bezoeker' in *Textuur*, Nederlands Textielmuseum Tilburg, no. 2, 2006, p. 16; Titus M. Eliëns, *Het Art Nouveau Art Deco boek*, Zwolle (Waanders) 2003; Ietse Meij, *Haute Couture & prêt-à-porter*, Zwolle (Waanders) 1998; Petra Timmer, *Metz & Co. De creatieve jaren*, Rotterdam (010) 1995

34 Yvonne Brentjens, *Piet Zwart 1885-1977, Vormingenieur*, The Hague (Gemeentemuseum) and Zwolle (Waanders) 2008, pp. 245-261

35 Sjarel Ex and Els Hoek, *Vilmos Huszár: schilder en ontwerper, 1884-1960*, Utrecht (Reflex), 1985; Gijsbrecht Friedhoff, 'Het Nederlandsche Paviljoen op de New York World's Fair 1939', *Bouwkundig Weekblad Architectura*, vol. 60, no. 31 (5 August 1939), pp. 305-316; Michael White, *De Stijl and Dutch modernism*, Manchester (Manchester University Press), 2003; Ad Petersen and Pieter Brattinga (eds.), *Sandberg: een documentaire/ a documentary*, Amsterdam (Kosmos) 1975

Colophon

Translation
Sue McDonnell
David McKay

Design and typesetting
Typography Interiority & Other
Serious Matters, The Hague

Illustrations editor
Lieke Wijnia

Colour separations
Peter Couvee

Printing
DeckersSnoeck, Antwerp

Permission to reproduce the works
of visual artists affiliated with a
CISAC organization has been
obtained from Sabam in Brussels.
© c/o Sabam Brussels 2011

Copyright © Ludion
and the authors

Cataloging-in-Publication Data
has been applied for and may
be obtained from the Library
of Congress.

ISBN 978 1 4197 0112 2

Distributed in North America by
Abrams, an imprint of ABRAMS.
All rights reserved. No portion of
this book may be reproduced,
stored in a retrieval system, or
transmitted in any form or by any
means, mechanical, electronic,
photocopying, recording, or other-
wise, without written permission
from the publisher.

Printed and bound in Belgium
10 9 8 7 6 5 4 3 2 1

Abrams books are available at
special discounts when purchased
in quantity for premiums and
promotions as well as fundraising
or educational use. Special editions
can also be created to specification.
For details, contact
specialsales@abramsbooks.com
or the address below.

ABRAMS
THE ART OF BOOKS SINCE 1949
115 West 18th Street
New York, NY 10011
www.abramsbooks.com

Photographic Credits

Every effort has been made to
trace copyright holders. If, however,
you feel that you have inadvertently
been overlooked, please contact
the publisher.

Biographical Credits
H.P. Berlage, p. 17 –
 Gemeentemuseum Den Haag
Bart van der Leck, p. 21 –
Private collection
Piet Mondrian, p. 31 – RKD,
 photograph by André Kertesz
Theo van Doesburg, p. 37 – RKD
Vilmos Huszár, p. 43 – RKD
Antony Kok, p. 53 – RKD
Georges Vantongerloo, p. 63 –
 Angela Thomas Schmid,
 Pro Litteris
Robert van 't Hoff, p. 73 –
Private collection
Piet Zwart, p. 101 –
 Nederlands Fotomuseum,
 Rotterdam
Jan Wils, p. 109 –
 NAi, Rotterdam
J.J.P. Oud, p. 117 –
 NAi, Rotterdam
I.K. Bonset, p. 129 – RKD
Lena Milius, p. 135 – RKD
Aldo Camini, p. 141 –
 Gemeentemuseum Den Haag
Gerrit Rietveld, p. 145 –
 Centraal Museum, Utrecht
Cornelis van Eesteren, p. 163 –
 NAi, Rotterdam
Truus Schröder, p. 169 –
 Centraal Museum, Utrecht
César Domela, p. 195 – RKD
Nelly van Doesburg, p. 213 – RKD
Mart Stam, p. 225 –
 Private collection

Cover

Detail of: Piet Mondrian, *Composition
with Yellow, Black, Red and Gray*,
1921, oil on canvas, 88,5 x 72, 5 cm.
Private collection (© Mondrian/
Holtzman Trust c/o HCR
International, Virginia, USA).